With our
compliments

**Cascadia
Art Museum**

Edmonds, Washington

THE SCOTT AND LAURIE OKI SERIES IN
ASIAN AMERICAN STUDIES

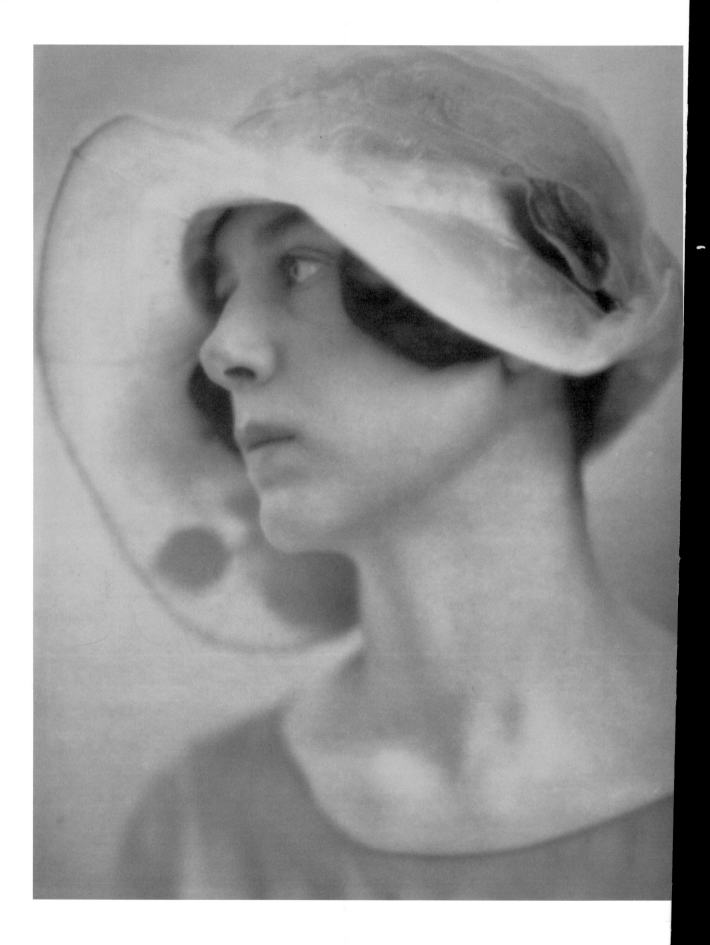

SHADOWS OF A FLEETING WORLD
PICTORIAL PHOTOGRAPHY AND THE SEATTLE CAMERA CLUB

DAVID F. MARTIN

AND NICOLETTE BROMBERG

UNIVERSITY OF WASHINGTON PRESS
SEATTLE AND LONDON

IN ASSOCIATION WITH

UNIVERSITY OF WASHINGTON LIBRARIES
AND THE HENRY ART GALLERY

16 15 14 13 12 11 5 4 3 2 1

University of Washington Press
PO Box 50096, Seattle, WA 98145–5096, USA
www.washington.edu/uwpress

University of Washington Libraries
PO Box 352900, Seattle, WA 98195–2900, USA
http://www.lib.washington.edu/

Henry Art Gallery
University of Washington
PO Box 351410
Seattle, WA 98195–1410, USA
http://www.henryart.org/

Library of Congress Cataloging-in-Publication Data
Martin, David F. (David Francis)
 Shadows of a fleeting world : pictorial photography and the Seattle Camera Club / David F.
Martin and Nicolette Bromberg.
 p. cm. — (The Scott and Laurie Oki series in Asian American studies)
 "In association with University of Washington Libraries and the Henry Art Gallery."
 Includes bibliographical references.
 ISBN 978–0–295–99085–9 (pbk. : alk. paper)
 1. Photography, Artistic. 2. Japanese Americans—Pictoral works 3. Pictoralism (Photography
movement)—Washington (State)—Seattle. 4. Seattle Camera Club. I. Bromberg, Nicolette.
II. University of Washington Libraries. III. Henry Art Gallery. IV. Title.
 TR653.M366 2011
 770.9797'772--dc22
 2010035650

CONTENTS

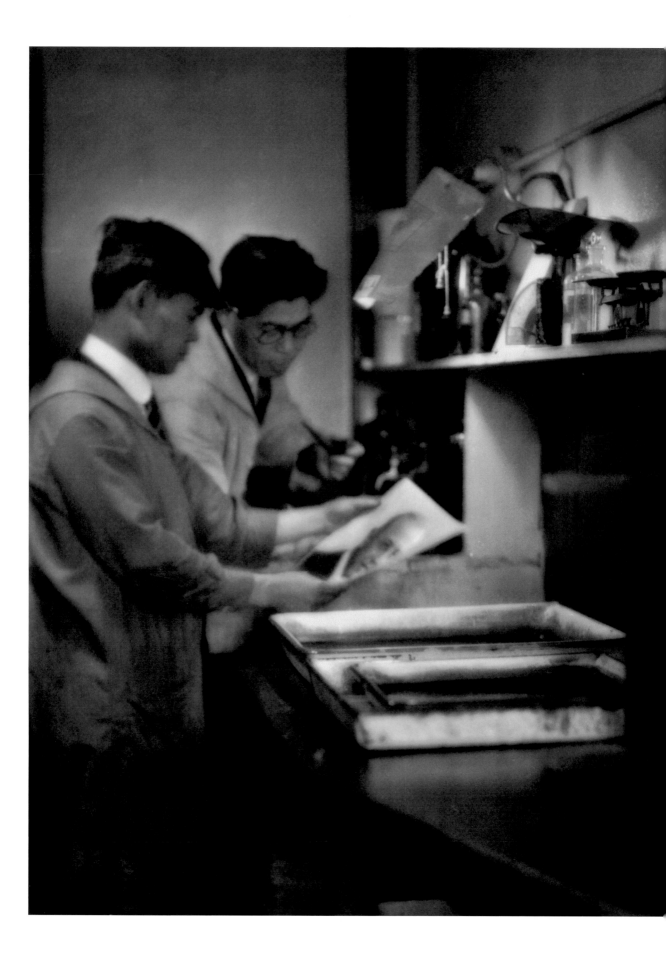

FOREWORD

JAPANESE AMERICAN HISTORY is often inevitably defined by World War
II. The incarceration of more than 110,000 Nikkei (those of Japanese descent)
in 1942 has, in a sense, obscured all the history that came before and after this
watershed event. So it is welcome to see a book that brings to light a forgotten era
of Nikkei history and shines a focus on Nikkei contributions to twentieth-century
photographic history.

Before there was an International District in Seattle, there was
Nihonmachi—Japantown. Nihonmachi in the 1920s was a bustling area spanning
some fifteen blocks south of downtown, filled with shops and restaurants. The
Seattle Camera Club's headquarters in the Empire Hotel at 422 1/2 Main Street
was geographically on the border dividing white and Asian Seattle—a providential
location well suited for an organization that attempted to bridge race through its
artistic endeavors and membership. Nearby, Dr. Kyo Koike, Iwao Matsushita, and
other members of the club could find noodle shops and tailors, bookstores and
barbers, public baths and theaters.

Japanese immigration to the Pacific Northwest began in earnest as restric-
tions against Chinese immigration were enacted and the demand for labor grew
in the late nineteenth century in industries such as railroads, mining, timber, and
fisheries. By 1900 Japanese were the largest nonwhite minority in Seattle, a more
than twentyfold increase in a single decade, from 125 people to 2,990. By 1920 the
population had grown to almost 8,000.[1] Unlike Chinese immigration, which was
predominately male—especially after the passage of the Page Act of 1875, which
hindered the immigration of Chinese women in order to prevent prostitution (the
ratio of Chinese men to women in 1900 was an astounding 18 to 1)—Japanese im-
migrants were more likely to be family units.[2] In addition, a loophole in the 1907
Gentlemen's Agreement to stem Japanese immigration allowed women to immi-
grate, creating a flourishing migration of "picture brides" to the United States. So,
although Asian immigration effectively ended with the passage of the Immigra-
tion Act of 1924, there was already in the United States a population of Nikkei
that could sustain itself and grow. By 1920 nearly a quarter of Seattle's Nikkei
community were American citizens born on U.S. soil; by 1930 almost half of the
8,448 Nikkei were citizens.[3]

The economic impact of this relatively small minority (never more than 3
percent of Seattle's population) far outpaced its size. A study in the 1920s found
that there were almost 1,500 Japanese-owned businesses in the city. Likewise,
Japanese farmers dominated truck farming in the Puget Sound region from World

War I through the 1930s, leasing the majority of space in Seattle's public farmers' market at Pike Place.[4] By 1942, in an attempt to prevent the wholesale incarceration of Nikkei on the West Coast, the Japanese American Citizens League (JACL) stressed the economic importance of the community to Seattle. The JACL reported to the Tolan Committee that Japanese operated over 60 percent of the city's hotels, 10 percent of its restaurants, and 17 percent of its grocery stores. In the agricultural arena, Nikkei dominance was even more profound, with some 90 percent of Puyallup Valley farming under Japanese cultivation.[5]

One scholar credits the success of Seattle's Nikkei community partially to a higher class of Japanese immigrant coming to the Pacific Northwest, one more educated and politically active than those that settled in California and in the Hawaiian Islands.[6] Perhaps, too, the Seattle community, even in the late nineteenth century a frontier city, was more open to the influx of Japanese immigrants and others coming to the region. And certainly the city foresaw that its future success lay as the "Gateway to the Orient," where trade with Japan and other Asian nations would be economically critical. The Alaska-Yukon-Pacific Exposition in 1909 exemplified this notion, with its official seal depicting three women symbolizing Alaska, the United States, and Asia (a Japanese woman dressed in a stylized kimono). Whatever the mix of factors, there appeared to be a different dynamic between Nikkei and the greater Caucasian community in Seattle and the Pacific Northwest than in other parts of the West Coast. One Issei (first generation of Japanese immigrants) reminisced of prewar times, "In Seattle there was an air of freedom."[7] Certainly there were anti-Japanese movements in the region, especially those aimed at lessening Nikkei economic success. However, the prewar period in Seattle can be more characterized by the overtures across racial lines than by the racial tension found in California and other parts of the west. This climate of less racial antagonism and separation was even evident after Pearl Harbor with greater community support for the Nikkei community and significantly higher rates of military enlistment among Pacific Northwest Nikkei men than of those from California.

It is perhaps not surprising that the major national Nikkei organization, the Japanese American Citizens League, was founded in Seattle in 1929. One of the moving forces of the JACL was James Sakamoto, a Nisei (second generation, therefore an American citizen) who served as the group's president in the 1930s and founded the first English-language Nikkei newspaper, the *Japanese American Courier*, in 1928. Both the JACL and the *Courier* emphasized Americanization and assimilation.

It is into this mix that Dr. Kyo Koike and his fellow photographers established the Seattle Camera Club in 1924. From its inception, the club served as a meeting place among races and cultures. Though membership was predominately Japanese—most members were Issei men and hobbyists rather than professional

photographers—the club was partially successful in attracting Caucasian members and considered itself interracial.[8]

The popular and artistic success of Seattle Camera Club members as evidenced by salon showings and prizes throughout the 1920s illustrates that critics, too, appreciated this cultural merger between East and West. One Caucasian contemporary characterized the artistic works of club members as "an amalgamation of Japanese treatment and American composition, resulting in what may be termed a new expression of Japanese American portrayal."[9]

In the few short years of the Seattle Camera Club's existence, its members put Seattle on the artistic national map. Koike understood that regional boosterism was one purpose and outcome of the club's success. He wrote, "Living in Seattle we have the privilege, not duty, to introduce this splendid scenery to outsiders by photographic means. When you show your pretty photographic products to friends out of town, think how deeply they will be impressed."[10] Indeed the visual identity of Seattle created and promoted by the Nikkei photographers of the Seattle Camera Club continues to be the dominant geographic iconography of the region—one of mountains (especially Mount Rainier) and of water and atmosphere (light, mists, rain, and clouds).

This book celebrates the artistic contribution and historical significance of the Seattle Camera Club. David F. Martin provides grounding in Pictorialism and places club photographers in the national and international setting of the time. Nicolette Bromberg turns her attention to the club and the fascinating story of how the photographs and accompanying material found their way to the University of Washington Libraries. Without the efforts of Iwao Matsushita, who donated the Seattle Camera Club materials, and the foresight of Robert Monroe, head of the University of Washington Libraries Special Collections (1963–80), who accepted the collection, these materials might not have survived.

This book also honors the work of the many librarians and archivists who are dedicated to collecting and curating special collections material. This project eloquently demonstrates that the research value of manuscripts, books, photographs, and other visual materials cannot always be predicted at the time they are acquired. It is the responsibility of librarians and archivists to see beyond the present moment and to take on the task of imagining future research. Without their dedication, projects like this one might never be realized. We are extremely fortunate to have this opportunity to revisit the past and to see our history through the eyes of and images by members of the Seattle Camera Club, whose legacy enriches us all.

DEAN LIZABETH (BETSY) WILSON
AND THERESA MUDROCK, HISTORY LIBRARIAN
UNIVERSITY OF WASHINGTON LIBRARIES

1 Calvin Schmid, "Social Trends in Seattle," *University of Washington Publications in the Social Sciences* 14 (October 1944): 131.

2 Shelley Sang-Hee Lee, "Cosmopolitan Identities: Japanese Americans in Seattle and the Pacific Rim, 1900–1942" (PhD diss., Stanford University, 2005), 38.

3 David Takami, *Divided Destiny: A History of Japanese Americans in Seattle* (Seattle: University of Washington Press, 1998), 32.

4 Lee, "Cosmopolitan Identities," 44.

5 "Statement by Emergency Defense Council, Seattle Chapter, Japanese-American Citizens League," in House Select Committee Investigating National Defense Migration, *National Defense Migration, Part 30: Portland and Seattle Hearings: Problems of Evacuation of Enemy Aliens and Others from Prohibited Military Zones,* 77th Cong., 2nd sess., March 2, 1942, pp. 11450–460.

6 Kazuo Ito, *Issei: A History of Japanese Immigrants in North America* (Seattle: Japanese Community Service, 1973).

7 Ibid., 138.

8 Lee, "Cosmopolitan Identities," 128.

9 "The Pictorial Photographic Workers of the Pacific Northwest and Their Relation to the Art of Pictorial Photography," *Notan,* September 13, 1929, cited in Lee, "Cosmopolitan Identities," 148.

10 "To the Seattle Photographers Amateur and Professional," *Notan,* March 11, 1927, cited in Lee, "Cosmopolitan Identities," 140.

(RIGHT)

(above) Seattle Camera Club logo.
(below) Seattle Camera Club members and guests, ca. 1928. Standing from left: Frank Asakichi Kunishige, Dr. Kyo Koike, H. Ihashi, I. Kambara, N. Ike, Yukio Morinaga, Charles A. Musgrave. Seated left to right: Dr. D. J. Ruzicka, Ella McBride, Mrs. Ruzicka, and Mrs. Musgrave. Dr. Drahomir J. Ruzicka (1870–1960) of New York was a leading Pictorial photographer and an avid supporter of the SCC.
Photograph by Harry A. Kirwin
University of Washington Libraries, Special Collections, UW29046Z

THE SEATTLE SCC CAMERA CLUB

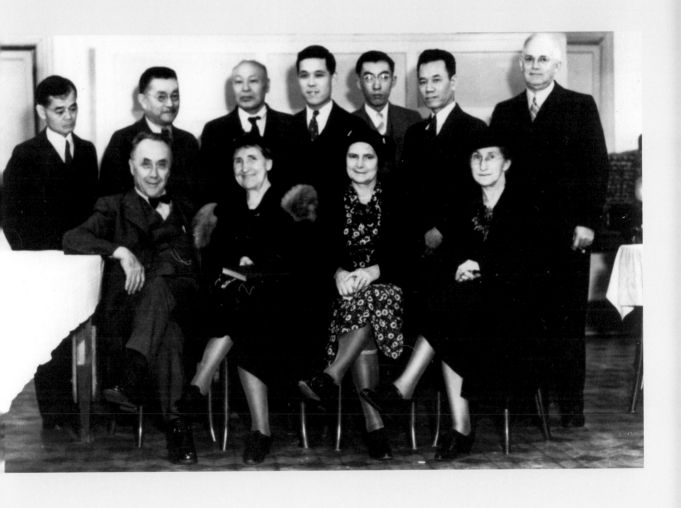

INTRODUCTION

NEW DISCOVERIES bring extraordinary energy to a discipline. Reviving the history of the Seattle Camera Club has proven to be a gratifying project for the Henry Art Gallery. Located on the main campus of the University of Washington, the Henry has collaborated with its sister organizations, the University of Washington Libraries and the University of Washington Press, to develop the first comprehensive monograph on this important but little known group of artists. The Henry Art Gallery's distinguished photography collection includes works ranging from the invention of the medium to its present-day experimentation. Heretofore the Henry has focused very little on Pictorialism, a style that dominated photographic expression for half a century or more. The present publication and the exhibition that greets its release provide an opportunity to reexamine a moment in Seattle's history when photography captured the general imagination.

Seattle is celebrated for its many Asian American immigrants, including the Japanese-born generation of Issei. In the first quarter of the twentieth century, a group of Seattle Issei developed a remarkable community centered on art photography, which in 1924 established an organization called the Seattle Camera Club. Although the Seattle Camera Club (or SCC) lasted a scant four and a half years, its members established effective models for working collectively. Moreover, their work significantly helped to promote discourse about Seattle artists in national and international publications.

The environment in which the Seattle Camera Club flourished was similar to that of Los Angeles at the time, where, as Tim Wride observed, "The city, its cultural institutions, and the medium [of photography] came of age together, aiding each other's growth. The burgeoning metropolis provided a rich visual environment as well as ready acknowledgement for the creative use of this evolving technology, while the medium helped to spur economic and cultural advances in the rapidly growing city."[1] Like Los Angeles, Seattle offered both extraordinary natural resources and exciting urban developments. Although both cities featured vigorous Issei communities (as did San Francisco, the third West Coast city to develop distinctive Pictorialist photography), artists of Japanese origin dominated the Seattle scene much more than in California.

In his study of Japanese American photography, Dennis Reed speculates on the particular appeal of camera clubs:

> In the circle of pictorial photography, the Japanese photographers in America found greater acceptance than in many other

areas of their lives. Pictorialists were generally enthusiastic about photography by American Japanese, even if a few critics scoffed at their work. On the whole, pictorialists were supportive and fair to the Japanese in America.... Reflecting the general diversity of pictorial photographers, the work of some Japanese ... was among the most adventurous in American Pictorialism....

The camera clubs formed by the Japanese in America reflected their sense of community. An advantage of membership included traveling, not alone, but as a group, on photographic excursions in a social climate often hostile to the Japanese in America. Although unintentional, perhaps the greatest benefit of belonging to an exclusively Japanese club was the degree to which members preserved their Japanese viewpoint. While members had access to Western photography through books, exhibitions, and from Caucasian friends, they could retreat to their club for discussions of photography—free, if they preferred, from Western influences.[2]

Shadows of a Fleeting World reveals multiple strands of the Seattle Camera Club's inventive art. In her essay, Nicolette Bromberg provides excellent histories of Dr. Kyo Koike, Iwao Matsushita, and Frank Asakichi Kunishige, three of the central figures behind the success of the SCC. David F. Martin, a devoted and assiduous scholar of early- and mid-twentieth-century Seattle art, surveys SCC activities within a carefully established photographic history of the region and has supplied biographical sketches of all the major figures whose activities and work can still be traced. Both essayists have vividly characterized the Japanese American experience that created this distinct organization and have evoked its aftermath—particularly the painful ruptures that the Japanese internment produced in the artists' lives and work.

Although the history of the Issei during the first half of the twentieth century is a central aspect of the present study, feminist history is nearly as significant to our understanding of the SCC. Ella McBride, proprietor of her own photography studio, was among the first Caucasians to join the Issei artists. McBride found her ideal métier in Pictorialism. Her elegant floral studies won numerous awards, and she became one of the most popular and celebrated participants in photographic salons across the United States and abroad. More than a generation younger, the boldly experimental Virna Haffer joined the club in the late 1920s and opened her own studio in nearby Tacoma, where she employed fellow SCC member Yukio Morinaga.

Exploring the history of Pictorialism in Northern California, Michael G. Wilson notes, "Photography was one of the few areas of the graphic arts that provided a lucrative career opportunity for women. By 1900 more than thirty-

five hundred women were employed as professional photographers in the United States, and by 1911 it was estimated that sixteen hundred women were proprietors of photographic studios. California women were particularly successful in this field."[3] The same pattern held farther up the coast, where Imogen Cunningham had her start. Both McBride and Haffer were intrepid and innovative in their art. McBride seems to have effortlessly assimilated into a group of Japanese American men when she joined the SCC, and the presence of Western male artists, such as Charles Musgrave and R. M. Lewis, didn't make her entry any easier. Haffer's photographs reveal an originality and self-confidence remarkable in such a young artist. *His First Growth,* dated 1924, when the artist herself was twenty-four, is extraordinary for the delicate tracery of the line, the bold occupation of the entire picture plane, and the startling focus on the back of a head. The radical treatment is made charming by its infant subject but is nonetheless surprising in the first quarter of the twentieth century, given that the same motif was explored by post-modernists in the 1980s and beyond.

Much of vanguard contemporary art follows the example of Pop artist Roy Lichtenstein in hiding its real meaning behind flamboyance or irony. For a curator who specializes in the art of the present moment, the expected challenge is to help general audiences experience beauty, power, or sensitivity in art that ostensibly rejects these notions. In contrast, the case of the Seattle Camera Club poses a very different charge: to find ways to demonstrate the continuing relevance of work made nearly a century ago. Exploring its history has been revelatory. Like so many of my generation, I absorbed the message that Pictorialism was conservative, the backwater against which we enjoyed Dada or sleek modernist accomplishments of the avant garde. Finding strikingly original accomplishments among these unknown artists was eyeopening, and their achievements complicate any simple summary of Pictorialism. The clean, incisive lines of Hiromu Kira's precise abstractions counter the stereotype of soft-focus imagery, for example, and the bold lighting of Yukio Morinaga's dockworker photos provides a dramatic contrast to the timeless decorative motifs we have been trained to expect in Pictorialism.

The alliances the Seattle Camera Club forged with major schools in Seattle are also significant. Ambrose Patterson, chair of the School of Art at the University of Washington, participated in judging the Seattle Salon, and Glenn Hughes, a professor in the UW Drama Department, helped to edit the SCC bulletin *Notan*. Ella McBride's studio was contracted to photograph for Cornish School of Allied Arts, which fostered an astonishing spectrum of artists, and Frank Kunishige, Soichi Sunami, and Wayne Albee made powerfully original photographs of these and other artists.

One of the most striking qualities of the Seattle Camera Club was its collective activity, its powerful need to gather and be counted together and the accomplishments that grew out of this union. Camera clubs were extremely prevalent in the period between the world wars (for example, in the United

Kingdom alone, camera clubs existed in Birmingham, Bridge of Allan, Cardiff, Edinburgh, Glasgow, Hammersmith, Leicester, Liverpool, London, Wilmington, and Worchester). Camera clubs represented a truly international phenomenon, as Bromberg and Martin have both effectively traced. Artists in Uruguay, Belgium, Czechoslovakia, Australia, and America communicated regularly, sending images, opinions, encouragement, and congratulations through their postal services in much the same way various communities today engage across the World Wide Web. I am hard pressed to think of comparable examples in the postwar years where individuals linked only by their common interests have been able to sustain strong groups independent of extant organizations, such as governments, religions, or employers. The alliances the camera clubs built encouraged internal support as well as public advocacy. Judging from some of the accounts published in *Notan*, club-sponsored salons and expositions garnered broad public attendance, which helped to spread an interest in photography, establish the seriousness of the medium, and create a vibrant market. Sending prints to distant venues for exhibitions—and as greetings and gifts at Christmas time—created a durable visual communication. Along the way these artists distributed new ideas about composition, printing techniques, imagery, and representation, deepening the worldly sophistication of all the participants.

At the same time, artists found their independent creative work immeasurably strengthened by such alliances. Working collectively supported their experimentation: bringing new prints to club meetings, members found insightful critics and generous mentors. As Christian Peterson explains, "Camera clubs provided a place for pictorialists both to learn new techniques and to share their own expertise. Every club member was considered a source of information and was encouraged not only to attend meetings but also to work up his or her own demonstrations for others. Members of different social classes worked together in a cordial, democratic setting. Individuals checked their professional standing at the door and judged one another only on the basis of photographic skill and artistic accomplishment."[4]

Artists who bemoan the isolation and insecurity of solitary work often find new inspiration and companionship when engaging in collaboration. In this context, one imagines how supportive and exciting Seattle Camera Club activities must have been for its participants. On the one hand there were club outings, such as group visits to Mount Rainier and other picturesque sites, which would have been both fruitful and fun. But for artists trying to sustain focus and find meaning in their work, surely the monthly meetings, where participants' prints were analyzed and discussed, must have felt equally empowering. The collaborative nature of the SCC suggests a provocative parallel to contemporary art, which has lately been marked by the rise of artist collectives.

The Henry Art Gallery's exhibition will provide an opportunity for visitors to experience firsthand the work of artists who participated in the Seattle Camera

Club. In the 1920s, visitors to international expositions and salons of Pictorial photography expressed fondness for Ella McBride's asymmetrical still lifes and the dreamy eroticism of Frank Kunishige's nudes. They avidly purchased works by Hideo Onishi and remarked upon the many accomplishments of Dr. Kyo Koike. In the same way, this exhibition will afford new viewers a comparable doorway to the works of these artists and to the beauty they found in the world around them.

The greatest challenge of this exhibition has been to sketch the extent of the club when some of the artists are represented by only a handful of works, or sometimes by a single example, as in the intriguing case of Miss Y. Inagi. The work of yet others seems fully eradicated: the only evidence of their participation is a listing in *Notan* or their names recurring in the rolls of salon participants. In experiencing these photographs, we can sometimes trace interrelationships, influences, and debates among the practitioners, which reflect their activities and preoccupations, however fleetingly. We can glimpse a privileged perspective into the past and imagine something of the private conversations and intimate deliberations that generated their artistic production.

These artists came together primarily by their passion for the camera: a need to make art, a drive to self expression, a conviction that photography was as valid an art medium as painting. Most were amateurs (Kyo Koike was a physician and Hiromu Kira a salesman), and they took quite seriously the root of the word "amateur" in amour, love. This group of gifted artists reminds us of a time when art was both rigorous and popular. Seattle Camera Club artists adored making pictures, cared passionately about beauty, and strove not only to build upon their own work but to expand the audience for photography in general. Their example and their production promises to inspire new audiences today.

Elizabeth Brown
Chief Curator and Director of Exhibitions and Collections,
Henry Art Gallery

NOTES

1 Tim B. Wride, *Pictorialism, and the International Salons of Photography* (Los Angeles: Los Angeles County Museum of Art, 1998), n.p.

2 Dennis Reed, *Japanese Photography in America, 1920–1940* (Los Angeles: Japanese American Cultural and Community Center, 1985), 17, 77.

3 Michael G. Wilson and Dennis Reed, *Pictorialism in California: Photographs, 1900–1940* (Malibu, CA: J. Paul Getty Museum; San Marino, CA: Henry E. Huntington Library and Art Gallery, 1994), 7–8.

4 Christian A. Peterson, *After the Photo-Secession: American Pictorial Photography, 1910–1955* (New York: Minneapolis Institute of Art, W. W. Norton, 1997), 129.

PAINTED WITH LIGHT

DAVID F. MARTIN

The painter need not always paint with brushes, he can paint with light itself. Modern photography has brought light under control and made it as truly art-material as pigment or clay.
—Arthur Wesley Dow, *Pictorial Photography in America* (1921)

WHEN ARTHUR WESLEY DOW (1857–1922) wrote these words for his introduction to the 1921 edition of *Pictorial Photography in America*, he was reflecting on the new wave of interest in Pictorialist photography that was spreading throughout the world. Earlier, in the nineteenth century, William Fox Talbot (1800–77) had used the phrase "the Pencil of Nature" to allude to the artistic possibilities of the medium of photography. Talbot's development in England of several innovative processes, along with the earlier efforts of Joseph Nicéphore Niépce (1765–1833) and Louis-Jacques-Mandé Daguerre (1787–1851) in France, helped to develop the technology and artistic potential of the camera.

The word *Pictorialist* was used to describe both the photographic style as well as the photographer who used the medium for artistic expression. The term had its origins in Europe with pioneers such as Henry Peach Robinson (1830–1901), who coined the expression, and Julia Margaret Cameron (1815–79). Both Robinson and Cameron used paintings as their primary influences. In the United States, Pictorialism is best known through the early work of Alfred Stieglitz (1864–1946) and his organization of like-minded colleagues, the Photo-Secession. This group was formed in 1902 and was modeled after similar European groups, such as London's Linked Ring Brotherhood (1892) and the Photo-Club de Paris (1894). The goal of these organizations was to establish photography as a fine-art medium and to exhibit their photographs with the same commitment and professionalism afforded to painting. In period texts, the term *amateur* distinguished the artistic photographer from those who used the mode principally for commercial and documentary purposes to earn a living; though seemingly derisive, the term was not intended as a pejorative assessment of an individual's abilities.

The range of styles associated with Pictorialism followed parallel painting trends such as Tonalism, Symbolism, and especially Impressionism, whose preoccupation with transient light effects was perfectly suited to photography. To achieve their results, the photo artists used innovative darkroom techniques and processes to manipulate their negatives and prints into unique compositions that were compatible with their contemporaries in the fields of painting and printmaking.

I

Some Pictorialist works display identifiable characteristics, such as the deliberate blurring of the image, or "soft focus," and the incorporation of symbolic and esoteric objects such as crystal balls and other standardized props to convey an air of mysticism. Compositionally, the landscape images often utilize a high horizon line with an elongated foreground, emphasizing the designs created through water reflections or by the flattening of traditional perspective in the manner of Japanese woodblock prints.

This shared aesthetic is not the only hallmark of Pictorialism. Current scholarship is discovering that the movement was much broader and more individually creative than previously thought. These findings are coming to light through the study of American regional camera clubs and individual photographers in major U.S. cities who produced exceptional work that is just beginning to be reassessed and acknowledged. Most previous studies have been dominated by the activities of Stieglitz and a select group of his contemporaries, most of whom were based in New York. After the demise of the Photo-Secession, some of the prominent members—such as Clarence White (1871–1925), Alvin Langdon Coburn (1882–1966), and Gertrude Käsebier (1852–1934)—commanded the movement through the next several decades, with the founding of the Pictorial Photographers of America in 1916, an organization still active today. Many other prominent venues kept Pictorialism alive past World War I, including the Pittsburgh Salon, which held its first national exhibition in 1914. Other American, Canadian, and international Salons devoted to the movement, many of them hosted by established art museums, flourished during the 1920s and later.

American manifestations of Pictorialism usually reflected the characteristic light and atmospheric conditions of each particular region as well as its unique natural terrain and industrial activities. The participation of various ethnic groups and cultures, among them many immigrants, also brought forth interesting approaches to style and subject matter and often expressed a point of view from outside the mainstream. Another aspect of Pictorialism that awaits further study is the effect that the movement exerted on early twentieth-century American motion pictures. Many black-and-white films of the 1920s and 1930s display these influences, and several prominent practitioners became cinematographers whose films represent a type of mobile Pictorialism.

In the late teens and 1920s, some photographers turned away from standard Pictorialism, eschewing darkroom manipulation in favor of unaltered, or "straight," photographic images that relied heavily on the literal observation of subjects. This transition is exemplified by the careers of Ansel Adams (1902–84), Edward Weston (1886–1958), and Imogen Cunningham (1883–1976), all of whom produced Pictorialist works in the early stages of their careers and then adapted and promoted the opposite approach as their work progressed.

While Pictorialist photographs usually relied on the use of a close arrangement of tonal values, straight photography utilized the full range of contrast, from

deep black to brilliant white, emphasizing the volumetric and planar structures inherent in the subject. Instead of shadow and light being diffused and ethereal, the straight photograph is direct, sharply scrutinized, and sometimes almost surrealistically dramatic. Although it had its own technical innovations, even straight photography followed contemporaneous painting styles of the day, with hard-edged Precisionism as the most obvious example reflected in the works of painters such as Charles Sheeler (1883–1965) and, in Weston's case, the California Modernist Henrietta Shore (1880–1963), whose paintings were acknowledged by the photographer as a significant influence. Although there was, and still is, some disagreement among art historians and critics as to which approach had more modern artistic relevance, both Pictorialism and straight photography coexisted in competitions and exhibitions and were simultaneously successful.

The history of Pictorialist photography in Washington State offers an impressive example of regional manifestations of the movement. As in most areas of the United States, the crusade for artistic photography in Washington began with the banding together of like-minded enthusiasts in clubs, where they exchanged technical and artistic ideas and, more importantly, created public exhibitions to display the results of their efforts. The original Seattle Camera Club (SCC) was organized on January 28, 1895, and its first public exhibition was held for three consecutive days beginning on Wednesday, January 15, 1896. Officers and the membership included prominent local citizens, such as Viretta Chambers Denny (1862–1951; figs. 1 and 2), Orion Denny (1853–1916), and architect Emil deNeuf (d. 1915).[1]

 The Pioneer Building in downtown Seattle, home to the organization and its club rooms, included a laboratory, work rooms and darkrooms, and "ladies and

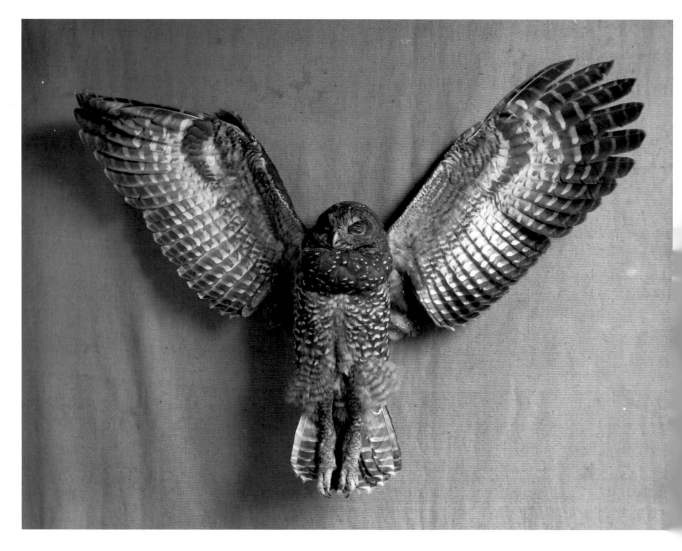

gentlemen's parlors" for socializing.[2] This was also the venue for the club's first exhibition, which was by all accounts a resounding success:

> The club rooms were beautifully decorated with wreaths and garlands of cedar, and the walls were completely covered with the 300 exhibits. . . . The exhibits were varied in every respect, and the work of the members was represented in pictures ranging from the results of pocket Kodaks to Bromide enlargements. It would be impossible to enter into a description of the individual exhibits; but the result certainly showed that every member had done his or her best in their particular line. Nearly every branch of photography was represented—portraits, landscapes, marines, copies, architectural work, interiors, transparencies and many others.[3]

It is unfortunate that the work of the majority of these early SCC members has not survived; information about their activities is limited. By 1901, members

FIGURE 2
VIRETTA CHAMBERS DENNY
Untitled, ca. 1895
Scanned and cropped from original glass plate negative
University of Washington Libraries, Special Collections, UW29051Z

of the organization attempted to reorganize and made a public appeal to other local amateur photographers to expand on the foundation of the club's first attempt.[4] With renewed vigor, Seattle's amateur photographers began appearing in regional and national publications supported by their membership in organizations such as the Columbian Photo-Amateur Exchange, which as the group's name implies allowed participants to exchange photographs with practitioners in different cities throughout the country.[5] Another more broadly regional organization, the Photographers Association of the Pacific Northwest (PAPN), began to hold conventions in 1900, with featured exhibitions and competitions; its membership included professional photographers from Washington, Oregon, and British Columbia.

One of the more active members of the PAPN was Wayne C. Albee (1882–1937) of Tacoma. In 1900, Albee produced one of the earliest known Pictorialist publications in the state, illustrated with his own artistic photographs. The privately published work was titled *Characters of Evangeline*, based on Longfellow's poem *Evangeline*, and was accompanied by a paraphrased text written by Ida Albee, the photographer's mother. No copy of the book has been located, but a published review describing it has survived. Albee used prominent local citizens of Tacoma to portray the characters of the famous poem, including the painter William H. Gilstrap (1849–1914) as René LeBlanc, the notary.[6] In 1902, Albee opened his first studio in Tacoma and concentrated on both artistic and commercial photographic portraiture. With his reputation growing, he remained in Tacoma until 1916, when he relocated to Seattle, where he would eventually become a major influence on other regional photographers.

In June 1904, the Woman's Century Club in Seattle sponsored the First Annual Exhibition and Sale of the Industrial and Allied Arts of Washington. Along with the oil paintings of prominent regional artists such as Alma Royer Lorraine (1858–1952), Emily Inez Denny (1853–1918), and Jessie Fisken (1860–1935), the exhibition included other craft-related mediums such as basketry, pyrography, copper work, and even engraved fungi. There was also the category of "Photographs and Bromides," with two listed exhibitors, Oliver P. Anderson (1859–1941) and Ed. Leach.

Anderson was the son of Dr. Alexander J. Anderson (1832–1903), who was president of the University of Washington from 1877 to 1882, and he was the husband of Ada Woodruff Anderson (1860–1956), author of several books related to Pacific Northwest history. In the late 1880s, he founded the O. P. Anderson Map & Blueprint Company and then in 1898 opened the Anderson Supply Company in downtown Seattle, selling cameras and photographic equipment.[7] Leach's background is unknown, and none of his photographs have surfaced. However, he exhibited sixteen artistic photographs, with titles such as *In the Days of Nero* and *Cupid's Troubles*, suggesting allegorical content. He was also listed in the Woman's Century Club exhibition's oil painting category. The 1904 exhibition's inclusion of a

section dedicated to photographs, albeit a small one, indicates some local acceptance of photography as an artistic medium by this time. Further reinforcement of this perception is indicated by the participation of the Northwest's most noted photographer, Edward S. Curtis (1868–1952), whose work was listed separately under the category of "Art Exhibit."[8] Although Curtis could certainly be placed within the rubric of Pictorialism, his work has been exhaustively studied and falls outside the intent of this essay. His brother Asahel Curtis (1874–1941) was also a prominent but commercially oriented photographer whose initial success rivaled that of his brother.

As the largest city in the state, Seattle became the acknowledged center for the arts as early as 1881, when the painter Harriet Foster Beecher (1854–1915) opened the first professional art studio in the developing urban center. Beecher and several other talented women artists and advocates would establish the nascent art community by offering private lessons to the city's pioneer citizens as well as institutional instruction at the Territorial University of Washington (later the University of Washington). In 1904, the Society of Seattle Artists became the first professional arts organization in the city. The group held its first exhibition in 1907 and continued through various small venues until a subgroup of artists and supporters founded the Seattle Fine Arts Society (SFAS) in 1908.

Imogen Cunningham, a talented young local photographer who was just beginning to establish her career, became a charter member of the SFAS. The organization was formed to "show to Seattle people what their town contains of artistic value and to bring to notice those struggling artists who are doing good work in the city." Members strove to "cultivate an interest and taste for fine art and artistic handicraft among residents of Seattle, and to promote such interest and taste by addresses and discussions on art topics, by acquiring and exhibiting works of art and by other suitable agencies."[9]

Cunningham presented a public lecture for the society titled "Art of Photography," joining several noted local and national experts who presented public programs on everything from aspects of modern art, by Frederic C. Torrey (1864–1935) of San Francisco, as well as several lectures dealing with Japanese prints, a popular area of interest for local collectors. Cunningham's activities with the SFAS assured a place for photography as a fine-art medium within the community.

Although Cunningham was rapidly becoming the leading Pictorialist in Seattle, a transplant from Salem, Oregon, also brought her formidable talent and reputation to Washington in 1907. Myra Albert Wiggins (1869–1956) was arguably the earliest internationally recognized artist from the Northwest. She began photography as a hobby in 1889. Initially, she had trained as a painter, attending the Art Students League of New York in 1891. It was there that her serious exploration of photography began. Wiggins studied with some of the greatest painters of the period, including John H. Twachtman (1853–1902), Willard L. Metcalf (1858–1925), and the man who would become her mentor, William Merritt Chase

(1849–1916). Chase encouraged her interest in photography and even critiqued her photographs as he would her painting, giving her a firm basis in composition and technique to apply to whatever medium she selected.

In 1892, Wiggins joined the Society of Amateur Photographers in New York and was included in their First Annual Members Exhibition organized by Alfred Stieglitz. She initially became known for her depictions of the Northwest landscape, a subject appreciated by the East Coast public who had rarely been exposed to such natural grandeur. Her career as an "amateur photographer" grew rapidly as she began to be included in numerous regional, national, and international exhibitions. In 1897, she won a highly coveted Eastman Award in the London International Salon for her photograph titled *The Forge*. Although an anomaly in her subject matter, this depiction of an industrial interior was of sufficient interest to be acquired by George Eastman of Eastman Kodak, who hung the photograph in his office in Rochester, New York, for many years.[10] Even with its great success, Wiggins would not produce any additional photographs with urban industrial themes; and, unlike many of her contemporaries, she never used the nude figure in any of her compositions.

In 1902, Wiggins's work was accepted into the prestigious Linked Ring Brotherhood exhibition in London. The following year she became an associate member of Stieglitz's elite Photo-Secession, affording her entry into some of the most prominent exhibitions of the period. After returning to Salem, she became an advocate for art photography and began making works directly inspired by painters such as Jean-Baptiste-Camille Corot (French; 1796–1875), James Abbott McNeill Whistler (United States/Europe; 1834–1903), and especially Jan Vermeer (Dutch; 1632–1675). In 1898, she produced the first works for which she would receive international acclaim. The subject matter, which she referred to as "Dutch Genre," was an intriguing hybrid reflecting various cultures and artistic approaches. The most noted of these works was titled *Hunger Is the Best Cook*, which was reproduced in Stieglitz's important publication, *Camera Notes*, in the October 1899 issue. Wiggins posed her models, in this case her young daughter Mildred, in heirloom clothing and set them within the local Oregon landscape or in Dutch-inspired rooms, which she cleverly constructed in her Salem home. Wiggins, like many artists of her day, also used a vertical delineation of her initials, imitating the chop signatures found on Japanese woodblock prints. She made her international vision complete by incorporating the unique Northwest landscape into compositions that included both Japanese- and Dutch-master influences.

In the spring of 1907, Wiggins moved to Washington and, after a brief stay in Yakima, settled in Toppenish, where her husband had developed an agricultural business called the Washington Nursery Company. She expressed her frustration and feelings of isolation in letters to her fellow artists, including Alfred Stieglitz. After adjusting to her new home, Wiggins continued her photographic production, although she made fewer new works. The photographs that she made in

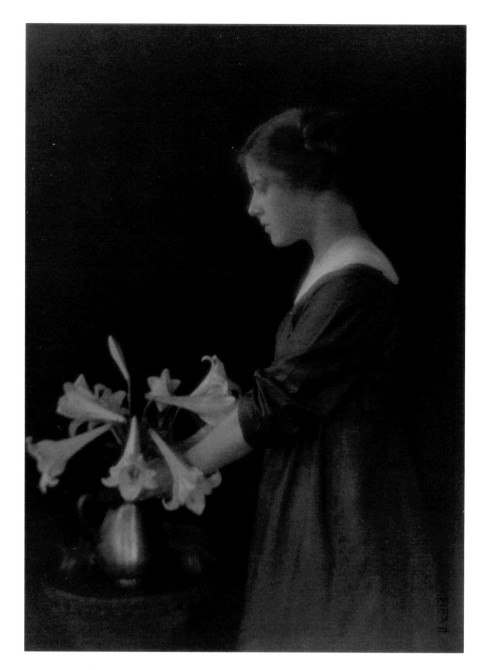

FIGURE 4
MYRA ALBERT WIGGINS
Untitled, ca. 1909
Platinum print
7 3/4 × 5 5/8 in.
Private collection

Washington are heavily influenced by the Symbolist movement, with its emphasis on evocative, dreamlike imagery, and are indebted to Pre-Raphaelite painters and writers such as William Morris (1834–96). Several of the works depict beautiful young women, usually in profile, in a dreamy, almost trancelike state, contemplating flowers or in quiet repose (fig. 4).

Her crowning achievement came in 1910, when Stieglitz included three of her works in the International Salon of Pictorial Photography held at the Albright Art Gallery in Buffalo, New York, the only Washington artist to be so honored. This landmark exhibition was the culmination of Stieglitz's efforts and is considered by many to have been instrumental in the establishment of photography as a fine-art medium in the United States. After the success of the Albright exhibition,

Wiggins, like her mentor, produced less photography. Stieglitz concentrated on promoting modern art in the United States, and Wiggins returned to painting.[11] She produced very few additional photographic works over the next few decades but was celebrated with an exhibition of her Pictorialist photography at the Seattle Fine Arts Society from December 6 through December 30, 1928. In 1930, she became a cofounder of the Women Painters of Washington and even served as a Works Progress Administration easel painter for the federal art projects during the Depression. Her paintings continued to garner her national success until her death in 1956.

Another Washington State transplant, also born in Oregon, was Adelaide Hanscom Leeson (1875–1931). Although her time in Seattle lasted for less than four years, Hanscom would exert a strong influence on Washington's Pictorialism over the next two decades. Raised in northern California, Hanscom was, like Myra Wiggins, first trained as a painter. She attended the Mark Hopkins Institute of Art in San Francisco, where she befriended fellow art students and Pictorialists Laura Adams Armer (1874–1963), Emily Pitchford (1878–1956), and later Anne W. Brigman (1869–1950), the only West Coast photographer to be a fellow in Stieglitz's Photo-Secession.[12]

After exhibiting her paintings in various California venues for several years, Hanscom turned to photography around 1900. Her work in this medium was immediately successful, and she developed her skills as an artistic portrait photographer. In 1902, she moved into Armer's vacated San Francisco studio with fellow artist Blanche Cumming (1874–?). Together with Pitchford, the two women developed a reputation for creating superior artistic photographs that were utilized as fine-art illustrations. In 1905, Hanscom had her first major success with the publication of *The Rubáiyat of Omar Khayyam*. This edition featured her highly innovative photographic illustrations, which she produced by manipulating the glass-plate negatives and altering the finished prints by incising, painting, and combining multiple exposures to produce some of the most unique illustrative works of the period. With her reputation established, Hanscom's life and career seemed promising. However, the 1906 San Francisco earthquake and fire destroyed her studio along with most of her existing prints and negatives. This was the first of many tragedies in her brief and difficult life.

Following the destruction of her San Francisco studio, Hanscom relocated to Seattle in 1906. Her arrival was celebrated in the local press as an exciting and successful addition to the burgeoning local arts community. The following year, she provided competition to Edward Curtis by opening her own artistic portrait studio to meet the demand among prominent local families. She reinforced the artistic aspects of her work and became recognized in several regional publications.

In 1909, the Alaska-Yukon-Pacific Exposition (A-Y-P) became the first nationally prominent event to take place in Seattle, following on the heels of other

national fairs such as the 1893 World's Columbian Exposition in Chicago, the 1901 Pan-American Exposition in Buffalo, New York, and the Lewis and Clark Exposition of 1905 in Portland, Oregon.

Hanscom played a significant role in this landmark event when she won the competition for designing the official emblem of the A-Y-P (fig. 5).[13] She was also commissioned by *Camera Craft* magazine to produce a series of Pictorialist images of Seattle's urban and rural landscapes in anticipation of the exposition.[14] Her *Rubaiyat* illustrations would prove a source of inspiration for several Seattle Pictorialists, especially Wayne Albee, who would later produce his own *Rubaiyat* series for *The Town Crier* in 1924.[15]

Besides the industrial, agricultural, and ethnic exhibitions at the A-Y-P, the fine arts were also represented. The Women's Building sponsored an exhibition of Washington's regional artists, but very little information about it has survived. In contrast, the California Building emphasized that state's regional painting, printmaking, and photography and recorded the exhibitors and prize winners in a catalogue.[16] Through some surviving publications as well as extant personal records, we know that Washington's Imogen Cunningham and Myra Wiggins along with California's Anne Brigman all won medals for photographs they exhibited at the A-Y-P.

Cunningham's early subject matter was compatible with Wiggins's in the two artists' shared interest in Symbolism and the aesthetic associated with the Arts and Crafts movement. Wiggins was more than twenty years older than Cunningham and was working in almost virtual isolation in Toppenish, Washington. Their intersection came at the apex of Wiggins's photographic career, while Cunningham's artistic ascent in Seattle was just beginning. Cunningham worked with a group of young Seattle artists who were establishing impressive professional reputations when their works were exhibited at the A-Y-P. John Davidson Butler (1891–1976) and Clare Shepard Shisler (1882–1983) were talented young painters and Cunningham's closest friends, who also served as her models. John Butler and his brother Ben possessed extraordinary good looks and strong, angular features that were well suited for Cunningham's vision. Years later, the Butler brothers would also be photographed by Wayne Albee and Ella E. McBride (1862–1965). Shepard, who had shared Cunningham's studio, was known for her portrait miniatures on ivory. She too was a suitable model for Cunningham because her physical appearance and fine facial structure was reminiscent of the female figures depicted in the nineteenth-century Pre-Raphaelite paintings that exerted such a major influence upon the young artists.

Shepard, John Butler, and their friend George Roi Partridge (1888–1984), a young etcher who was born in Centralia, Washington Territory, had bonded together to form the first modern-art group in Seattle around 1908. Calling themselves the Triad, they worked and exhibited together and wrote articles in local publications in support of contemporary art.

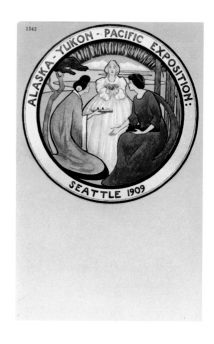

FIGURE 5

Alaska-Yukon-Pacific Exposition postcard showing the fair's official emblem designed by Adelaide Hanscom
Chromolithograph
5 1/2 × 3 1/2 in.
Published by Edward H. Mitchell, San Francisco
University of Washington Libraries, Special Collections, UW25966Z

In 1910, Cunningham produced a series of works using Shepard as the main model. Shepard was known to have psychic or clairvoyant abilities, and this underlying spiritual reference is evident in many of the works in which she is depicted.[17] The soft focus and light manipulation in Cunningham's photographs enabled her to physically depict the invisible forces of her subject's Spiritualist inclinations. Shepard is sometimes portrayed with an aura of light around her or is surrounded by paranormal atmospheric manifestations that relate to Cunningham's involvement with the Theosophical Society.

From 1887 until approximately 1890, Cunningham had lived with her parents in the Puget Sound Cooperative Colony at Port Angeles along the Strait of Juan de Fuca. This utopian, or communitarian, enclave was the first of several experimental communes that would develop in Washington.[18] Her father, Isaac Burns Cunningham, was an individualist (Imogen referred to him as a "great but easy going eccentric")[19] who inculcated his social consciousness and spiritual beliefs in his developing young daughter, whom he named after the character in Shakespeare's drama *Cymbeline*.[20] The young woman accompanied her father to Spiritualist congregations and to meetings of the Theosophical Society when Annie Besant (1847–1933) and Krishnamurti (1895–1986) were in attendance.[21] Cunningham's mother, a conservative and stolid woman, did not fully ascribe to these spiritual beliefs, and she was characterized as a "weak-kneed Methodist" by her husband.[22] But Imogen adopted this template of unique individualism and maintained it throughout her life; it was an important factor in the formation of her visual language.

From 1903 until 1907, Cunningham attended the University of Washington, where she received a degree in chemistry. From 1907 through 1909, she worked in the studio of Edward Curtis in Seattle and came under the tutelage of Adolf Muhr (ca. 1858–1913), who taught her additional advanced techniques in photography. It is likely that during her time at the Curtis Studio she was exposed to magazines such as Stieglitz's *Camera Work*, along with the California publication *Camera Craft* and other leading photographic periodicals of the time. Of interest is that future Pictorialist Ella McBride, who moved to Seattle in 1907 to manage the Curtis Studio, interacted with Cunningham in those early years of her career. After leaving the Curtis Studio, in 1909 Cunningham departed for Europe on a scholarship provided by her University of Washington sorority. She followed her European sojourn with a trip to New York, where she met Gertrude Käsebier and Alvin Langdon Coburn and visited Stieglitz's 291 Gallery.

Returning to Seattle by 1910, Cunningham opened an artistic portrait studio in the city's First Hill neighborhood, filling the void left by Adelaide Hanscom's departure. Several of Cunningham's painter friends—such as Yasushi Tanaka (1886–1941), John Butler, and Clare Shepard—had nearby homes or studios. It is likely that Tanaka and his wife, the writer Louise Gebhard Cann (d. circa 1966), played a dominant role in Cunningham's love for Japanese art and literature.

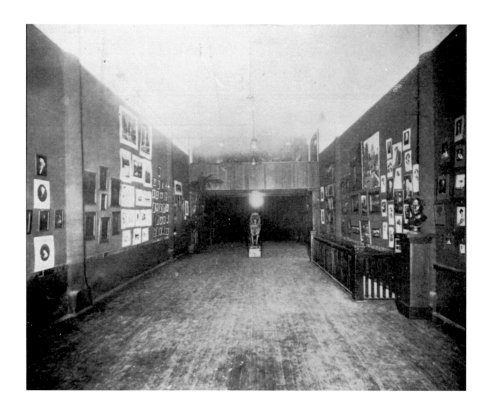

FIGURE 6

The Washington State Art Association
exhibition of photography, 1912
Museum-Auditorium Monthly 1, no. 2 (February
1912): 6
University of Washington Libraries,
Special Collections, UW29153Z

Cunningham would study a book of prints by the Japanese master Utamaro
(1753–1806) for inspiration before the arrival of sitters to her portrait studio.[23]

 Cunningham's international reputation was launched with the inclusion of
her work in the London International Salon in 1911 and with a successful solo
exhibition at the Brooklyn Institute of Arts and Sciences in 1914. The following
year, she was the only Washington State artist to be included in the Pictorial pho-
tography exhibition at the Panama-Pacific Exposition in San Francisco.

 Photography was gaining acceptance as a fine art in Seattle and would con-
tinue to build momentum. Beginning in February 1912, the Washington State Art
Association sponsored an exhibition of photographic art in its downtown galleries.
According to the group's bulletin, the show consisted primarily of photographs by
Seattle's leading commercial studios. These included the Curtis Studio, Webster
& Stevens, Nowell & Rognon, James & Bushnell, Aiko Studio, and several others.
Also included were a selection of gravures from Edward Curtis's book *The North
American Indian*, which were purchased for the association by a local collector. With
Asahel Curtis serving as the first curator of photographic art for the association,
the group sponsored a second exhibition the following year in January. This
included 120 examples of artistic photography by seventeen photographers,
including Edward Curtis, Myra Wiggins, and Frank H. Nowell (1864–1950),
who had been the official photographer for the A-Y-P.

 In 1913, the New York Armory Show had set off a great wave of debate
across the United States for its exhibition of European and American modern and
abstract art. One of the most controversial paintings was the oil *Nude Descending a*

Staircase No. 2 (1912), by Cubist/Futurist Marcel Duchamp (French; 1887–1968). Now acknowledged as a milestone in modern art, the painting was purchased for $324 by the San Francisco dealer Frederick Torrey. After the Armory Show ended, Torrey cleverly exhibited the provocative painting in other American cities, including Seattle.[24] Cunningham's friend and neighbor Yasushi Tanaka had likely seen the painting and, from its influence, produced the first Cubist and abstract paintings in Washington State by 1915.

Torrey had known Cunningham and Tanaka through his activities with the Seattle Fine Arts Society and was among the earliest supporters of Roi Partridge, who was becoming an etcher of renown. Torrey visited Seattle regularly during the early teens, bringing paintings and prints to sell through the department store Frederick & Nelson. Cunningham included a photographic portrait of Torrey in her Seattle studio exhibition in May 1913, just two months after the Armory Show ended on March 15.[25]

Partridge had begun a correspondence with Cunningham while he was studying art in Europe. At first, the letters were business oriented as Cunningham assisted Clare Shepard in assembling an exhibition of Partridge's work for the Seattle Fine Arts Society. Through their correspondence, a romance blossomed, and when Partridge returned to Seattle in late 1914 the relationship developed quickly. They were married on February 11, 1915, in John Butler's studio.[26] By 1914, Shepard had moved from Seattle to northern California, and Cunningham turned to her new husband as her main model.[27]

One of the most controversial series that Cunningham had produced at that time was a group of nude studies of Partridge with the landscape of Mount Rainier and its environs as a backdrop. The series began in 1915 and appears to have been inspired by Anne Brigman's male and female nudes in outdoor settings dating from 1905 to 1912, which Cunningham would have seen in *Camera Work* and other photographic journals. Adelaide Hanscom had used her husband, Gerald Leeson, as a nude model in the frontispiece of the *Rubaiyat* publication of 1910 (fig. 7). Later, other regional photographers, including Ella McBride, Virna Haffer (1899–1974), and "Frank" Asakichi Kunishige (1878–1960), would also use the nude male form in varying degrees in their work.

Later in life, Cunningham erroneously stated that the nudes of Partridge were published in Seattle's *Town Crier* magazine and that they had negatively affected her career and reputation: "This series [of Partridge] was printed in 1915 in *The Town Crier* in Seattle. Even though all the men are back views, it created such a fuss that I withdrew it for years." She also mischievously said that "you could never chase a naked husband around Mount Rainier today."[28] A modern myth developed, suggesting that this incident was the primary cause of Cunningham's move to California, and this misinformation would be reprinted in several publications.

The Town Crier was Seattle's major cultural publication from 1910 through 1937.

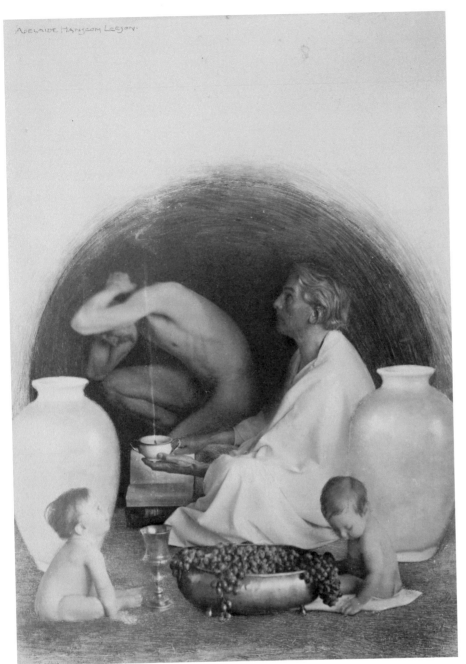

It covered the local visual arts, music, theater, and dance events as well as prominent nationally touring art exhibits and performances. Visual artists had their work illustrated in high-quality reproductions and were often invited to contribute articles that not only educated the public but gave the authors a platform to express their personal ideas and beliefs. The magazine supported all expressions of the visual arts and included photography as a fine art along with painting, printmaking, and sculpture. The December 1915 Christmas issue reproduced two of Cunningham's photographs, *Eve Repentant* (fig. 8) and *Reflections* (fig. 9), neither of which used Partridge as a model. Within two weeks of the publication, a local weekly newspaper, *The Argus*, malevolently attacked Cunningham's art and character:

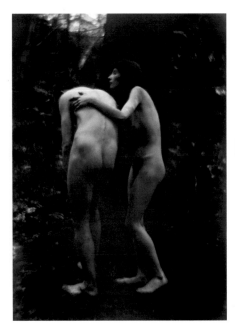

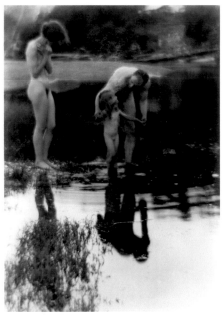

The very excellent and highly creditable Christmas number of
the Town Crier was disfigured by two reproductions of photo-
graphs which are inexcusably vulgar. There is but one excuse for
reproducing the nude human figure, and that is Art. Take away
Art and nothing remains but vulgarity and sensuality. "Eve Re-
pentant" and "Reflections," reproductions of the work of Imogen
Cunningham Partridge, an amateur photographer, can be said to
be bold in conception. But as far as having artistic value is con-
cerned, they are absolutely hopeless. Poor Anthony Comstock
would have died years before his time if he had ever conceived
in the wildest flights of imagination that such a bestial portrayal
of shame would be flaunted in the face of the public, even in
this far off corner of the world, and the author of the most ludi-
crous caricature of "September Morn" would have turned green
with envy because his imagination was not capable of conceiv-
ing anything as unattractive and inartistic as the flat-chested,
flat-footed, skinny armed female, who stands in the debutante
slouch, flaunting her lack of charms before a male degenerate
who appears to have suddenly become sick of feasting upon the
meager meal which the Gods have prepared. As to "Reflections,"
the least said, the better. Like the other photograph, there is not
the slightest excuse, from an artistic standpoint, for its existence.
If these pictures were posed in the open air, and there is a suspi-
cion that one of them was, the whole gang of moral perverts who
participated in the orgie [sic] should be arrested.[29]

As harsh as this single incident was, the criticism against Cunningham and her work was limited to *The Argus*. In reality, the only nude photograph of Partridge ever published in *The Town Crier* was *The Bather*, which appeared in the November 16, 1916, issue (on p. 30). The image is so nebulous and the figure so diffused that the gender is relatively indiscernible and, thus, rendered innocuous. Cunningham had actually received acclaim, support, and patronage from the Seattle arts community, which continued throughout her life. Her photographs appeared many times in *The Town Crier*, both as cover illustrations as well as artistic images reproduced within the magazine. She was given a platform to express herself and wrote several articles as well, but she never publicly responded to *The Argus* attack. After her move to California in 1917, she produced another series of nudes of Partridge the following year, posed along California's Dipsea Trail. Although she never permanently returned to the Pacific Northwest, both she and Partridge would frequently exhibit at regional venues and they enjoyed continuing local patronage.

With Seattle's loss of Cunningham and Partridge, two new additions to the community would soon change the course of Pictorialism in Washington. Dr. Kyo Koike (1878–1947) arrived on December 19, 1916, followed by Frank Kunishige in 1917. Both men would become catalysts for the widespread growth of local Issei Pictorialist photographers and assisted in the formation of one of the region's earliest internationally acclaimed arts organizations, the Seattle Camera Club.

By 1916, Ella McBride opened her own studio after a failed attempt to purchase the financially troubled Curtis Studio. She went into partnership with Edmund Schwinke (1888–1977) and they were later joined by Wayne Albee, who relocated to Seattle from Tacoma. Schwinke was an important associate of Curtis, assisting him as a photographer as well as in Curtis's audio recordings, films, and business dealings. McBride had not yet developed her own photographic skills and relied on Albee's talents until Frank Kunishige joined them after a short employment with the Curtis Studio. Another extremely talented young photographer, Soichi Sunami (1885–1971), would begin his career at the McBride Studio, where he benefited from Albee's experience and encouragement and made connections that would assure his future success in the field.

In addition to producing commercial and artistic portraiture, the McBride Studio was employed by the Cornish School of Allied Arts in Seattle to document performances and to produce advertising stills for local and visiting talents. Many of the greatest international dancers of the time passed through Cornish, and some even became instructors. By 1921, McBride herself had begun exhibiting Pictorial photographs, concentrating on floral studies, and she soon joined her assistants—Albee, Kunishige, and Sunami—in producing extraordinarily beautiful images of the iconic dancers who came to Cornish, including Ruth St. Denis (1879–1968), Ted Shawn (1891–1972), Doris Humphrey (1895–1958), Charles Weidman (1901–75), Anna Pavlova (1881–1931; fig. 10), Adolph Bolm (1884–1951), and

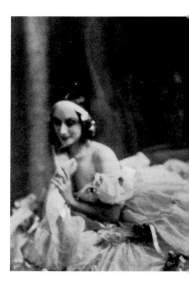

FIGURE 10 (ABOVE)
ELLA MCBRIDE
The Incomparable, ca. 1924
The American Annual of Photography (1927), 12:

FIGURE 11 (RIGHT)
SOICHI SUNAMI
Martha Graham in "Lamentation," ca. 1930
Gelatin silver print
9 $\frac{1}{2}$ × 7 $\frac{1}{2}$ in.
Collection of the Soichi Sunami estate

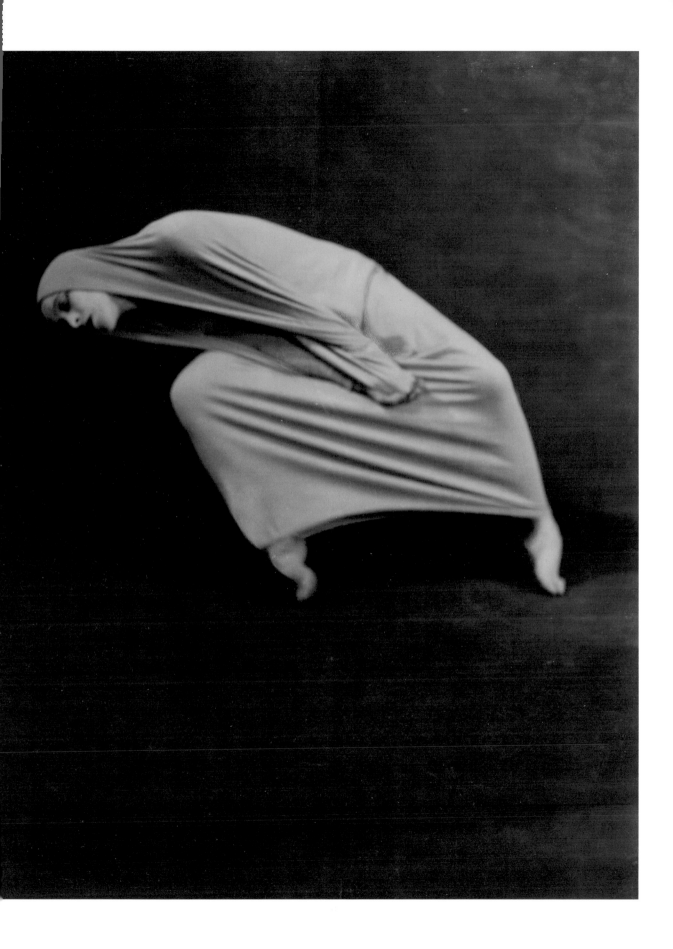

Martha Graham (1894–1991). It was through these initial contacts that Sunami became familiar with the dance world. In addition to portraiture, he produced Pictorialist landscapes of the Northwest as well as nudes and figure studies. He especially concentrated on dancers as subject matter and produced some of the finest and most imaginative images of Martha Graham during the next few decades (fig. 11). Sunami left Seattle for New York in 1922, where he eventually developed a lifelong association with the Museum of Modern Art as its chief photographer.

Beginning in November 1920, the Seattle department store Frederick & Nelson sponsored the first of six extremely successful Pictorial photography Salons. The jury included Wayne Albee, painter Paul Morgan Gustin (1886–1974), and photographer Asahel Curtis, whose brother Edward had relocated to Los Angeles the previous year. More than five hundred works were selected from eleven hundred entries. The Salon attracted several of the finest photographers active on the West Coast, such as Edward Weston and Margrethe Mather (1886–1952), both of whom won awards in the first exhibition, along with regional artists Myra Wiggins and Soichi Sunami.[30]

A few days before the second Frederick & Nelson Salon began on November 1, 1921, the local Japanese American newspaper, the *North American Times*, held its Exhibition of Pictorial Photographs for a brief two-day run on October 30 and 31. Although Dr. Kyo Koike did not participate, the exhibition is noteworthy because it consisted of regional photographers who were Issei (first-generation Japanese in the United States), with the exception of one female Caucasian, Ella McBride. This marks the first known exhibition of McBride's Pictorialist photographs, three of which were floral studies and one that was a figural work titled *Cain*, depicting an allegorical male nude. Sunami, Kunishige, and Iwao Matsushita (1892–1979) were included, among the other now-forgotten names. Matsushita participated in most of the SCC exhibitions as well as in the Frederick & Nelson Salons. Although he was an active member and sometimes won awards, his work never achieved the same artistic or critical success as the key members. His landscapes are indebted to his mentor, Dr. Kyo Koike, and the few floral subjects that he made are reminiscent of McBride's. However, he did occasionally produce some individual works that attained the same high level of quality of his more successful colleagues (figs. 12 and 13).[31]

Of the 131 photographers selected for the Frederick & Nelson Salon that year, only five local Issei were included, with Sunami winning two prizes. Carl F. Gould (1873–1939), an important Seattle architect and cultural figure not usually associated with the medium, was represented by three works; the legendary aviator Amelia Earhart (1897–1937) participated in the Salon in 1923. Myra Wiggins returned to exhibit in the fifth annual in 1924, winning an honorable mention for a work titled *Dethroned*. This annual also marked the local debut of Tacoma's Virna Haffer, who won an award.

Exhibition label from Frederick & Nelson Salon, 1925

The Frederick & Nelson Salons were frequently reviewed nationally in *Camera Craft* and were acknowledged as among the most active and successful in the country. Yet organizers lamented the lack of regional participation in the second Frederick & Nelson Salon. "It is to be regretted that Seattle entries are comparatively few in number," noted the show's catalogue. "In view of the known fact that there is no dearth of skilled pictorialists in this city and vicinity, this must to some extent be due to the lack of such healthy, competitive interest as would be stimulated by the existence of an active Camera Club in the community."[32]

The time was apparently ripe to establish a serious photography organization for the newly energized photographers in Seattle. Despite the energetic artistic scene in the region, the first Seattle Camera Club (1895) had long since ceased its activity. *Camera Craft* magazine made a reference to it in 1921: "Some years ago, Seattle boasted a camera club, which flourished a while and died. Whether its demise can be, in orthodox fashion, blamed to the war, matters little, but since the funeral, Seattle has had little opportunity to keep in actual touch with the things happening in the outside world so far as matters photographic were concerned. Occasionally a traveling show sponsored by a supply house reminded one that there was progress, and, of course, there were always the numerous excellent magazines devoted to photography."[33]

A key figure in the formation of the second incarnation of the Seattle Camera Club was Dr. Kyo Koike, who had exhibited in the first Frederick & Nelson Salon in 1920. He quickly became the leading force behind the emerging group of Issei photographers in Seattle. In explaining his understanding of the Japanese approach to Pictorialism, Koike wrote in *American Photography* that "most of the prints by Japanese photographers are influenced by Harunobu and Utamoro

FIGURE 13

IWAO MATSUSHITA
Untitled, ca. 1932
Gelatin silver print
9 3/4 × 6 11/16 in.
University of Washington Libraries,
Special Collections, UW29050Z

[*sic*] in the posing and placing of figures and by Hokusai and Hiroshige in the ar-
rangement and composition of scenery. The composition in 'still life' subjects is
influenced by the principles of 'Chado' [the etiquette of the Japanese tea party]
as originated by Rikyu. The 'Ikebana' [art of arranging flowers] in the style of
Ike-no-bo, a landscape architect and designer is exemplified by Enshu. It is one
of their principles that anything that is not pleasing to the eye, even the limb of a
tree, should be eliminated."[34]

Several photographs in Koike's archive suggest that he produced some Pic-
torialist works in Japan before his move to Seattle. A few soft-focus figure studies

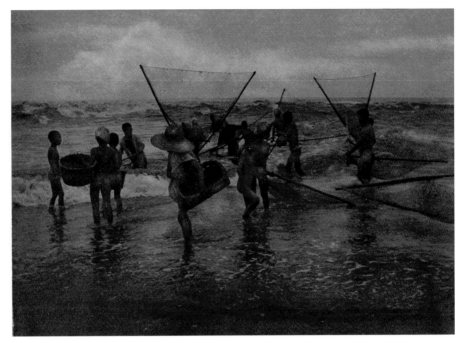

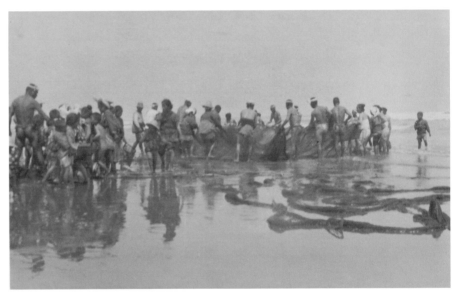

bearing handwritten titles indicate that he had more than a rudimentary knowledge of photography. These early works, dating from around 1915, display an attention to the human figure, contrary to the emphasis he later placed on landscape after his arrival in the Northwest (fig. 14). One of these photographs bears a similarity to a work titled *Muddy Sea* (1910; fig. 15), by the Japanese Pictorialist Yasuzo Nojima (1889–1964). This work won second prize in the juried 1912 Kenten exhibition of the Tokyo Photographic Research Society.[35] It may have inspired Koike's untitled work depicting a crowd of people at the shore gathering fish (fig. 16).

One of Koike's younger friends, Hiromu Kira (1898–1991), was a struggling novice photographer who was born in Hawaii and raised in Japan. His

family immigrated to Canada before moving to Seattle by 1920. He initially began teaching himself the photographic process with a camera that he borrowed from a friend. Frustrated with his lack of progress and unable to achieve the results he had envisioned, he began to lose interest. After attending the North American Times Exhibition of Pictorial Photographs in 1921, he began to see the possibility of overcoming his technical inadequacies and resumed his work with a renewed optimism. This time, with the older, established Issei photographers to provide him with some guidance, he submitted four of his prints to the Frederick & Nelson Salon in 1923 and two were accepted. Kira and photographer Yukio Morinaga (1888–1968) had worked together in the camera department of the Main Drug Store near Koike's office in Seattle's Nihonmachi (Japantown). Owned by Yasukichi Chiba (1886–1955), himself an amateur photographer, the store provided a place for the like-minded photographers to meet and discuss their craft. It was out of this socializing that the new Seattle Camera Club was formed in 1924.[36] The thirty-nine charter members of the SCC were local persons of Japanese ancestry and, like in the majority of other American camera clubs, most were amateurs or enthusiastic hobbyists. Koike wrote a national introduction to the SCC that was published in *Photo-Era* magazine in 1925: "We waited patiently for a long time, thinking that some Americans might organize a society for the friends of photography, but no light appeared on the dark sea. At last we Japanese determined to establish one by ourselves, and the result is the Seattle Camera Club. I cannot anticipate what the future of our organization will be; that is a puzzle which time will solve. . . .The purpose of the SCC is to promote, foster and advance by every honourable means, Photographic Art. Our intention is to make our work as pictorial as possible. Some of our members are making their names known in pictorial photographic circles throughout the world."[37]

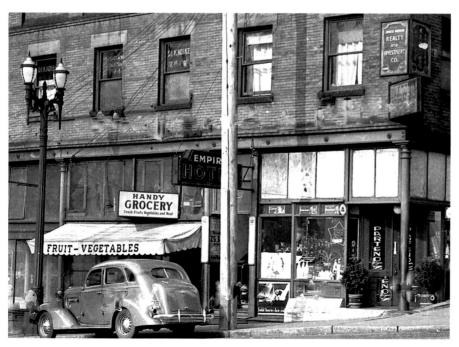

The SCC's first exhibition was held at Seattle's Japanese Academy of Music in April 1925. (The following October saw the sixth and final Frederick & Nelson Salon, although it did continue to sponsor solo exhibitions and traveling shows.) In this first SCC venture, photographers mostly from Seattle, but also a few from Oregon, Montana, and Illinois, exhibited ninety-eight prints. The jury consisted of three local members: Koike, Kunishige, and Hideo Onishi (1890–?) (fig. 18), who maintained their positions for nearly all of the remaining years of the organization. Some of the local Pictorialists, such as Koike, Kunishige, and McBride, had already experienced some national and international success by this time. The highly regarded International Salon of the Pictorial Photographers of America in New York included eleven prints by Washington State Pictorialists in its second annual that same year, 1925.

FIGURE 19

FRED YUTAKA OGASAWARA

Untitled, ca. 1921
Gelatin silver print
7 3/4 × 9 3/4 in.
University of Washington Libraries,
Special Collections, UW29086Z

Besides being founding members, Onishi and "Fred" Yutaka Ogasawara (b. 1883) of Seattle and later Portland, Oregon, were extremely successful members of the SCC and were among the most internationally exhibited. Onishi was born in Hyogo Prefecture, Japan, and arrived in Seattle in 1907 at the age of seventeen. To support himself, he worked as a chef while developing his photographic career. Both he and Ogasawara returned to Japan before World War II, and very little of their work and almost no biographical information has survived.[38] Similarly, biographical material was unavailable for a successful Caucasian member of the SCC, Charles A. Musgrave, and none of his original photographs were found.

Of the thirty-four photographers included in the SCC's first exhibition, twenty-five were Issei or Nisei (second generation and grandchildren born to Japanese immigrants) and nine were Caucasian, including Maurice Phelps Anderson (1888–?), the son of Oliver P. Anderson, discussed earlier in this essay. The younger Anderson's photographs in the collection of Seattle's Museum of History and Industry display the unmistakable influence of his Issei contemporaries.

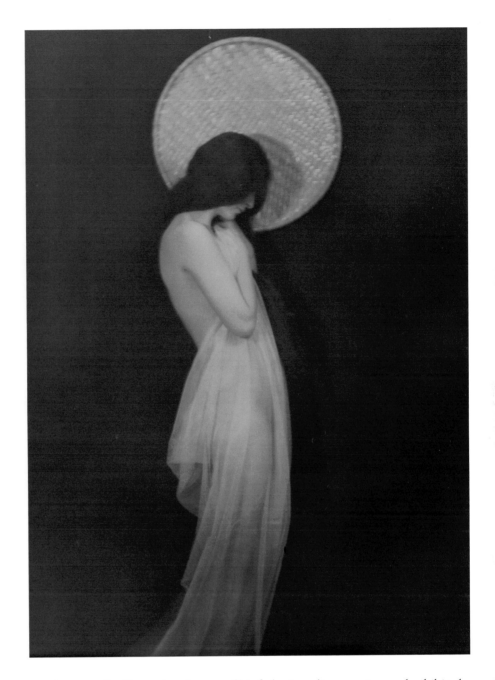

He also periodically reprinted some of his father's earlier negatives and exhibited them as his own work.

The year 1924 also brought Hiromu Kira a major success when his work was accepted by one of the most highly regarded venues in the United States at the time, the Pittsburgh Salon. Although none of his photographs were included in the SCC's first exhibition in 1925, six pieces were accepted for the group's second, for which he also served on the exhibition committee. The following year, his work was included in *The American Annual of Photography* and, with the exception of 1928, his photographs were consecutively reproduced in that publication each year until 1930. His work was also reproduced in the Pictorial Photographers of America annuals in 1926 and 1929 (figs. 22 and 23).

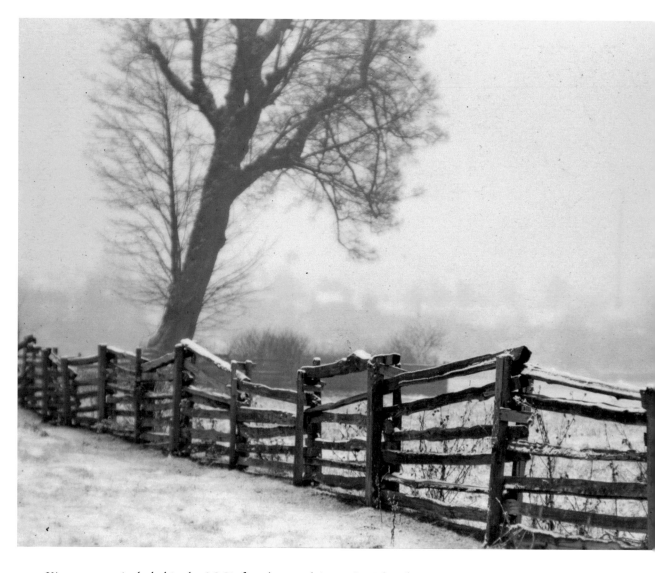

Kira was next included in the SCC's fourth annual, in 1928, with only one print, which was titled *Study-Paper Work*. He had moved to Los Angeles in June 1926 and radically changed his style away from the poetically inspired landscapes and urban compositions that he had been producing in Seattle. He began producing stark, geometric compositions using cut paper, origami birds, and inanimate objects in a still-life format that indicated a growing interest in Modernism and Surrealism. He showed two additional Modernist prints in the final SCC exhibition in 1929, the same year he received the distinction of being made a fellow of the Royal Photographic Society of Great Britain.

Within the shared Pictorialist aesthetic of the region's practitioners, several surviving works indicate that the photographers often also shared models and studios, producing individual works during the same shoot. Soichi Sunami's female nude with a sphere was composed both as a photograph (fig. 24) and as a plaster relief sculpture (fig. 25). The same model also appears in some of Frank Kunishige's photographs.

FIGURE 21 (ABOVE)
FRED YUTAKA OGASAWARA

The Aged Fence, ca. 1921
Gelatin silver print
4 1/2 × 5 5/8 in.
University of Washington Libraries,
Special Collections, UW29087Z

FIGURE 22 (RIGHT)
HIROMU KIRA

Chimneys, Steam and Smoke, ca. 1925
Gelatin silver print
9 × 6 5/8 in.
University of Washington Libraries,
Special Collections, UW29049Z

FIGURE 23

HIROMU KIRA

Peaceful City—Seattle, ca. 1925
Gelatin silver print
10 × 13 3/8 in.
University of Washington Libraries,
Special Collections, UW13196

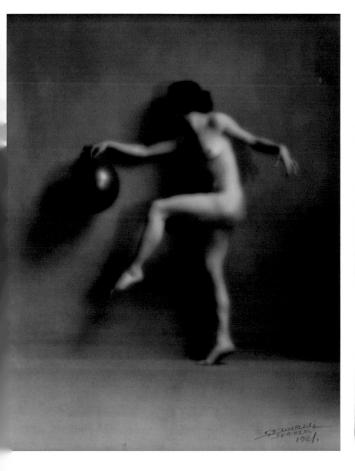

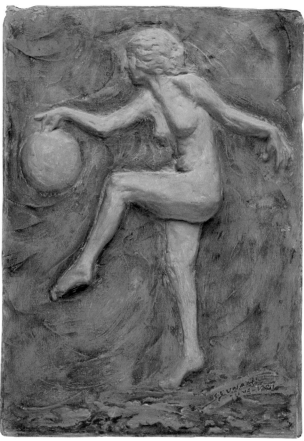

FIGURE 24 (ABOVE)
OICHI SUNAMI
Untitled, 1921
Gelatin silver print
8 1/4 × 10 1/4 in.
Collection of Richard Rhoda

FIGURE 25 (ABOVE RIGHT)
OICHI SUNAMI
Untitled, 1921
Patinated plaster sculpture
× 8 3/4 in.
Private collection

Several of the Pictorialists also interacted with popular local painters and printmakers, such as Paul Gustin, a leading painter-etcher of Seattle in the early part of the twentieth century. He was a close friend of Imogen Cunningham and Roi Partridge and was photographed not only by Cunningham (in both his youth and his old age) but also by Wayne Albee and Ella McBride. Frank Kunishige photographed Gustin's superb paintings for press reproductions and promotions. As one of the leading and most beloved of local artists, Gustin's etchings may have been the inspiration behind some of the works by local Pictorialists. This appears to be the case with his 1912 etching depicting the ornate cast-iron pergola in downtown Seattle's Pioneer Square (fig. 26). Kunishige's photograph of circa 1920 depicts the local landmark in a heavily manipulated technique that gives the effect of a charcoal drawing or aquatint, indicating a debt to Gustin's work (fig. 27).

In a reversal of influence, Elizabeth Colborne (1887–1948), a talented regional painter and printmaker, may have taken some cues from the Northwest Pictorialists. She began producing color woodcuts depicting the Northwest landscape sometime in the mid 1920s. She had been very successful as an illustrator and had moved to New York, where she lived for several years before returning to the Northwest. Her color woodcuts were created by using the traditional Japanese method of multiblock printing to stylistically adapt the Northwest landscape into beautifully rendered Japanese-inspired compositions (fig. 28). These prints signal

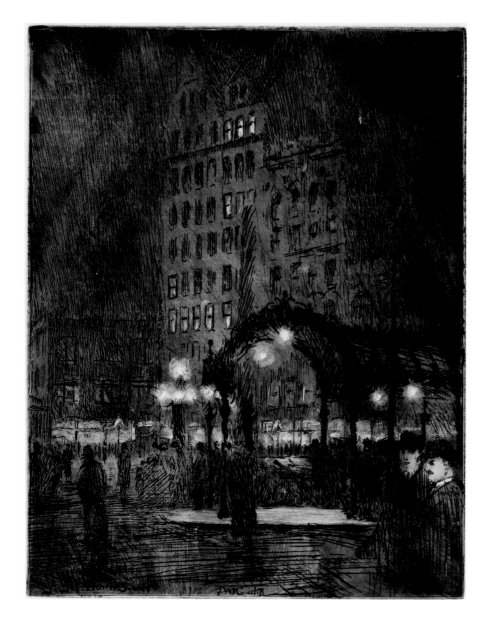

FIGURE 26 (LEFT)

PAUL MORGAN GUSTIN

Pioneer Square, 1912
Etching
7 ¼ × 5 ⅞ in.
Collection of Lindsey and Carolyn
Echelbarger

FIGURE 27 (RIGHT)

FRANK ASAKICHI KUNISHIGE

Pioneer Square, ca. 1920
Gelatin silver print
13 × 9 ¾ in.
Private collection

a marked stylistic change from her previous work and are very compatible with some of the popular images by the local Issei Pictorialists of the same time (fig. 29). Although it would be conjecture to claim that she was directly inspired by any of their specific photographs, Colborne certainly would have been aware of their work and she shared their aesthetic.

By the second SCC exhibition, in 1926, the Salon had grown to include 194 prints by eighty-four photographers. The venue had become sufficiently visible to attract photographers from major U.S. cities such as New York, Chicago, and San Francisco. Other countries were also represented—Japan, Belgium, England, Scotland, Czechoslovakia, and even the Indonesian island of Java in the colonial Dutch East Indies. Names of prominent photographers appear in the catalogue, including Prague's Frantisek Dritikol (1883–1961), Dr. Max Thorek (1880–1960) of Chicago, and Canada's Jan (John) Vanderpant (1884–1939). In the first SCC

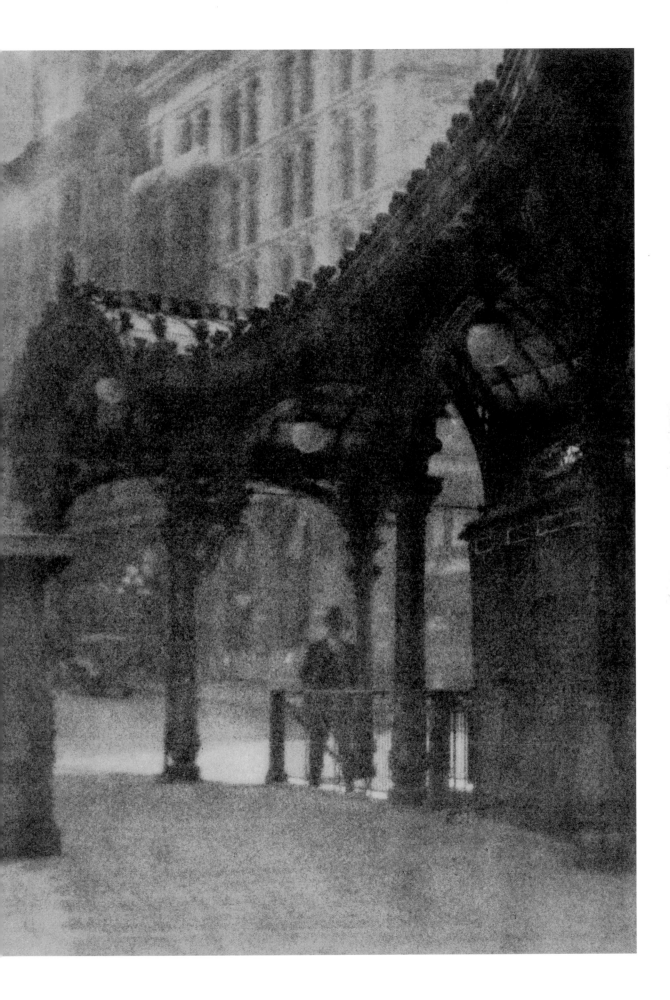

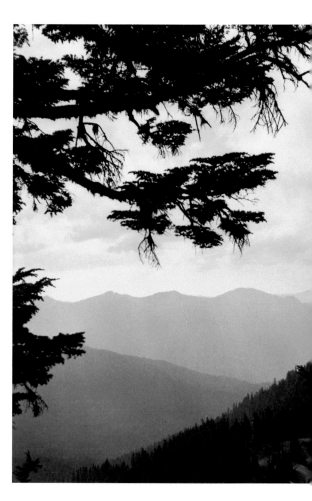

exhibition, Ella McBride had been the only woman included, but in the second Salon she was joined by seven others, including Mary Callaghan and Sophie Lauffer (1876–1970) of New York, Miss M. Hughes of Scotland, and the only female Issei member known to be associated with the SCC, Miss Y. Inagi of Seattle.[39] No information about Inagi has survived outside of two nationally published reproductions of her work. The first was titled *After a Drizzle*, which appeared in *The Camera* in 1926, and the second was titled *Through the Spring Curtain* (fig. 30), which won first prize in the Photo-Era Beginners Competition in October 1927. When *Photo-Era* reproduced the photograph again the following month, she was erroneously referred to as "Mr. Inagi."

As a member of the Association of Camera Clubs of America, the SCC also hosted numerous traveling exhibitions by clubs from Los Angeles, Cincinnati, Newark, and other major cities as well as sponsoring solo exhibitions by some of these clubs' members. The SCC sometimes sought out regional venues outside of the club as well, such as the 1925 Prize Winning Prints in the Fifth Annual Competition, organized by *American Photography* magazine. Hosted by the Seattle Public Library, the traveling exhibition offered examples of some of the finest Pictorialist works by American and international photographers.

FIGURE 28 (ABOVE LEFT)
ELIZABETH COLBORNE
Mt Baker, ca. 1928
Color woodblock print
13 × 9 in.
Collection of the Whatcom Museum, Bellingham, Washington

FIGURE 29 (ABOVE RIGHT)
DR. KYO KOIKE
Untitled, ca. 1930
Gelatin silver print
9 7/8 × 7 in.
University of Washington Libraries, Special Collections, UW29038Z

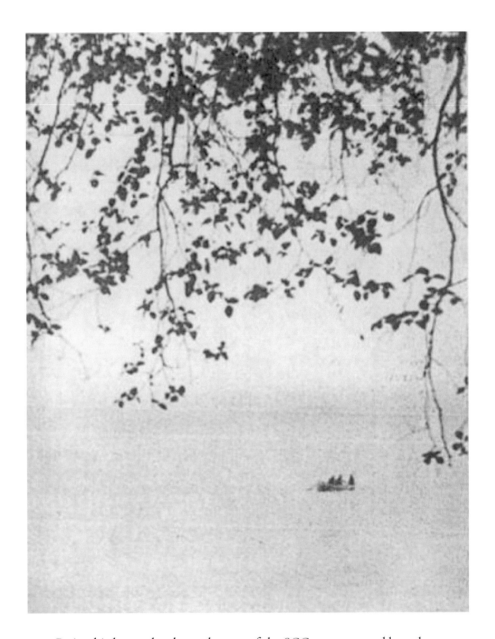

By its third year, the elevated status of the SCC was measured by a change from its previous annual exhibition name—Seattle Exhibition of Pictorial Photography Held under the Auspices of the Seattle Camera Club—to the more expansive International Exhibition of Pictorial Photography Held under the Auspices of the Seattle Camera Club. The club also added a second venue. The Seattle Chamber of Commerce, which had hosted the second annual show the previous year, sponsored the third Salon from May 5 through 15, 1927. Then the exhibition continued at Seattle's Bush Hotel from May 17 through 20.

This third Salon included 244 prints by 162 photographers, representing nineteen countries in addition to the United States. Even more prominent names appeared than in prior years: Frank R. Fraprie (1874–1951) of Boston, Joseph Petrocelli (d. 1928) of New York, and Jane Reece (1869–1961) of Ohio. Returning international exhibitors included Dritikol, along with his Czech colleagues

Jaromir Funke (1896–1945) and Josef Sudek (1896–1976). Eight exhibitors were from Japan and two were from the Soviet Union. Only fourteen Seattle photographers were included this time: six Caucasians and eight local Issei, including the three jurors, Dr. Kyo Koike, Frank Kunishige, and Hideo Onishi.

As the SCC exhibitions improved, the catalogues became more detailed. To the cover of the catalogue for the fourth exhibition, Koike, in his capacity as chairman, added the club's distinguished affiliation with the Royal Photographic Society of Great Britain and membership in the Association of Camera Clubs of America. Besides listing the jury and exhibition committee, the catalogue also described the photographic processes used by the exhibitors. These creative and complicated processes indicate the variety and specialized labor involved in making images that would help substantiate the photography medium as a fine art. Some of the processes were new and some were making new use of the old. Besides the familiar chloride and carbon processes, innovative and painterly effects were realized through the use of bromoil, oil pigment prints, resinotipia, gum, Fresson, metallon, pallideotype, and other processes with equally cryptic names.

In 1927, Japan held its First International Photographic Salon at the Tokyo Asahi Shimbunsha (fig. 31). Nine SCC members were in this exhibition, including Dr. Kyo Koike, Frank Kunishige, Yukio Morinaga, Hideo Onishi, Soichi Sunami, and Ella McBride as well as the lesser known S. Tada, R. Morita, and Shuji Nagakura (fig. 32).[40] This Salon must have been a particular source of pride for Issei SCC members, who were afforded recognition as successful artists in their homeland where many of their family members and friends still resided. Directly following the Japanese Salon, the noted Ohio photographer Jane Reece sponsored an exhibition of one hundred prints by the SCC at her studio in Dayton in June 1927, with a great deal of positive press from the local newspapers.

The venue for the fourth SCC exhibition, held in June 1928, marked a return to the Frederick & Nelson department store in downtown Seattle, home of the previous Pictorial Salons that the store had sponsored from 1920 to 1925. This time, the exhibition included 166 photographers from twenty-six countries, along with 295 prints from U.S. photographers such as Laura Gilpin (1891–1979) of Colorado and Edward P. McMurtry (1883–1969) of California. Dorothy Wilding (1893–1976) of Great Britain also joined many of the well-known previous exhibitors. This exhibition was the first time that Virna Haffer exhibited with the SCC. Her entry, a bromide print titled *Gian Paolo* (p. 104), foretells the dark and disturbing imagery that would sometimes inhabit her work throughout her career. This mysterious image uses a female model, the Tacoma writer Elizabeth Sale, as a disturbed and frightening male character. The nightmarish figure is called the Italian version of Jean Paul, the name of Haffer's son born in 1924.

Both before and after the formation of the Seattle Camera Club, several of the Washington State members achieved a great deal of renown. Their works

FIGURE 31
Exhibition label from the First International Photographic Salon of Japan, 1927
7 1/4 × 2 3/4 in.
Private collection

FIGURE 32 (RIGHT)
SHUJI NAGAKURA
The Painter, ca. 1926
Gelatin silver print
13 1/4 × 9 1/4 in.
Patrick Suyama Collection

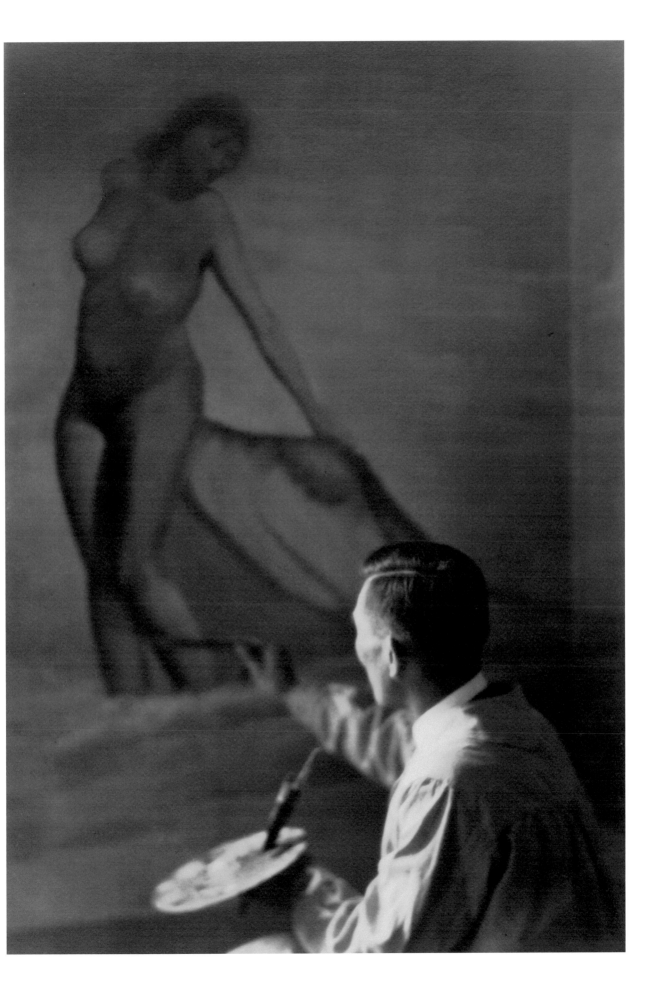

appeared in dozens of photographic and arts journals, and they exhibited in some of the leading Salons in the world. They were praised by numerous writers and critics and gained the respect of their colleagues for their refreshing and unique approach. Also, by virtue of their geographical location, many SCC members were able to utilize the mountains and grandeur of the Pacific Northwest landscape to distinguish their work from that of their national contemporaries—the region's shifting atmospheric light produced unique effects, and the abundance of large mountains, vast panoramas, and unique vegetation enabled the photographers to alter perceptions of scale. Such natural variation gave the Northwest Pictorialists advantages not available to most others.

In the eastern United States, members of the SCC were included in prominent exhibitions sponsored by the Pittsburgh Salon, the Syracuse Salon, and the Portage Camera Club in Akron, Ohio, which also provided several SCC members with solo exhibitions. The highly successful Buffalo Camera Club in New York State featured the work of SCC members on several occasions. That city's Albright Art Gallery (now Albright-Knox) had sponsored Stieglitz's landmark 1910 Exhibition of Pictorial Photography and was an important early supporter of the medium. Edward Curtis had a solo exhibition there in 1908—titled A Collection of Photographs of the North American Indian— in which he displayed 155 prints. In nearby Toronto, Ontario, SCC members often exhibited in the annual international photography Salons of the Canadian National Exhibition.

In a review of the Buffalo Camera Club's 1925 Salon, a critic gave special recognition to the SCC: "Especially unusual and interesting in this exhibition was the work of the Seattle Camera Club, a Japanese organization whose pictures gave a most unusual insight into the effect of the impact of Eastern minds on Western methods."[41] This tendency to see an Asian influence in the work of SCC photographers, Issei or otherwise, was typical of the national response to their work. Ella McBride, for example, heavily displayed the influence of Japanese art in her compositions, perhaps even more so than some of the Issei members who were often more inspired by Western art styles. Her floral studies are compatible with celebrated Buffalo Camera Club member Clara Sipprell (1885–1975).

Another interesting western New York connection is the apparent source for one of Frank Kunishige's most intriguing photographs. Titled *Butterfly* (fig. 33), the Kunishige photograph appears to imitate the female figure in the poster for the Pan-American Exposition held in Buffalo in 1901 (fig. 34). The Symbolist imagery depicts Niagara Falls as the mythical "Maid of the Mist," whose veiled nude body is comprised of the descending waters and rising mists of the iconic natural wonder. In both works, the female figures are almost identically posed, with Kunishige utilizing a sheer, crinkled fabric to replicate the illusion of the engulfing water. It is not known whether Kunishige attended the exposition in Buffalo, but the similarities between the 1901 poster and his photograph are striking. Kunishige did produce other draped female nudes, as did his contemporaries; Gertrude

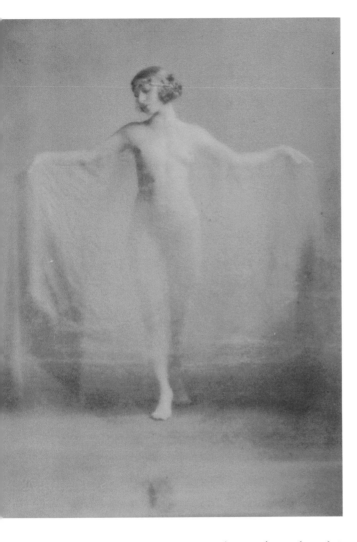

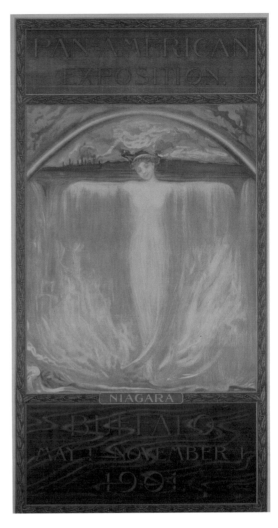

Käsebier's *The Bat* (1902) is one such work, as is Anne Brigman's *The Heart of the Storm* (1902), although these works display a darker vision and lack the sensuality that Kunishige emphasized.

Kunishige also looked to other visual artists that he admired for inspiration, as evidenced by works with titles such as *After Mestrović* and *Laocoön of Today*.[42] In other pieces he produced photographs based on musical favorites, such as his *Traumerie* (p. 137), after the popular Schumann composition, and *Anitra's Dance* from Grieg's *Peer Gynt* suite.

Some of the earlier and more celebrated Pictorialists, mostly those associated with Stieglitz and the Photo-Secession, appear to have exerted an influence on Washington State photographers and members of the SCC. This occurred through reproductions in publications such as *Camera Work*, *Camera Notes*, and other leading journals of the early twentieth century. Imogen Cunningham acknowledged the influence and inspiration of Gertrude Käsebier, whose work she had noticed in *The Craftsman* magazine in 1907.[43] The work of Baron Adolph DeMeyer (1868–1946) also appears to have been admired by Cunningham, Kunishige, Wayne Albee, and Ella McBride. DeMeyer's beautifully designed compositions

concentrated on floral studies, incisive portraiture, and studies of well-known dancers such as Vaslav Nijinsky (1889–1950) and other members of the Ballets Russes. Such influences compelled Washington artists to produce images that reached new levels of beauty, some infused with a Japanese aesthetic. These unique works would win the Northwest photographers worldwide acclaim.

In a French review of Kunishige's work from the 1925 exhibit of the Royal Photographic Society of Great Britain, one of the leading Parisian art publications featured a glowing assessment: "F. A. Kunishige has just won a new and resounding success at the Royal Photographic Society with the 'Portrait of Betti' [p. 136]. This is a first class print, the style and character of which are no less remarkable than the beauty, or technical perfection, so exquisitely demonstrated by the artist. F. A. Kunishige possesses to a rare degree the talent of imparting to his work an esthetic quality never separate from the play of light serving as pretext or accompaniment to his theme—an esthetic quality so superior that he triumphs everywhere just by appearing."[44]

Besides gaining attention in prominent Salons, the international acclaim of Seattle's Pictorialists was further reinforced when their works were reproduced regularly in leading international publications. Albee's portrait of the great ballet dancer Anna Pavlova was published in the British edition of *Vogue* magazine in August 1923; McBride's *Dogwood* was reproduced in several American and European journals, including the November 1927 issue of the *Photographic Journal*, the official monthly publication of the Royal Photographic Society;[45] and Kunishige's work appeared in *Photo-Era*, *The American Annual of Photography*, Berlin's *Photofreund*, and London's *The Year's Photography*.[46]

The Northwest photographers' status was also substantiated by prominent publications, such as when the *New York Herald* included Kunishige and McBride in an article titled "World's Best Photographs Shown in Paris Exposition."[47] In 1927, *The American Annual of Photography* began publishing a who's who in Pictorial photography, listing the 538 leading American and Canadian exhibitors, the number of American and international Salons they were accepted in, and the number of prints exhibited in total. The first publication covered the 1925 through 1926 seasons, and six of the top ten were members of the SCC, including Ella McBride, the only female.[48] It is interesting to note that Imogen Cunningham was listed as having only one print accepted in one Salon. During this busy period of her life (she had three small children), she never exhibited in either the Frederick & Nelson or the SCC Salons of her hometown. And unlike her Seattle contemporaries, her work was never reproduced in *The American Annual of Photography*.

With all of the national and international publicity amassed by Washington's Pictorialists, perhaps the most important publication to document their activities is the Seattle Camera Club's own monthly bulletin, *Notan* (fig. 35). Originally titled *Shumi no tomo* (Friends through Hobby) for the first eight issues, *Notan* appeared

FIGURE 35

Cover of *Notan*, February 11, 1927, listing some of the numerous salons that exhibited *Shirley Poppy* by Ella McBride
University of Washington Libraries, Special Collections, UW29137Z

as issue number nine on February 13, 1925. Written in English and Japanese, the publication lists most of the major achievements of the members and provides illustrations of some of the photographs, with captions detailing the Salons they were exhibited in. Along with Japanese art, poetry, and literature translated by Dr. Kyo Koike, some international reviews were also published in their original languages.

The word *Notan* is derived from the Japanese characters meaning shadow and light. It was adapted and used by Arthur Wesley Dow in his seminal publication *Composition*, of 1899, one of the most influential of all books related to art and its instruction. Dow's reverence for Japanese art and design is at the very heart of his aesthetic. He describes the three elements integral to good design and composition as "*Line*, the chief element of beauty in architecture, sculpture, metal work, etching, line design and line drawings; *Notan*, the chief element in illustration, charcoal drawing, mezzotint, Oriental ink painting and architectural light and shade; *Color*, the chief element in painting, Japanese prints, textile design, stained glass, embroidery, enameling and pottery decoration."[49]

Members of the SCC most likely derived the name for their publication from Dow's use of *Notan*, which, of his three elements, is the most applicable to photography. Koike cited Dow in an article written for *Photo-Era* in 1925: "Arthur W. Dow says in his 'Composition' that the 'Japanese knew no division into Representative and Decorative; they thought of painting as the art of rhythm and harmony, in which modeling and nature-imitation are subordinate.' "[50]

The first issue of *Notan* appeared on February 13, 1925; it was then published on the second Friday of each month thereafter. The magazine was funded by advertisements, individual contributions, and members who contributed the proceeds from the sale of their works. (Yukio Morinaga donated the $4.76 he was paid by a German magazine to reproduce his photograph *Magellans of Today*.)[51] Koike was one of the four editors, and Glenn Hughes (1894–1964) of the University of Washington Drama Department was associate editor.

The April 1925 issue documents the First Seattle Exhibition of Pictorial Photography and includes the catalogue of exhibited artists and titles of their works. Besides professional announcements, *Notan* published articles about the members' group outings as well as descriptions of certain areas around Seattle, Tacoma, and other parts of the state that offered good material for landscape photography. The bulletin introduced new members and listed news of the monthly SCC meetings held at the Gyokkoken Café at 508 1/2 Main Street in Seattle's Nihonmachi.

In the February 11, 1927, issue, Koike inserted a small paragraph in a review of the club's 1926 activities. "In conclusion," he wrote, "I shall not omit to tell you that we were given the privilege to hold the Photo-Era Trophy Cup for one year and that The Camera, September, 1926, was the Seattle Camera Club number; but I shall not take the time or space to tell how many prints by our members were used as illustrations or appeared in various books and magazines throughout

the world. They are so many and I have told you before in our monthly bulletin. We are happy to have made a new record and wish our members increased success in the coming year." This statement illustrates the reserved pride that Koike displayed in his own accomplishments as well as those of his fellow SCC members.

In reality, winning the Photo-Era Trophy Cup in 1926 was an impressive achievement. It was the first year that the renowned photographic journal presented a trophy to an American or Canadian camera club whose members had the most winning entries in their monthly competitions.[52] Winning the competition elevated the SCC to an even higher level of respect and visibility, especially among their peers.

Notan also provided a forum for out-of-state photographers and critics to comment on the SCC's activities as well as for discussions related to Japanese American contributions to Pictorialism. Most of the dialogue was positive and complimentary, although tinged with the stereotyping common for the period. On one occasion, Koike took umbrage with a review by photographer Nicholas Haz (1883–1953) of the Third International Salon of the Pictorial Photographers of America, which was published in *American Photography* in July 1929.

The exhibition was held at the Art Center in New York City and, according to Haz, "the show consisted of 199 prints which included the foreign prints, [and] of these there were twenty-seven. Of the one hundred seventy-two American prints, thirty three were by Japanese workers." After some initially complimentary words, he insensitively stated, "However, an American Annual should not contain twenty percent of Japanese work, no matter how good it is, and even if exhibitions are made up in that proportion. Americans are fully able to supply good enough prints to make up an annual, showing a lot of this country, with much less Japanese help."[53]

These contemptuous remarks were not tolerated by Koike, who bravely challenged readers who might have shared Haz's racist ideas. Koike responded in the pages of *Notan* that "the remarks recently made by Mr. Nicholas Haz of New York are an injury to the cause." He reprinted the slanderous words from Haz and continued,

> His saying does no harm to our Japanese activity in the pictorial photographic field, but I was surprised at what he said and pity him for his narrow mindedness. I am a Japanese, three of my prints were accepted by the Pictorial Photographers of America Salon and one of them will appear in the annual publication. I am not the representative of a Japanese group, but still I have my right to say something in reply to Mr. Haz. We are not allowed to become American Citizens by law, but we may live in America just the same. What trouble could be caused by the difference in nationality in the realm of pictorial photography,

I can not understand. The Pictorial Photographers of America
Salon judges paid no attention to the workers nationality, but to
the pictorial value and photographic quality of the pictures, I am
sure. . . . I wonder why Mr. Haz put our Japanese only on his dis-
secting table, but leaves all others untouched. According to my
memory, Mr. Nicholas Haz was born in Zvolen, Czechoslovakia,
on January 18, 1883, and in 1913 he came to America as an immi-
grant. We Japanese are also immigrants. He may be an American
citizen at present, but he is not native American as we are. Is the
citizenship paper worth so much in the pictorial photographic
field of America? . . .What difference does it make in the field of
American photography when both he and we live in America
on equal terms? His work was not accepted by the Pictorial
Photographers of America Salon Judges, but some of our Japa-
nese were given the honor of being included in the annual pub-
lication.[54] That is wrong according to Mr. Haz. I wish to know
who may agree with Mr. Haz. Don't be too much excited, Mr.
Haz, because your work was not accepted by some salon. Be
calm when you discuss the thing from your artistic and critical
standpoint. Otherwise, you may miss your right mark and be a
laughing stock to the bystanders.[55]

Koike's verbal trouncing of Haz reached well beyond Seattle. *Notan* had been
widely distributed to camera clubs and libraries throughout the world, including
to the New York Public Library. Koike published Haz's response in *Notan* in the
September 13, 1929, edition. Under the heading "Vindication," Haz addressed his
accuser. "My Dear Dr. Koike: Your article printed in Notan has reached me and
I am glad that you gave me an opportunity to answer it. It seems to me that you
have misunderstood the motives of my remarks. I want you to know that if there
is one man on earth who most humbly admires Japanese art in general and Japa-
nese pictorial photography in particular, I am that man." After several obsequious,
shallow sentences, Haz further explained, "Please take note that I not only do not
object to the large number of Japanese prints in any exhibition, but devoutly wish
for it. But now comes the question of annuals. I do not mind international ones.
One of them, Photograms of the Year I greatly admire. If an editor who is making
up a national annual wants to include foreign work in it, that is his own business.
Who am I trying to dictate to any editor what to do?"[56] Haz did not retract his
statements concerning the presence of "foreign" work in American annuals and
tried to justify his objections without much success.

Sigismund Blumann (1872–1956), the noted photographer and influential
editor of *Camera Craft*, had defended the work of the SCC and was a staunch sup-
porter: "Our Japanese Artists have swallowed the contumely of being accused of

imitativeness and plagiarism and have quietly gone about their rule, and unselfish service and unfailing courtesy they have enlisted all earnest workers with them to a common purpose—to make pictorial photography a fine art, not by contention but as a matter of fact. More power to them."[57]

In June 1929, the SCC's fifth exhibition was held at the Art Institute of Seattle, indicating the club's well-deserved status in the community. The Art Institute and its antecedents, the Washington State Art Association and the Seattle Fine Arts Society, were the city's major cultural venues and sponsored the leading local, national, and international visual-art shows until the founding of the University of Washington's Henry Art Gallery in 1927 and the Seattle Art Museum in 1933. Once again, the SCC exhibition showed hundreds of works by local and international photographers; even the club's earliest enthusiastic supporter, Wayne Albee, who had by this time relocated to California, finally displayed his work. His sole entry bears the prophetic title *Life Leers*, which in retrospect is an ironic foreshadowing of the impending stock market crash, the economic depression that had disastrous results for many SCC members, and ultimately of his own untimely death at age fifty-five only eight years later.

In its final year, 1929, the SCC was arguably the leading artists' organization in the state, evidenced by the major international recognition of its membership. It undoubtedly served as an inspiration for other local art groups such as the Northwest Printmakers Society, which held its first exhibition in 1929 and would continue to achieve national and international recognition until its demise in 1971.[58] Two successful surviving organizations, the Puget Sound Group of Northwest (men) Painters formed the same year, followed by the Women Painters of Washington in 1930.

In the final edition of *Notan* on October 11, 1929, the tireless Dr. Kyo Koike once again printed the membership's accomplishments and related news of their activities. Under the simple heading "Farewell" he explained the club's demise:

> We decided to disband our Seattle Camera Club because of non-activities and financial difficulties of most of the members. Our organization was in flower at one time, but its autumn has come and it is withered now. We owe our success in the past to all of our friends here and there and we are sorry we can not stand any longer even with their encouragement. We should not keep our group for the name only, but rather we shall be separated until the time has come again for us to join once more. There is no more Seattle Camera Club and neither this monthly bulletin, Notan. We express our hearty thankfulness to the friends, contributors and advertisers, who helped us and stimulated us in every way during our existence. Good-bye everybody. We wish you good luck.[59]

Two months after the Seattle Camera Club folded, the Art Institute of Seattle honored Dr. Kyo Koike with an exhibition of his work that ran from December 5, 1929, through January 6, 1930. It also cosponsored the SCC's Sixth (and final) International Exhibition of Pictorial Photography from June 4 to September 20, 1930, after the demise of the organization. Having his physician's salary to sustain him throughout the Depression, Koike was able to continue producing and exhibiting his works during the 1930s, maintaining an international presence.

Several other SCC members had commercial photography–related employment to assist them through this difficult period. Ella McBride and Frank Kunishige continued their commercial work at her portrait studio, and Virna Haffer relied on her close friend Yukio Morinaga to print all of the works for her Tacoma studio. Although their incomes were substantially diminished, the most noted members managed to survive. Like Koike, McBride was honored with a solo exhibition of her photographs at the Art Institute of Seattle from January 7 through January 18, 1931. In the midst of her exhibition, she delivered a lecture titled "Photography: Its Place in Art."

Although the SCC disbanded and international acclaim for most of the individual members waned, local publications like *The Town Crier* continued to promote photography as a fine art. In its December 17, 1930, issue, two contrasting articles illustrate the changing attitudes towards Pictorialism. The first was titled "Looking through the Lens" and featured halftone reproductions of the works of Koike, Morinaga, Kunishige, Onishi, and others. The caption above each reproduction marked them as "Japanese Photography," even though most of the photographs displayed a decidedly Western influence. Directly following this article was another, titled "The Camera Goes Modern," which reproduced some recent images by former Seattleite Imogen Cunningham and wrote that "lately we *know* that photography is an art, for has it not its exponents of Modernism? Imogene [*sic*] Cunningham. . . has sent from California some interesting examples of what can be done by the camera in the nebulous fields of abstraction. Cunningham's work is an abrupt contrast from that of the Japanese prints on the preceding pages, which had as their ultimate aim pictorial effect. The following prints wrestle with composition, values, lights and darks, rhythm, in short, with all the qualities that concern devotees of modernism in other fields of art."[60]

The article included two of Cunningham's plant studies, *Glacial Lily* and the now iconic *Tower of Jewels*, which depicts the interior of a magnolia blossom. *The Town Crier* gave a fair assessment and provided both points of view in the issue, comparing Pictorialist and modern works. However, in retrospect, Cunningham's modern floral studies are compatible with some of Kunishige's and McBride's floral compositions that were, in some instances, created and exhibited before Cunningham had success with the subject.

A new organization appeared with the founding of the Seattle Photographic Society in 1933, a group still active today. *The Town Crier* was there to cover the

club's activities, and in the June 1935 issue an article titled "Pictorial Photography in the Northwest" appeared.[61] After providing further reinforcement and defense for Pictorial photography, the author wrote that "a stimulating interest is the Seattle Photographic Society. The club is partially an outgrowth of the old Camera Club which existed for so many years in Seattle. And the membership of which was ninety percent Japanese." Several of the prominent members of the old SCC became members of the new organization, including Koike, Kunishige, McBride, and Haffer, although the officers were all Caucasian and the group produced no bulletin that equaled *Notan*. In 1940, Koike and Kunishige founded the Seattle Japanese Camera Club, which had a very brief existence.

Of the former SCC members, Virna Haffer best exemplifies the continued success and innovation of the initial membership. After producing Pictorialist works in the early 1920s that showed the influence of her older colleagues, Haffer's imagery soon took an abrupt change of direction into a much darker and more abstract vision. Her innovative works sometimes contained disfiguring distortions or hinted at underlying sexual tensions. This culminated in the mid-1930s, when she produced a series of highly unusual and suggestive photographic illustrations intended to be reproduced in a collaborative book of erotic poetry by her friend, writer Elizabeth Sale (fig. 36). The book's title, *Abundant Wild Oats*, contained the literary and visual ruminations of the two women's relationships with men. Although the book was never published, due to either the erotic content that subtly suggested free love or a lack of funding resulting from the Depression, the illustrations that Haffer produced are among the most innovative works made by a Washington State artist of that time.

Haffer continued in the commercial and artistic fields until the early 1960s, when she began to concentrate on the production of photograms. This process essentially discarded the camera and produced imagery by using the direct contact of objects with photosensitized paper or via the manipulation of these objects through several layers of glass, producing a multidimensional effect. Haffer's photograms and subsequent publication on the subject serve as one of the crowning achievements by any Washington State artist. Not only did she develop new techniques for the photogram process, but the imagery in many of her works successfully elucidated the dehumanizing effects of war and the serious industrial impact on the environment long before such themes were widely taken up by other conscientious artists.

Of the remaining members of the SCC, several returned to Japan before World War II and were never heard of again. Others lucky enough to survive the Depression faced still another challenge when President Roosevelt signed Executive Order 9066 on February 19, 1942, which directed that all Japanese American citizens on the West Coast be remanded to detention centers and eventually to concentration camps, where many remained throughout the war years. Most

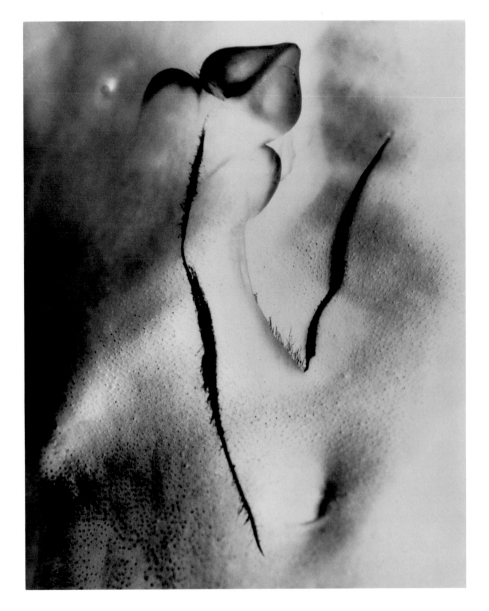

of the Issei Pictorialists remaining in the Northwest were sent first to so-called Camp Harmony, the Puyallup Assembly Center in Washington, and then were relocated to the Minidoka concentration camp in Idaho. Hiromu Kira was interned at the Gila River camp in Arizona.

A few Japanese American photographers were lucky to have Caucasian friends who stored their work during the five-year internment. Others lost the majority of their output, along with the records of their exhibitions and achievements in the field of fine-art photography. Dr. Kyo Koike remained active as a doctor in Minidoka, although under extreme duress. Since owning and operating a camera was illegal for the internees, many passed their time by becoming involved in group activities and carving walking sticks from the local desert brush. One of Koike's activities in the camp centered on the formation of a haiku poetry society called the Minidoka Ginsha in October 1942. He had been active with the Rainier Ginsha Haiku Society since its formation in Seattle in 1934 under the direction of

Kyou Kawajiri, who died while interned at Minidoka. With the ironic publishing date of July 4, 1945, a book titled *Kusazutsumi* (meaning "grass-covered bank") was edited by Koike and printed at the camp.

When the internment ceased, many of the Issei photographers were past retirement age and lived out the remainder of their lives struggling financially and dealing with the psychological and physical effects of such a life-altering hardship. Haffer assisted her friend Morinaga by purchasing a small house for him in Tacoma, where he sustained himself with printing jobs from her and other local commercial studios. Kunishige worked in a commercial studio in Twin Falls, Idaho, and even held two exhibitions there before returning to Seattle by 1951 (fig. 40). Years after his death, his widow Gin married former fellow SCC member Iwao Matsushita, who had been widowed in 1965. Koike spent his final years exploring his continuous love of nature as well as being actively involved with his Buddhist temple and the Rainier Ginsha.

As the current reassessment of Pictorialism continues, the unquestionable international success and timeless artistic merits of the Seattle Camera Club will continue to justify the group's rightful place in the evolving canon of photographic art history. Rapidly expanding digital technology is coinciding with the revival of the artistic potential found in older techniques such as bromoil, carbon and carbro, cyanotypes, and even the use of extremely low-tech pinhole cameras. With the question of whether photography constitutes a fine art long laid to rest, and with the pressure artists feel to align themselves in the direction of any specific movement almost completely eradicated, contemporary and future photographers will benefit from the progress of all the forces that contributed to the growth of the medium.

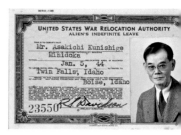

FIGURE 37

Frank Asakichi Kunishige's internment identification card, n.d.
University of Washington Libraries, Special Collections, UW14752

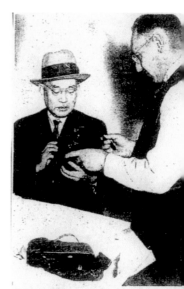

DOCTOR COMPLIES—Dr. Kay Koike, Seattle reside since 1916, turns over two cameras and offered to give his binoculars to Lieut. C. E. Neuser, police defense deta

FIGURE 38

Newspaper clipping of Dr. Kyo Koike surrendering his cameras and binoculars authorities in Seattle, ca. 1942
Author's collection

JRE 39

zutsumi, Minidoka Ginsha publication,

× 4 3/4 in.

rtesy of the Rainier Ginsha, Mrs.
iko Takamura

URE 40

k Asakichi Kunishige exhibition at the
h Century Club in Twin Falls, Idaho,
6
versity of Washington Libraries,
cial Collections, UW29032Z

1 Walter E. Woodbury, *The American Annual of Photography and Photographic Times, Almanac for 1897* (New York: Scovill & Adams Co., 1897), 355. Other members of this first incarnation of the Seattle Camera Club included Dr. F. A. Churchill, J. D. Lowman, Charles W. Parker, and James Bert Barton.

2 *Anthony's Photographic Bulletin* 26 (1895): 212.

3 "First Exhibition of Camera Club," *Seattle Post-Intelligencer*, January 19, 1896, p. 9. The article also mentions that a catalogue of the exhibition was printed and that the members photographed the exhibition itself, although neither the catalogue nor the photographs have been located.

4 "To the Amateur Photographers: Seattle Washington," printed flyer, 1901, Photographer's Reference File—C. L. Denny, University of Washington Libraries, Special Collections.

5 *The American Annual of Photography*, vol. 5 (1905), 341.

6 "An Artistic Souvenir," *The State* 5, no. 5 (May 1900): 167.

7 Information about Oliver Anderson is from two sources: Charles Thomas Hommel, "Guide to Three Historical Photograph Collections in Seattle" (master's thesis, University of Washington, 1974), Seattle Collection, The Seattle Public Library; and Cornelius H. Hanford, *Seattle and Environs, 1852–1924*, vol. 1 (Seattle: Pioneer Historical Publishing Co., 1924), 447–48. Both sources contain several errors that have been updated and corrected for this essay.

8 *First Annual Exhibition and Sale of the Industrial and Allied Arts of Washington* (Seattle: Woman's Century Club, 1904), exhibition catalogue, Seattle Collection, The Seattle Public Library. The exhibition was sponsored by the Woman's Century Club, an early regional cultural and social organization still in existence. It was held from June 1 through June 3 at Little's Hall at 312 Madison Street in Seattle.

9 Hanford, *Seattle and Environs*, 632–33.

10 Beaumont Newhall (director of the George Eastman House museum in Rochester, New York) to Reuben C. Benz (Wiggins's son-in-law), February 19, 1957, courtesy of Robert and Shirley Benz, the Myra Wiggins estate.

11 For an in-depth study of the life and work of Myra Wiggins, see Carole Glauber, *The Witch of Kodakery: The Photography of Myra Albert Wiggins, 1869–1956* (Pullman: Washington State University Press, 1997).

12 Michael G. Wilson and Dennis Reed, *Pictorialism in California: Photographs, 1900–1940* (Los Angeles: J. Paul Getty Museum, 1994), 141.

13 The original painting for the emblem has not been located, but Hanscom described her design to the Seattle press as follows: "The figure to the right typifies the Pacific Slope with right hand extended in welcome, and the left holding a train of cars, representing commerce by land. The figure to the left represents the Orient, and the ship in her hand represents commerce by sea. The central figure in white is that of Alaska, the white representing the North and the nuggets in her hand representing her vast mineral resources. Across the sky in the background is seen the Aurora Borealis so vivid in the North. The purple background with the many colors of the northern lights makes a rich coloring. At the side of the figure on the right are tall trees, typical of the immense forests of the territory represented by the exposition. My whole idea in this design was to keep it simple and still give suggestions of all the essential things to be represented." *Seattle Post-Intelligencer*, July 5, 1907.

14 C. H. E. Asquith, "Photographic Possibilities of the Alaska-Yukon-Pacific Exposition which Will Be Held at Seattle in 1909," *Camera Craft* 14 (n.d.): 73–81.

15 Wayne Albee, "Omar—Materialist or Mystic?" *The Town Crier*, December 13, 1924, pp. 17–25. Albee accompanied his essay about Omar Khayyam with his own illustrations for *The Rubaiyat*. Although clearly inspired by Hanscom, they do not utilize any of the technical innovations that distinguished her work from his. In addition to Albee, both Ella McBride and Frank Kunishige produced Pictorial works that were unquestionably inspired by Hanscom's illustrations.

16 *Catalogue of the Fine Arts Gallery and Exhibit of Arts and Crafts, California Building, Exposition Grounds, Seattle, 1909*, 28–30, in the library of the Museum of History and Industry, Seattle.

17 Margery Mann, *Imogen! Imogen Cunningham Photographs, 1910–1973* (Seattle: Henry Art Gallery, University of Washington Press, 1974), 22.

18 Charles Pierce LeWarne, *Utopias on Puget Sound, 1885–1915*, 2nd ed. (Seattle: University of Washington Press, 1995), 15.

19 Imogen Cunningham to Charles Pierce LeWarne, August 10, 1975 (in author's possession, copy provided by Mr. LeWarne).

20 Richard Lorenz, *Imogen Cunningham: Ideas without End* (San Francisco: Chronicle, 1993), 11.

21 Cunningham to LeWarne, August 10, 1975.

22 Ibid.

23 Margery Mann, *Imogen Cunningham: Photographs* (Seattle: University of Washington Press, 1970), 7–8.

24 "With the Fine Arts Folk," *The Town Crier*, June 12, 1915.

25 *The Town Crier*, April 26, 1913, p. 5.

26 Jennifer Kate Ward, "The Etchings of Roi Partridge," in *The Graphic Art of Roi Partridge: A Catalogue Raisonne*, by Anthony R. White (Los Angeles: Hennessey & Ingalls, 1988), 7.

27 Clare Shepard continued painting after her move to northern California, although she rarely exhibited. She died in Reno, Nevada, in 1983 at the age of one hundred. Only a few of her paintings have surfaced. Susan Ehrens, a friend of Clare Shepard, telephone conversation with the author, May 22, 2007.

28 Quoted in Mann, *Imogen!*, 34, 36.

29 *The Argus*, December 25, 1915, pp. 2–3.

30 Madge Bailey, "Fine Art Notes," *Seattle Post-Intelligencer*, November 7, 1920, p. 3.

31 For an in-depth study of the life of Iwao Matsushita, see Louis Fiset, *Imprisoned Apart: The World War II Correspondence of an Issei Couple* (Seattle: University of Washington Press, 1997). Fiset's outstanding and sensitive book documents the life of Matsushita and his wife, Hanaye, and provides insightful and important facts concerning other SCC members.

32 Foreword in *Frederick & Nelson Second Annual Exhibition of Pictorial Photography, November 1st to 12th, 1921*, exhibition catalogue (Seattle, 1921).

33 *Camera Craft* 28, no. 12 (December 1921).

34 Kyo Koike, "The Influence of Old Japanese Literature and Arts on Pictorial Photography," *American Photography* 22, no. 1 (January 1928): 16–19.

35 Anne Tucker, *The History of Japanese Photography* (Houston: Museum of Fine Arts and Yale University Press, 2003), 117, 354.

36 Dennis Reed, *Japanese Photography in America, 1920–1940* (Los Angeles: Japanese American Cultural and Community Center, 1986), 65. Reed knew Kira personally and gathered information about the founding of the SCC from Kira's recollections. Dennis Reed, telephone conversation with the author, n.d.

37 Kyo Koike, "The Seattle Camera Club," *Photo-Era* 55, no. 4 (October 1925): 182, 184.

38 Ogasawara had returned to Japan by 1935. In a letter dated August 31, 1935, American artist Frances Blakemore, then living in Japan, wrote the following to her family: "The morning after our pictures appeared (in a Tokyo newspaper), we had an early caller in the person of Mr. Ogasawara, who had lived in the states for ten years and had an American wife. When in Seattle, he lived in Wallingford and knows many people we know. He helped Conway with Japanese plays at the U., and he is a photographer by profession." Michiyo Morioka, *An American Artist in Tokyo, Frances Blakemore, 1906–1997* (Seattle: Blakemore Foundation, 2008), 51. Onishi's return to Japan is documented by an extant postcard in the Virna Haffer archive in the Randall Family Collection, Seattle.

39 The other two female exhibitors were Mrs. George Eckenroth Jr. of Springfield, Ohio, and Miss Eleanor F. Jones of Holland, Michigan. Inagi's photograph "Through the Spring Curtain" was reproduced twice in *Photo-Era*, in the October 1927 issue, p. 203, and in the November 1928 issue, p. 272. Her photograph *After a Drizzle* was reproduced in *The Camera*, September 1926, p. 138.

40 A founding member of the SCC, Shuji (also called Shuga) Nagakura typifies a number of members who produced beautiful Pictorialist works for a brief period of time. Nagakura exhibited in many of the local Salons and a few international venues, including the First International Photographic Salon of Japan in 1927. Very little information about him has survived, outside of the fact that he was living in Seattle in the 1920s and worked as a retoucher for the McBride Studio. It is presumed that he returned to Japan before World War II.

41 C. A. Pierman, "Photography as One of the Fine Arts," *Buffalo Arts Journal* 7, no. 2 (May 1925): 25.

42 Croatian American sculptor Ivan Mestrovic (1883–1962) was a popular artist of the period. *Laocoön and His Sons* is a Hellenistic sculpture group in the collection of the Vatican. It has served as a source of inspiration for many artists over the centuries, including Caravaggio and William Blake.

43 Lorenz, *Imogen Cunningham: Ideas without End*, 13.

44 *Revue du Vrai et du Beau*, December 1924. There is a photocopy of the page in Photographer's Reference File—F. A. Kunishige, University of Washington Libraries, Special Collections (hereafter, Kunishige File).

45 McBride's photograph *Dogwood* was also published in *The Amateur Photographer* 64, no. 2030 (n.d.); *The American Annual of Photography*, vol. 22 (1928); *Fotokunst* (Antwerp), February 1928; and *Focus* (Holland), February 1928.

46 *Notan*, various issues, 1925–29.

47 *New York Herald* (Paris edition), October 4, 1924, Kunishige File.

48 The top ten leading American and Canadian exhibitors listed in the 1927 *American Annual of Photography* were (1) John Vanderpant, New Westminster, BC, 28 Salons and 150 prints; (2) Frank Kunishige, SCC, 23 Salons and 84 prints; (3) Hideo Onishi, SCC, 22 Salons and 87 prints; (4) Ella McBride, SCC, 21 Salons and 71 prints; (5) Dr. Kyo Koike, SCC, 19 Salons and 51 prints; (6) Hiromu Kira, SCC, 16 Salons and 49 prints; (7) Henry Hall, New Jersey, 16 Salons and 42 prints; (8) Yukio Morinaga, SCC, 15 Salons and 56 prints; (9) Johan Helders, Ottawa, 15 Salons and 50 prints; (10) James W. Aughiltree, New Jersey, 15 Salons and 32 prints.

49 Arthur Wesley Dow, *Composition* (New York: Doubleday, Page and Co., 1899), 19.

50 Koike, "Seattle Camera Club," 186.

51 *Notan*, September 10, 1926.

52 *Photo-Era* 57, no. 4 (October 1926): 228.

53 *American Photography* 22, no. 7 (1929): 341–42.

54 Haz's work was published in *Pictorial Photography in America*, vol. 4 (New York: Pictorial Photographers of America, 1926).

55 *Notan*, August 9, 1929, pp. 8–9.

56 *Notan*, September 13, 1929, pp. 10–11.

57 Sigismund Blumann, *Camera Craft* (June 1927), reprinted in *Notan*, July 8, 1927.

58 The Northwest Printmakers Society began in 1928, held their first exhibition in 1929, and continued until 1971. This group of national and regional graphic artists also attracted numerous national and international printmakers, including Picasso and Georges Braque.

59 *Notan*, October 11, 1929, p. 10.

60 "The Camera Goes Modern," *The Town Crier*, December 17, 1930, pp. 21–24.

61 Sally Goodwin, "Pictorial Photography in the Northwest," *The Town Crier*, June 1935, pp. 15–16.

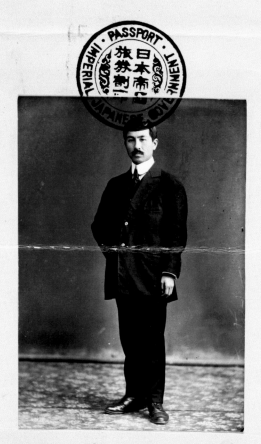

This is to certify that the photograph
attached hereto is a likeness of the
person to whom this visa is issued.
In witness whereof the seal of
the American Consulate General at
Yokohama, Japan, is impressed
upon the photograph.

PRESERVING A LEGACY OF LIGHT AND SHADOW: IWAO MATSUSHITA, KYO KOIKE, AND THE SEATTLE CAMERA CLUB

NICOLETTE BROMBERG

My life as a historian has brought me vivid reminders of how partial is the remaining evidence of the whole human past, how casual and how accidental is the survival of its relics.
—Daniel J. Boorstin, *Hidden History: Exploring Our Secret Past* (1987)

DURING THE 1920S, many Japanese immigrants on the West Coast found a successful way both to express themselves and to share in the culture of the West by making and exhibiting Pictorial art photography. So many of them were making photographs that they came together to form amateur camera clubs to share their love of the medium. They were amazingly successful. The photographs these immigrant photographers produced were exhibited in both national and international competitions and were included in nearly every book and magazine of popular photography.[1] The artists were so talented and prolific that *The American Annual of Photography* noted in 1928 that, in various exhibitions, there had been "762 prints hung that were by Japanese photographers in the three [Pacific coast] states in contrast to 237 by non-Japanese photographers from the same region."[2] These were photographers who, in the words of the editor of the 1928 *American Annual of Photography*, "put a lasting mark on photography in this country, the repercussions of which are echoing throughout the world."[3]

Los Angeles, San Francisco, and Seattle, in particular, had large and active camera clubs regularly producing and exhibiting work—yet a few decades later, most of this photography was lost, hidden away, or destroyed. Regrettably, most of the achievements of these enthusiastic and talented Japanese camera club members faded into obscurity, in part hastened by World War II and the internment of West Coast Japanese American citizens. After the war and for many decades later, their work was relatively unknown, as were their achievements. In an article about a 1988 Museum of California exhibit titled Japanese Photography in America, 1920–1930, the author discusses how much of this work was lost by the end of the 1940s. The exhibition curator, Dennis Reed, sought out work of California camera club members, but it was a struggle for him to uncover work as he prepared the exhibit.[4]

Although San Francisco had the largest camera club, relatively few examples of the work of these photographers has survived.[5] The same is also true with the Los Angeles club.[6] The case of the Seattle Camera Club, however, is different. We are fortunate to have available a significant body of the work of the club members, along with a detailed record of their activities and achievements. While we celebrate the work of the Seattle Camera Club today, many circumstances over the years worked against the preservation of this material. During World War II, when the West Coast Japanese American photographers were in internment camps, it was illegal for any person of Japanese descent to own a camera or practice photography. Much of the work of the camera club members was lost when they were sent to camps or else was hidden away or destroyed by the photographers, who feared government reprisal.[7] Continuing anti-Japanese sentiment after the war also made them reluctant to let it be known that they had been photographers, so they did not mention their previous work and achievements.[8] In her discussion about the loss of most of the work done by the California Japanese Pictorialists, Abby Wasserman reflects on Boorstin's statement when she says, "History is never definitive, but a process of accumulation which is inexact and subjective."[9] To be included in history, some record of the event, achievement, or person needs to exist for future historians, which means that someone must act to preserve it. Dennis Reed's efforts helped to uncover traces of the California camera club work and bring it back into our national history.

Collecting decisions made by institutions (and the people who work for them) have a major influence on the selection of what is preserved for our historical record. As places where our photographic heritage is stored, museums and historical archives have a great impact on which photographer's work will be preserved for future generations. It was through the actions of two members of the Seattle Camera Club that a large part of the history and photography of the club was preserved. Dr. Kyo Koike, whose energy and enthusiasm were the driving force behind the club, helped create a written record of Seattle Camera Club activities and philosophies. His close friend, Iwao Matsushita, saved the club records, along with a large collection of photography by the members. The collection includes a large body of work made by Koike and Matsushita, along with a significant amount from Frank Asakichi Kunishige and some prints by others such as Hiromu Kira, Kusutora Matsuki, Fred Yutaka Ogasawara, and Yukio Morinaga.

A third person instrumental in preserving Seattle Camera Club materials was Robert Monroe, who was the head of the University of Washington Libraries Special Collections. Monroe was particularly interested in photography and was ahead of his time in recognizing the broader value of photographs in the historical record. He was able to see the value of collecting a type of photography that, during the 1960s and 1970s, would normally be rejected by historical archives. In particular, images of personal expression or art did not fit into the realm of

the historical archive. Monroe's philosophy was that it was his responsibility to anticipate the needs of future scholars—to see fifty or one hundred years into the future.[10] He believed in the importance of the Seattle Camera Club work at a time when photography was relegated to the back rooms of archives and when Pictorial photography was of very little interest in the world of art photography.

But in the 1920s, Pictorial photography was a perfect fit for the Seattle Camera Club's Japanese Americans, with its emphasis on nature and emotion and presenting the photograph as art. It has been suggested that, for these immigrants, photography was a convenient way of maintaining their cultural heritage of Japanese arts and aesthetics.[11] They came from a culture that prized art and design in daily life. As Boye De Mente noted in *Elements of Japanese Design*, "There is no other culture in which design and quality have played such a significant role in the day-to-day life of the people."[12] At the same time, the immigrant photographers could also participate in the American mainstream, sharing a common interest and visual language with the broader photographic community unconstrained by language barriers. While they sometimes encountered racism (such as when a New York photographer and art critic reviewing an exhibition complained that Japanese American photographers should not be allowed to exhibit in the "American" category),[13] generally their work was well accepted on the national and international scene in exhibitions and in photography magazines.

The Seattle Camera Club was one of the most active and successful of the camera clubs on the West Coast. While there had been the Seattle Amateur Photographic Club organized in 1901, during the early 1920s there wasn't an active camera club in Seattle. "We waited patiently for a long time," wrote Dr. Kyo Koike, "thinking that some Americans might organize a society for the friends of photography, but no light appeared on the dark sea. At last we Japanese determined to establish one by ourselves, and the result is the Seattle Camera Club."[14] The club was formed by a group of immigrants from Japan who were drawn together through their enthusiasm for Pictorial art photography. Seattle was a popular destination for Japanese who wished to come to America. By 1917, when the thirty-nine-year-old Koike had set up his practice as a doctor in the heart of Seattle's Nihonmachi (Japantown), there was a vibrant community of around eight thousand Japanese immigrants. Koike, who was born on February 11, 1878, in Shimane Prefecture, Japan, was the first Koike son and was descended from a long lineage of physicians. He, too, studied medicine, eventually opening a clinic in Hachibon-do, Okayama City.[15] He was a widower at the time he arrived in America and had no children except for a son in Japan who had been "adopted" to assume the family name, as was a custom in Japan.[16] He may have chosen Seattle because he already had two friends there, Mr. Tamura and Mr. Katayama.[17] While he made his living as a doctor for the local Japanese community, Koike was an artist and poet at heart. He was both creative and articulate. He taught Japanese haiku poetry and helped to organize the Rainier Ginsha, a haiku club in Seattle.

He also translated Japanese literature into English and typed his drafts and bound them into book form using his own photographs as illustrations.[18]

In 1919, twenty-seven-year-old Iwao Matsushita and his wife, Hanaye, arrived in Seattle (figs. 2 and 3). Iwao was born on January 10, 1892, in Miike on the island of Honshu, and had been exposed to Western culture because his family was among the very few members of the Methodist Church in Japan. He grew up with an interest in the English language and graduated from the University of Foreign Languages in Tokyo with a certificate to teach English. He began work at a high school and met and married Hanaye, the daughter of the principal of his school. Dr. Kyo Koike was a friend of Hanaye's family and was close enough that she called him "Uncle." Hanaye was adventuresome and Iwao wanted to study more English to further his career as a teacher of English in Japan.[19] Since they knew Koike and he arranged for them to stay with his friend, Mr. Katayama, in Seattle, it was a logical place for Iwao to study English.[20] When they entered the United States in 1919 it was for scholarly reasons and, while they did not originally intend to stay, Iwao would not return to Japan for almost fifty years, and Hanaye would never return.

In Seattle, Matsushita and Koike began a close and lasting friendship, seeing each other almost every day and sharing their love of nature and their interest in creative expression through haiku and photography.[21] In his school days in Japan, Koike had owned a camera but had lost interest in it. In the United States, he was given a Kodak 3A camera by a friend and found that photography captured his imagination. "It was a fire-lighter to re-kindle the extinct ambition of my heart and to make me a photo-mania again," he recalled.[22] Koike would go out photographing every Sunday and on holidays all throughout the year no matter the weather. He had little interest in the equipment of photography but was more concerned with his images. "I paid less and less attention to the photographic apparatus all the time," he wrote. "When pictorial photography is the heart's desire, the photographic apparatus is only secondary. Neither the apparatus nor our hands alone can create pictorial photography which is the record of our inspiration."[23]

Iwao Matsushita often went out into the mountains to hike and photograph the landscape, usually with his friend Koike and his wife, Hanaye, who loved outdoor activities. He was also making still-life photographs at home and early on was an obsessive photographer of cats. The Matsushitas did not have any children but had a long succession of cats, and Iwao loved to photograph them. By 1921, he created a photograph album, *The House That Cats Built*, which included views of the cats engaged in various activities and even showed dead cats laid out for funeral ceremonies, such as in his photograph *The Death of the Prettiest*. Some of his cat photographs were exhibited and one, *Interested* (fig. 5), was later published and critiqued in a photography publication. During the 1930s, he made a home movie of his cats, also titled *The House That Cats Built*. It is not clear when he began doing photography, but he was most likely developing and printing his own work.[24]

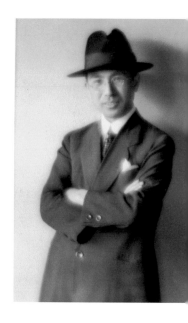

FIGURE 2
FRED YUTAKA OGASAWARA
Iwao Matsushita, ca. 1920
Gelatin silver print
6 × 4 ¹/₈ in.
University of Washington Libraries,
Special Collections, UW29063Z

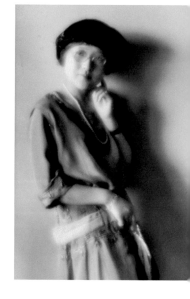

FIGURE 3
FRED YUTAKA OGASAWARA
Hanaye Matsushita, ca. 1920
Gelatin silver print
6 × 4 ¹/₈ in.
University of Washington Libraries,
Special Collections, UW29064Z

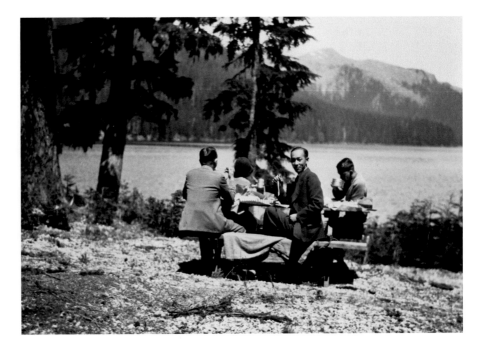

Koike, whose medical office was on Main Street in the Japanese district, took his photographs to be developed and printed at a nearby drugstore owned by Yasukichi Chiba. Chiba, who was a photographer himself, employed Hiromu Kira and Yukio Morinaga (who was a skilled photographer, said to have studied at the Eastman School of Photography) to process photographs in his store.[25] The four men (and possibly also Matsushita) often gathered at lunch breaks to discuss photography and, eventually, they discussed starting a Pictorial photography group.

Another talented professional Japanese American photographer was Frank Asakichi Kunishige, who was the same age as Koike, having been born on June 5, 1878, in Yamaguchi-ken, Japan. He came to San Francisco in 1895 at age seventeen and went to study photography in Chicago in about 1911. He opened a studio in San Francisco on Fillmore Street but by 1917 came to Seattle, where he went to work in the photography studio of the well-known photographer of Native Americans, Edward S. Curtis. He also worked for the Bon Marché department store doing display windows.

Koike, Matsushita, Kunishige, and other Japanese American photographers were already showing their work by the early 1920s. Matsushita exhibited in the North American Times Exhibition of Pictorial Photographs, October 30–31, 1921, with Kunishige and about twenty other Japanese American photographers. Koike had two photographs, *Plain Foliage* and *Autumn*, in the Frederick & Nelson Salon in 1920 and was first published in *Photo-Era* magazine in 1922.[26] Koike, Chiba, Morinaga, Kira, Matsushita, Kunishige, and a number of other Japanese photographers began to meet in late 1924. They held meetings at the Gyokkoken Café and paid club dues of fifty cents.[27] Members brought prints to view and discuss at the meetings. They also had a reading room at the Empire Hotel that contained a collection of photography magazines, catalogs, and other related publications for

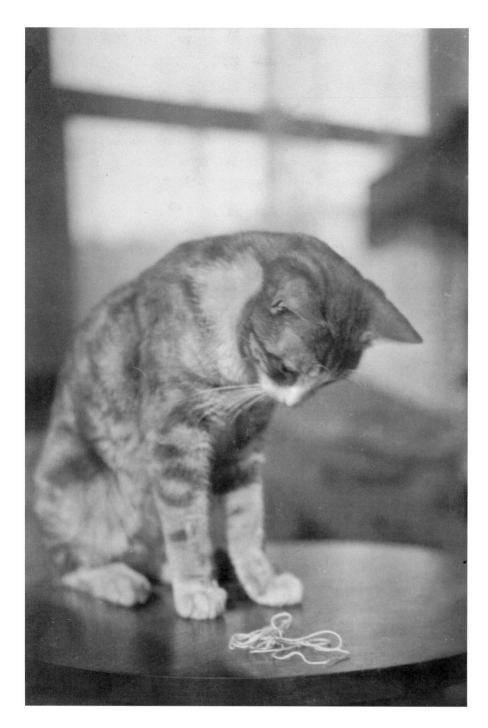

FIGURE 5
IWAO MATSUSHITA

Interested, ca. 1921
Gelatin silver print
9 ¹/₂ × 6 ¹/₂ in.
University of Washington Libraries,
Special Collections, UW29065Z

the use of the members. The first officers of the Seattle Camera Club were Koike, Iwasaki, and Kunishige. There were thirty-nine charter members—all Japanese Americans.[28] Also among them was Fred Yutaka Ogasawara, a highly regarded Pictorial photographer who moved to Portland but remained an active member of the group. Most of the members were not professional photographers.: Hideo Onishi, who became one of the most successful club members, was a cook at the Paramount Restaurant in Chinatown; Hiromu Kira was a traveling sewing-machine salesman; Kusutora Matsuki worked in a drugstore; and R. Sato was a barber.[29]

Dr. Kyo Koike was the leader and spokesperson for the club. The Seattle

Camera Club was one of the very few Japanese camera clubs that documented their activities.[30] Koike was one of the editors and a frequent contributor for the club's bilingual Japanese-English journal, *Notan*, which was filled with Japanese literature translated by Koike, essays on photography and other arts, monthly reports of members' work and shows, announcements, prizes the club and members won, and reports of the meetings. Koike's energy and commitment to photography remained the guiding light of the club. He wrote essays for national photography magazines such as *Photo-Era* and *Camera Craft*, with titles such as "Why I Am a Pictorial Photographer," "Mount Rainier," "The Seattle Camera Club," and "Mountain Pictures with or without Figures." Koike's writing on photography both enhanced and defended the reputation of the Seattle Camera Club. His writing was lively and usually addressed personally to the reader. In "My Photographic Trip," published in *The Miniature Camera* in 1934, he brings the reader along on his photography outing, discussing his philosophies and techniques: " 'Why do you keep only one photographic apparatus on hand,' you may ask. One of the reasons is that I am not rich enough to buy many instruments at one time, but there is a more important reason. . . . Pictorial work is the use of the photographer's mental abilities and we use the apparatus only as a means to express our ideas. . . . My old Kodak is good enough for me; I know its foibles and I can use it correctly. This is why I cling to only one Kodak at a time."[31]

As the Japanese American photographers became more successful, Koike also responded to statements claiming that Japanese photography should not be considered "American," which sometimes appeared in the photographic magazines. (It has been suggested that the anti-Japanese statements were more about resentment of Japanese Americans' high level of success and the exposure they attained.)[32] The head of the Cleveland Photographic Society complained that while the work of the Seattle Camera Club was beautiful, "I do not like to see a Japanese get into the habit of trying to reproduce the American art. . . . I really feel that both the Japanese and the Americans are losing something unless the Japanese are careful to avoid this tendency."[33] In reply to a similar complaint, Koike said, "We are not allowed to become American citizens by law, but we may live in America just the same. What trouble could be caused by the difference of nationality in the realm of pictorial photography, I cannot understand."[34]

Pictorialism has been defined as "the conscious attempt to turn beautiful objects and experiences into beautiful images."[35] This was the avant-garde style of its time that developed as photographers tried to gain acceptance of photography as an art form in the early part of the twentieth century. It often involved darkroom manipulation to make the work look more like "art." However, by the time the Japanese photographers came to it, the emphasis had changed to less manipulation and more expression, and many of them did not print their own work or do darkroom manipulation. Their ideas were visualized in the camera rather than in the darkroom. They took the Pictorial ideas of expression of beauty and

emotion and blended them with characteristic elements of Japanese art—use of patterns, flat surfaces, and lack of perspective.[36] These Japanese American photographers were not seeking to be on the cutting edge of photography but found that the emotional and personal nature of Pictorial photography suited what they wanted to express about the world in their art. Indeed, by the 1920s, the Modernist "straight" photography movement, with its emphasis on sharp clear forms and direct documentation of the subject, was already on its way to overshadowing Pictorialism.

Koike discussed his ideas on why he saw Pictorial photography as an art in "Why I Am a Pictorial Photographer," published in the September 1928 issue of *Photo-Era*:

> Some think pictorial photography is not a species of art; but I hold another view. Some compare photography with painting pictures; but I think pictorial photography has its own standing, somewhat different from that of painting. ... I read a few photographic books and magazines to learn something about compositions; but it is certain my idea is based on Oriental tendency, much influenced by the Japanese literature and pictures to which I am accustomed. I understand Japanese poems; and I think pictorial photography should not be an imitation of paintings, but it should contain a feeling similar to that of poems.[37]

In "The Characteristics of Japanese Art," written by Hoshin Kuroda and translated by Koike, the author writes that while Western art focuses on "human life," nature is more often the subject of Japanese art. The Japanese artist uses nature in an "idealistic" rather than realistic way: "Accordingly, the Japanese picture is not a real sketch, but is an ideal image of nature."[38] Koike compared his work to Japanese sumi-e painting in the 1925 issue of *Camera Craft*, saying that "photographic work depends on the expression of atmosphere with only black and white masses. ... To be decorative is a strong point of Japanese workers. To be suggestive or poetic is another of our characteristics." He illustrated his statement with a set of photographs, *Winter Decoration* (fig. 6) and *Summer Breezes*, that evoked the spare and expressive brushstrokes of the sumi-e painting.[39] "Art must not explain the detail, but it must abound in reverberation, that is the Japanese conception," Koike explained in "Pictorial Photography from a Japanese Standpoint." "To understand Japanese art, therefore you must shut your eyes and go far away to the slumberland where imagination governs the whole."[40] Koike saw himself as bringing the poetic "reverberation" from his Japanese culture together with the Western ideas of photography as an art to create his artistic sensibility.

Koike's work was intimate and subtle poetry, whether it was a photograph of a muddy track through the woods or a tree in the snow that hinted of the soft sound of snow falling. His images are quiet and thoughtful, with the slightly soft focus and matt-surface photographic paper helping to make them experiences rather than documents. It was said of Koike's work, "Our eyes are soothed by the gentle textural softness of snow; a shimmering surface of water becomes a moment of experience rather than a vision ... for him photography was not self-expression of ego, but it was an expression of a desire to gain quietude in himself, a way to convey the echo of his inner calling."[41] While generally Koike's photographs created a sense of serene nature, his image of a rushing waterfall, *Thousand Thunders* (fig. 7), is at once both tumultuous and ethereal—it shows the power of the rushing water at the top; you can almost hear the booming thunder—then it fades into an echo of mist at the bottom. This is more than just a waterfall—it is powerful and yet delicate at the same time.

The legacy of Japanese culture meant that a sense of harmony was important in these Japanese Americans' work and that the decorative styles of bold shapes and flat two-dimensional patterns and shadows were also common characteristics. The name of the Seattle Camera Club's journal, *Notan*, and the Japanese idea of this term was a key part of their work. Arthur Wesley Dow defined this as "darks

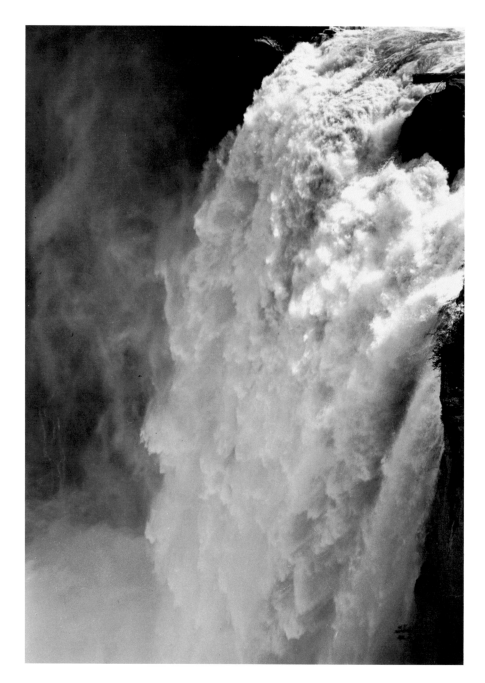

FIGURE 7
DR. KYO KOIKE

Thousand Thunders, ca. 1932
Gelatin silver print
9 7/8 × 7 in.
University of Washington Libraries,
Special Collections, UW29067Z

and lights in harmonic relations," which for the Pictorial photographer was the
use of the negative space as a design element where the picture space maintains
a balance between the dark and light elements.[42] Koike explained in an article
about the club in the November 13, 1925, *Photo-Era*, "We Japanese must, of course,
work within the limit of Japanese ideas, and our art is decorative, suggestive and
poetic. . . . Most of us have still to learn how to fill the picture space with a
pleasing combination of light and shade, and telling but little. Suggest a story that
fills our picture space with meaning, and with pleasure to the beholder. If one may
add to this a 'telling' placement of light and dark, perhaps that is as near as I can
get to what I have in mind as Notan."[43] In Iwao Matsushita's photograph of trees
and light streaking across the sky (fig. 8), the well-known world is suggested by

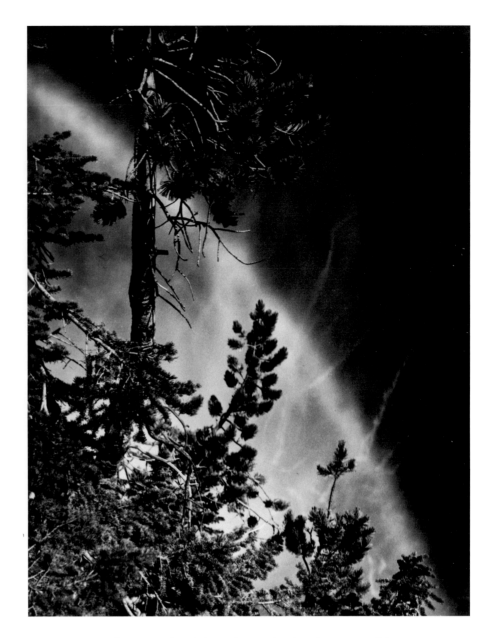

the trees in the foreground and the unknown by the placement of the mysterious light streak and shadow behind. What at first seems to be a simple picture of trees becomes more complicated and striking when the eye travels beyond the trees to the background. It is not clear what is happening here. Is something emerging from darkness? What is this world appearing behind the very mundane trees?

The Seattle Camera Club members not only loved photography, they also loved their adopted city. Seattle was a good place for creative Japanese immigrants who were interested in Pictorial photography. There was a large Japanese community for support and there were physical similarities to Japan in the landscape. Mount Rainier towers over the city, and Mount St. Helens farther south, then with its perfect ice-cream cone shape, was commonly called the Mount Fuji of the West. Just as in Japan, water surrounds the city and there are islands nearby (Bainbridge Island, for example, had a large Japanese farming community). There

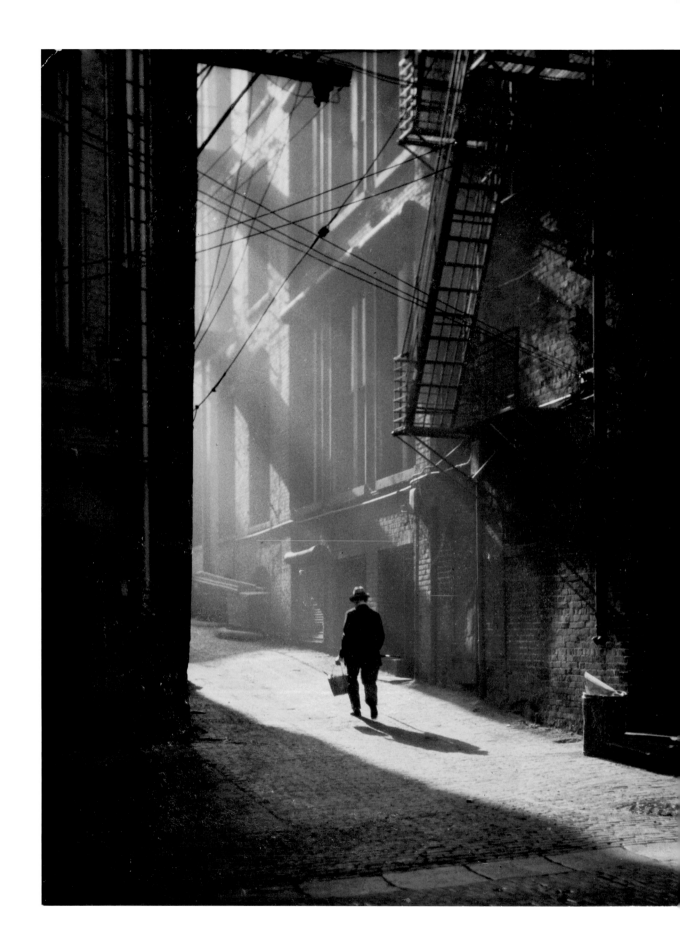

is easy access to the natural world of the woods and forests. The light is diffuse and soft, and the rain is light and moody rather than heavy and pounding as it is in the Midwest and east. The trees bloom in February and March and spring lasts a long time, with waves of cherry, apple, and plum blossoms along with the spring flowers. In an article in *Photo-Era*, Koike said, "Well, give me some time to consider whether or not Seattle is a suitable place for pictorial photographers.... There are many changes in the climate during the year. We are able to find spring flowers and snow scenes. Even in short trips of a few days, there are many famous high mountains and peaks or numerous lakes … in short there are plenty of subjects there."[44]

While the club was started with Japanese members only, they invited all photographers to join. In the March 11, 1927, issue of *Notan*, Koike wrote, "Fellow photographers … in Seattle: please think about what I have said and plan to join us or at least to visit our club room.... The latch string is always out to you." They had little success in attracting non-Japanese photographers to join in the beginning, although a few did join over the years and were noted in the club journal. Charles A. Musgrave was an early member and was an active one, even serving as an officer in the last year of the club. Also in the last months of the club, Virna Haffer, who had a photography studio, joined the group. She became close friends with Yukio Morinaga, who went to work for her, and helped him throughout the rest of his life.[45]

The most important non-Japanese member joined not long after the club was formed. Ella McBride started a second career in 1907 at age forty-five when she moved to Seattle at the invitation of the well-known photographer Edward Curtis. McBride was a schoolteacher and principal in Portland, Oregon, who so impressed Curtis when they met on a mountain-climbing expedition in 1897 that he asked her to come to Seattle to assist in running his studio. In 1913, when Curtis's studio manager Adolf Muhr died, she took over the management. It was there she met Frank Kunishige, and they became good friends. She established a close and lasting relationship with Kunishige, taking him with her in 1917 when she left Curtis to open her own studio.

McBride fell in love with photography. She had not been a photographer previously and began doing her own personal photography by about 1920. "I went into pictorial photography, and my avocation and vocation were one," she said. "I was most fortunate in finding a partner who, I think, is one of the world's most finest artists and a most cultured gentleman. It was his work that inspired me to make photographs."[46] She was the only non-Japanese included in the list of exhibitors in the North American Times Exhibition of Pictorial Photographs in 1921. It is probable that she was taught photography by Wayne Albee and Frank Kunishige. They often photographed together, using the same models or subjects.[47] The three of them were published together in a special section of the 1924 Christmas issue of the Seattle arts magazine *The Town Crier*. Although she

made portraits and landscapes, she became most well-known for her floral studies, which used elements from the Japanese aesthetic. She would become one of the most successful of all the Seattle Camera Club members.

McBride had an open mind for her time—while living in Portland, she had become close friends with a young Chinese man, Goon Dip, who remained close to her over the years. He later became a merchant in Seattle and also the Chinese consul. He was the Chinese representative for Seattle's first world's fair—the Alaska-Yukon-Pacific Exposition (A-Y-P). He gave McBride a number of artifacts from the Chinese exhibit at the A-Y-P, which she would sometimes use in her photographs.[48] As an unmarried woman, possibly subject to many raised eyebrows from the proper community, she may also have felt kinship with the Asian minorities who were at times subject to prejudice from the surrounding community. She certainly shared their love of photography and nature and felt comfortable with both their company and aesthetics.

Other supporters and friends outside the Japanese American community encouraged members of the Seattle Camera Club and contributed to club meetings and activities. Wayne Albee, a photographer who worked for McBride (but was not a club member), served as a behind-the-scenes mentor. He wrote supporting articles about the club, photographed with members, was a guest speaker, and served as a judge for their shows. The Seattle Camera Club hosted many guest speakers from the Seattle, national, and international arts communities. University of Washington professor Glenn Hughes, who was a major contributor to the development of theater in Seattle, spoke about stage lighting at the second meeting of the club, contributed articles to *Notan*, and served as associate editor for the journal. The club secretary and a coeditor of *Notan*, Y. Iwasaki, helped Hughes translate a Japanese play, *The Razor*, for a production at the Cornish School of Allied Arts, where both European and Japanese plays were produced. Artists and writers also spoke at club meetings. Mark Tobey, a painter and instructor at Cornish, lectured at an early meeting on modern trends in painting. Tobey, who was not well known at the time, would go on to become famous for his paintings that were clearly influenced by Japanese art.

The Seattle Camera Club served not only as a creative outlet for the members but also as a social group. Members went on hiking trips to Mount Rainier and Mount Baker and had other photography outings (fig. 10). The historian Shelley Sang-Hee Lee has noted that many of the members were bachelors or never had children and that the broader family-centered Japanese community may have regarded them as eccentric or strange for spending their time with photography.[49] Koike was a widower without children, Iwao and Hanaye Matsushita did not have children, nor did Frank and Gin Kunishige. For many, this group may have taken the place of family for a time. Certainly for Koike, his photography and the work of the club were a large part of his life, and he in turn gave his time, enthusiasm, and support to the club.

URE IO (RIGHT)

tle Camera Club outing to Mount
nier, July 28–29, 1928
tograph by Rainier National Park
npany
versity of Washington Libraries,
cial Collections, UW29069Z

URE II (BELOW)

son's greetings cards sent to Dr. Kyo
ke by Seattle Camera Club members
io Morinaga, Charles Musgrave, Hiromu
a, and Iwao Matsushita
Koike Photograph Collection,
versity of Washington Libraries,
cial Collections

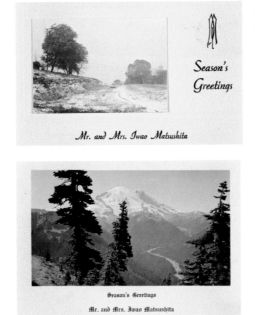

The Seattle Camera Club and its members became extraordinarily successful in a short period of time. The club held its first juried exhibition in 1925. There were thirty-four photographers in the show, including Koike, Kunishige (who won third prize), Matsushita (who won honorable mention), McBride, Morinaga (who won honorable mention), Ogasawara (a member living in Portland), Onishi, and others. The contributors were from Seattle, Portland, Whitefish, Montana, and Effingham, Illinois. The first prize was awarded to Laura Gilpin. The Second Seattle Exhibition of Pictorial Photography was in May 1926. It had 429 prints submitted from the United States, Canada, England, Scotland, Belgium, Switzerland, Austria, Czechoslovakia, Japan, and Java. The third annual had even more prints from even more countries. Eventually, the Seattle Camera Club would hold five juried exhibitions in all.

In 1925, members had 367 prints accepted into twenty-one Salons around the world. The success of the club peaked in 1926, when 589 photos from twenty members were accepted at thirty-three Salons. *A Shirley Poppy*, by McBride, was accepted into fifteen Salons. *One of a Day*, by Onishi, was accepted into ten Salons. *Betti & Hamadryad*, by Kunishige, and *Magellans of Today*, by Morinaga, were accepted into nine Salons. *Looking Down Emmons Glacier*, by Koike, and *The Magic Vase*, by McBride, were in seven Salons. In 1925, McBride became the sixth most exhibited Pictorial photographer in the world.[50]

During the peak of Seattle Camera Club activities, in 1926–27, members were among the top exhibited Pictorial photographers worldwide. Notable prize-winning members were Dr. Kyo Koike, Frank Kunishige, Hiromu Kira, Hideo Onishi, Yukio Morinaga, Fred Ogasawara, and Ella McBride. Onishi in particular was so successful that when he had a one-man show at the Japanese Commercial Club more than 1,000 people attended. He sold 233 copies of his prints, including 26 copies of *Gathering* and 17 copies of *Sea Breeze*. In total, he made $1,191 from print sales, and he donated $411.26 (the net profit after expenses) to the Seattle Camera Club.[51] This was amazing given that generally the photographers only sold a few prints when they did have sales of their work. Matsushita, while he was not among the top exhibitors of the club, was successful in both exhibiting and publishing his work, and he won prizes now and then, including a first prize in a *Photo-Era* competition in 1926.

Though the majority of the members were beginners, they kept winning prizes. In 1926, *Photo-Era* offered a trophy for the club whose members won the most awards in the magazine's competitions. As the first winner of the trophy, the Seattle Camera Club (SCC) won an engraved silver cup and was congratulated in *The View Finder*, the official bulletin of the California Camera Club: "We notice that the SCC has won the cup offered by Photo-Era for the Club whose members win the most prizes in the Photo-Era monthly competitions during the past year. The members of the SCC are real hard and honest workers, and the Club is now one of the leaders in pictorial work. Congratulations, SCC."

FIGURE 12
IWAO MATSUSHITA
Narcissus, n.d.
Gelatin silver print
10 × 5 1/2 in.
University of Washington Libraries,
Special Collections, UW29070Z

Koike was the most successful of the club members. He was extremely prolific and won many awards. He had articles published in national magazines and was chosen as one of the few photographers to offer advice about photography in *Photo-Era*. His work was shown all over the world, from Asia to South America, Europe, and across the United States, and by 1929 he rose to be the most exhibited Pictorial photographer in the world. He was also honored with a membership in the Royal Photographic Society of Great Britain and was its only Japanese member.[52]

Koike and Matsushita shared a reverence and love for Mount Rainier and found much of their inspiration and imagery in nature. While Mount St. Helens was commonly called the Mount Fuji of the West, Mount Rainier, which was closer to Seattle, also reminded them of Mount Fuji and it served as a spiritual wellspring for them—Koike often referred to it as the "holy mountain."[53] Koike said, "When I go out for my photographic trips, I see the mountain from any-where in the vicinity of the city of Seattle. The snow-cap is similar in the form to our holy Mount Fuji, so we Japanese often call it 'Tacoma Fuji.'"[54] Koike and Matsushita often climbed and photographed the mountain together. On one trip, Matsushita, who was a devout Methodist, made a vertical photograph titled *The Mountain That Was God* (fig. 13), in which a brightly lit Rainier looms up out of the mist as God made visible. A dark tree points the way, and there is no way to go in this scene but to the mountain/God.[55] Koike wrote about his experience on an August 1928 trip, when he made *Sea of Clouds* (p. 112), a view at the top of the peaks. After encountering a severe storm as they rested at 10,000 feet up the mountain, Koike came out of the tent and, "looking back, there stood the holy peak of Mt. Rainier. . . . Just before our face there was a sea of clouds, the top of Tatoosh Range (6,562 feet) appearing and disappearing like sunken rocks amidst dashing waves."[56]

Ella McBride's specialty was delicate floral photographs, with strong Japanese design elements. She first exhibited at the 1921 North American Times Exhibition of Pictorial Photographs. She was immediately successful and quickly achieved world-class status. In 1922, at the Sixty-Seventh Annual Exhibition of the Royal Photographic Society of Great Britain, only 154 photos were accepted from many hundreds of submissions. Only 12 photographs were from the United States and, remarkably, 3 of the 12 were McBride's prints of flowers: *Poppies*, *Zinnias*, and *Life & Death*, the latter a study of water lilies.[57] She remained among the top exhibitors throughout the years of the Seattle Camera Club.

Frank Kunishige's work was quite different than most of the other club members and was further removed from the traditional Japanese subjects and appearance; much of it was more mysterious and erotic. He was one of the few photographers in the group who was not an amateur. He worked for McBride and also had a studio in his apartment and taught photography. Kunishige stud-ied photography in Chicago and was exposed to European and American art and photography, which may be why he developed a style that incorporated more of

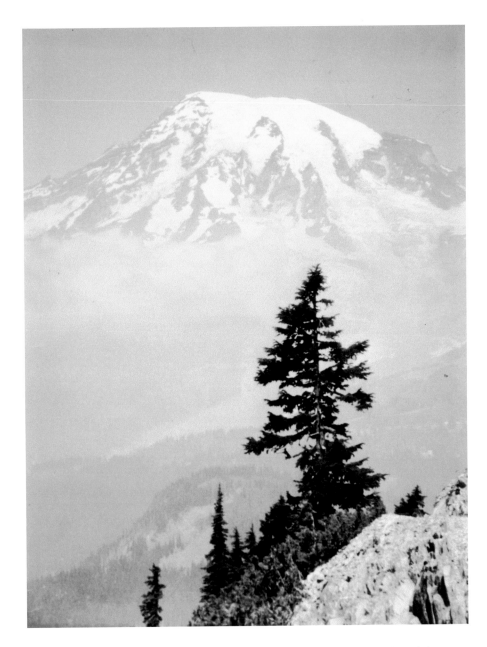

those influences and had less of the "Japanese" decorative effects, although he often placed his subjects in a flat picture plane common to some of the Japanese-influenced work. His photographs were exhibited widely and he was one of the most successful of the camera club members, receiving praise from around the world.

Kunishige was an expert printer and experimented with various types of papers. He often printed on his own paper, Textura Tissue, a thin, delicate printing-out paper, which he sold to other photographers. His information sheet on the paper said, "Textura Tissue Sensitized Tissue Art Paper: A Printing-out Paper of Extremely Luminous Quality," and he listed himself as the "sole manufacturer" for the paper (fig. 14). The paper was very coarse and thin, and prints on this paper appear almost like drawings. Printing-out papers have a wider tonal

FIGURE 14

Textura Tissue printing-out paper made
Frank Kunishige
University of Washington Libraries,
Special Collections, UW29074Z

"Textura Tissue"

SENSITIZED TISSUE ART PAPER

A Printing—Out Paper of Extremely Luminous Quality

DIRECTIONS FOR USE

EXPOSURE

The printing is done in a printing frame under a negative by contacting the sensitized tissue paper and exposing to daylight or strong source of artificial light. The sensitized side of the paper is marked with an (X).

The visible image appears as the exposure proceeds, the print at first assuming a reddish-brown color. This gradually becomes a dark brownish-black in the shadows. The printing should be carried much darker than the desired shade until the high-light is well-tinted, without giving any attention to the shadows, as the print will be somewhat reduced during the subsequent toning operation.

It is advisable to print in the shade outdoors. If the printing is to be done under the direct sunlight, it is advisable to cover the printing frame with one or two sheets of white tissue paper to soften the strong light, especially when a thin negative is being printed, otherwise the contrast may be insufficient.

WASHING AFTER EXPOSURE

After printing, wash the prints in several changes of water for about 5 minutes, then wash them thoroughly under a slow stream of running water. It takes at least 15 minutes for a small (5x7) print. Avoid running the water directly upon the prints as the paper is fragile.

TONING

When the prints are washed, they are toned with "Textura" toning solution which is prepared especially for use with "Textura Tissue" papers. Dilute the solution as directed on the label and tone the print to the desired shade. The print in the toning solution first assumes a reddish blue-brown color and this gradually becomes a warm black. It usually takes 5 to 10 minutes at 65 degrees F. After toning, rinse the prints in a few changes of water.

"Textura" toning solutions are furnished in 2 oz. bottles, to be diluted with distilled water to make 48 oz. 12 oz. of the diluted solution will tone approximately 16 (5x7) prints.

FIXING

Formula:

Water	64 oz.
Hypo	5 oz.
Sodium Carbonate	25 grs.

Dissolve the hypo in 16 oz. of hot water, then add the sodium carbonate. Add cool water to make 64 oz. of fixing solution. Always use a fresh fixing bath.

The fixing should be done for 10 minutes. The temperature of the fixing bath should be the same as that of the toning solution (65 degrees F).

The final washing should be done in a slow stream of running water for at least 15 minutes, changing the water at intervals.

DRYING

Dry the toned prints face up on clean sheets of blotting paper. To shorten the drying time, one may change the blotting paper at intervals. The dried prints are prepared for mounting by ironing out the wrinkles from the reverse side or both sides of the print with a warm iron.

MOUNTING

In mounting the prints, use white paste only. Lay the print face down on the table. Place a clean sheet of paper over the print, leaving ¼ inch along the edge of print where the paste is to be applied, and using this paper to protect the back of the print from smudging with paste, apply the paste along the four edges. Place the print carefully on the mount. In smoothing out the print, do so with a sheet of clean paper over the print to protect the print from danger of surface friction.

F. A. KUNISHIGE

Sole Manufacturer

1712 Jackson Street Made in U. S. A. Seattle, Washington

range than prints made with the developing-out papers used later in the twentieth century. Such prints tend to have a smoother transition through the darkest to lightest tones and look softer than modern prints, which have more definition between the various dark to light grey tones.

Although Kunishige photographed landscapes, portraits, and still lifes, he became more and more interested in working with the human form and the nude. The McBride Studio regularly did the photography for the Cornish School of Allied Arts, which had well-known dancers such as Anna Pavlova, Ruth St. Denis, and Ted Shawn visit and perform. Often, Kunishige, Ella McBride, and Wayne Albee would photograph together at Cornish, making portraits of the same subjects and photographing sets and actors for the plays at the school. Kunishige

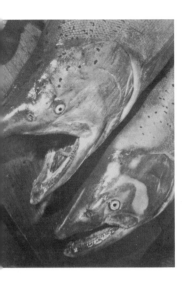

worked with models that were posed nude or draped in diaphanous cloth and made his photographs using controlled lighting to create an evocative mood. He tended to use flat backgrounds and a narrow depth of space. This combined with the coarse Textura Tissue printing-out paper made the subject almost sink into the background, helping to create a sense of mystery. One reviewer said of Kunishige that "a touch of intimacy, eroticism or mystery were ingredients he understood how to handle."[58] He made photographs for literature and poetry that fit with mysterious or erotic themes, such as series of photographs printed in *The Town Crier* with text claiming they were illustrations for "that weird and esoteric allegory, 'The Queen of the Dead,' of the mad mystic, Talhora." One of the captions quoted from the allegory, paired with his photograph of a draped nude figure (p. 140), said, "Silent and luminous, floated from the dark. A face of sorrow. The magic gossamer garment, tenuous as fog, yet strong, impenetrable. Armour it was to guard against the Black Queen's sorcery."[59]

By 1928, the Seattle Camera Club made Seattle a significant force in the world of Pictorial photography. Dr. Kyo Koike wrote, "Our members have tried hard and taken chances. Now we have been able to put the name of Seattle on the map of the world's pictorial photographic field."[60] While the club was gaining accolades on the national and international scene, it had little recognition at home. Historian Shelley Sang-Hee Lee points out that while the club was receiving wide acclaim, Seattle was curiously reluctant to embrace the success of the club, which would have helped build Seattle's desired reputation as a national cultural center.[61] But even as the Seattle Camera Club was receiving worldwide attention in 1928, participation was declining and the members were exhibiting less work. By 1929, the club began to fail, as many members could no longer afford to do photography. Fewer of them brought prints to the meetings and attendance fell. Since many of them worked in low-paying jobs, the bad financial times made it difficult for them to continue with their hobby. The club had its last meeting in October 1929. Yet even as the club said its farewell, the final *Notan* reported that Charles Musgrave was donating the $10 prize he won in the Eastman Kodak Company contest to help the club, and *Shadows on the Snow* by Dr. Kyo Koike and *Sunlight in the Morning* by Kusutora Matsuki (see fig. 9) had won awards in the advanced competition in *Photo-Era* magazine.[62] Ironically, in 1929 the Fort Dearborn Camera Club had named the Seattle Camera Club exhibition one of the best in the world.[63]

Some of the members continued to photograph and exhibit—those like Kunishige and Morinaga, who were photographers by occupation, and Koike and Matsushita, who had enough money to continue. While the club may have disbanded, members' work was still being prominently displayed. In the 1930 Christmas issue of *The Town Crier*, their work was highlighted as the main picture essay of the issue. "Looking through the Lens" noted, "The following photographs are by Seattle Japanese; most of the prints have been hung in salons throughout the world."[64] The article included photographs by Hideo Onishi, Kusutora

Matsuki (who was exhibiting widely by the time the club ended) (fig. 16), Yukio Morinaga, Frank Kunishige (two prints), and Dr. Kyo Koike. In an interesting twist, farther back in the issue were three photographs by Imogen Cunningham, illustrating an article called "The Camera Goes Modern," which compared her Modernist work to that of the Seattle Camera Club.

In the 1930s, Matsushita expanded his photography by also making home movies of trips to Mount Rainier, of Seattle, and of his cats. He intercut views of his photographs into the films along with the live action. He also continued to exhibit his work. For example, during 1933, *Autumn Clouds* (fig. 17) was shown at the Salón Internacional d'Art Fotographic in Barcelona, the Third International Salon of Photography in San Diego, the Preston Scientific Society International Photographic Exhibition, and the Camera Club of Syracuse. Kunishige continued to run his studio, exhibit, jury photography shows, and teach photography. He went to Japan for a year, where he was offered an opportunity to do photography, but he returned to the United States because he and his wife did not like Japan.[65] Ella McBride continued to operate her studio but soon stopped doing her own personal work. Hideo Onishi also continued to exhibit his photographs but eventually returned to Japan in the 1930s, where his work may have been lost during the war. Hiromu Kira left for California and continued to photograph there. But their world changed drastically on December 7, 1941, when the Japanese attacked Pearl Harbor.

On that day, some hours after the attack on Pearl Harbor, two FBI agents came to Iwao Matsushita's home, arrested him, and confiscated papers, letters, miscellaneous written materials, as well as his reels of home movies.[66] Iwao and his wife, Hanaye, had never been separated, and it would be more than two years before they would see each other again. Unknown to Matsushita and other Japanese, the FBI had been building dossiers on the Japanese community. Matsushita had been put on a surveillance list because he worked for a Japanese trading company with offices in Tokyo and because he was an intellectual and a language teacher. The fact that he was a teacher, bilingual, and a member of Japanese organizations such as the haiku club identified him as a community leader whose loyalty was suspect. He also had been marked by some members of the Japanese community, who accused him of being in the pay of the Japanese government. These accusations were never substantiated but were accepted as fact by the U.S. government.[67] By December 18, he was on his way to a detention holding camp in Fort Missoula, Montana, as a dangerous alien, while the government decided what to do with him.

On December 9, 1941, Dr. Kyo Koike turned his camera over to the Seattle Police Department to comply with the federal order for enemy aliens to turn in their radios and cameras because they might be used for spying.[68] By March 30, 1942, it became officially illegal for any Japanese to have a camera. Later in April, as evacuations of the Japanese began in Seattle, Matsushita's wife, Hanaye, was

FIGURE 16
KUSUTORA MATSUKI
The Express as printed in *The Town Crier*,
December 1930
University of Washington Libraries,
Special Collections, UW29034Z

sent to the Puyallup Assembly Center, known as Camp Harmony. Matsushita's
Italian landlord offered to store the family's possessions. Koike, whose residence
was outside the targeted areas to be evacuated, offered to be evacuated also and
went along to be with Hanaye. She and Koike eventually were placed in Minidoka
along with Morinaga, Kunishige, and other Japanese Americans from Seattle.

Hanaye Matsushita was devastated to be separated from Iwao. Both she
and Koike wrote to him almost weekly. Koike and Matsushita discussed Hanaye's
health and also talked about their creative outlets—their interest in haiku and
other arts. "You must have some spare time now to read books," Matsushita wrote
to Koike. "Our haiku group are all scattered and we have no meeting but I still
compose sometimes."[69] When the detainees at Fort Missoula took up shaping
stones as a creative outlet, Matsushita wrote to Koike that he had "stone fever":
"I have been spending every day by doing some stone work.... You can't

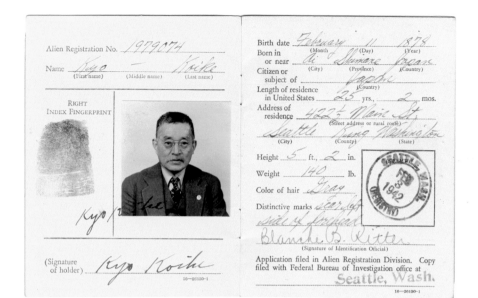

FIGURE 18

Dr. Kyo Koike's alien registration card, 19[]
University of Washington Libraries,
Special Collections, UW29077Z

imagine how all detainees spend every day from morning to bedtime, working on stones. Some are grinding, some are polishing them, and some are even making flower vases and suiban (water basin) with stones & cement."[70] Koike in turn sent Matsushita a cane made from greasewood that he made in Minidoka. Matsushita commented that all of them, including the guards, were amazed at the wood.[71]

Matsushita often spoke in his letters of the mountains that he could see from the camp: "The mountain slopes which confront us have crazy quilt pattern of emerald green, rustic brown, tilled black soil. I wish I could hike on trails which I can see very clearly on the mountain side."[72] Sometime later, the guards at the camp took a group on a climbing trip to the mountains. Matsushita wrote to Koike, "You probably read my letters to my wife about mountain climbings. It was my pipe dream to stand on the top of mountains, surrounding us, but my dream came true, thanks to the kindness of officers here. But how I wish I were with you and enjoy the Snake River scenery together!"[73]

Matsushita taught English in the camp and served as the camp mayor. As time passed, the number of internees at Fort Missoula dwindled to twenty-eight as they were cleared to be transferred to Minidoka and other camps; but Matsushita's requests to go to Minidoka were denied. He continued to apply to be moved to be with his wife, who was nervous and ill. At one point he wrote to his wife, "You, as well as a host of others, know that I haven't done anything that would harm America. I stand before God innocent of all guilt.... The fact that I couldn't be released to Minidoka may be God's divine will, and we won't know whether it'll be for the best until later. ...The reason for my internment, according to the Attorney General, was that I was 'potentially dangerous to the public safety.' I am keenly disappointed that the sincerity of my love of America in my appeal had not been accepted."[74] It was not until January 11, 1944, that he was finally paroled to Minidoka, where he was reunited with his wife and his friends

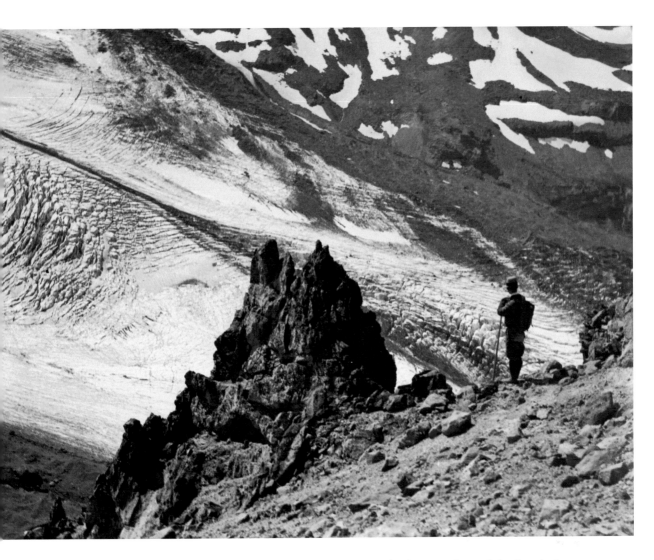

[FIG]URE 19
[TOSHI]O MATSUSHITA
[Un]titled, n.d
[gel]atin silver print
[...] × 9 3/4 in.
[Uni]versity of Washington Libraries,
[Spe]cial Collections, UW29075Z

Koike, Kunishige, and Morinaga, and other members of the Seattle Japanese American community.

Minidoka had an Outside Employment Office, which received offers of jobs outside the camp and procured approvals for residents to leave the camp to work. While he was at Minidoka, Frank Kunishige was able to go to work for The Album, a photography studio in Twin Falls, Idaho. The Album studio advertised in the *Minidoka Interlude, September 1942–October 1943* yearbook put out by the Minidoka residents, so Kunishige may have been working there by then. John Harrington Edwards, who supplied letters of recommendation for Gin Kunishige and Frank's cousin, Tomoko, to work for families in Twin Falls, kept the Kunishiges' possessions, which they finally had sent to Idaho in March 1945. Kunishige must have found part of the community welcoming, because he was invited to show his photographs to the 20th Century Club in July 1945. An article in the *Twin Falls (ID) Telegram* of July 16, 1945, "Exhibit of Internationally Known Photographer Here," reported, "Mr. Kunishige who has had a photo studio in Seattle for 30 years has resided in Twin Falls during the past two and a half years. . . . A noted artist has made this statement of the photographer and his work: 'Frank Kunishige's name

is Japanese, but his pictures are American.' "[75] Apparently at this point, a Japanese American photographer's work could be finally said to be "American."

By 1943, some Nisei (American-born children of Japanese immigrants), such as students who were attending colleges away from the West Coast and those who joined the army, were allowed to leave the camps. Others were permitted to leave over time. After a "presettlement" interview in May 1944, Iwao and Hanaye Matsushita decided to wait to resettle because Japanese Americans were not allowed back to the West Coast yet and they wanted to return to Seattle. As the war ended, Iwao, who had no employment prospects, applied for a position in the War Relocation Authority (WRA) to help returning Japanese Americans with various problems of resettling, such as housing, employment, medical issues, and discrimination.[76] He returned to Seattle in August 1945, leaving Hanaye behind at Minidoka while he stayed in the WRA lodging. The housing market was very difficult for the returning Japanese Americans, whose homes had been taken over by whites, African Americans, and Filipinos who had moved into the Japanese district.[77] Lack of housing and hostility to the returning Nikkei (those of Japanese descent) made it difficult to find places to live. Even Iwao, who was there to help others with resettlement, could not find a home and had to leave Hanaye at Minidoka until October 1945, when he finally was able to rent a home for them.

Dr. Kyo Koike's time in the camp seems to have affected him greatly. When interned in Camp Harmony before the move to Minidoka, Hanaye wrote to Iwao that Koike "walks round in a daze"; and Koike wrote to Iwao that "our daily life is like the floating cloud, moving aimlessly in the mercy of various winds."[78] Although his work as a doctor in the camp helped to ground him, one wonders if he ever truly recovered from the experience. He returned to Seattle and opened his medical office again but never was the same. At age seventy, he was outside in his beloved nature, picking ferns on March 31, 1947, when he collapsed. Matsushita was called to the hospital where Koike was dying and in Koike's pocket he found forty-five specimens of the fern called *sawarabi* in Japanese. In honor of this, the Rainier Ginsha haiku group published a memorial book for Koike titled *Sawarabi*.[79] All of his work was left to his friend Matsushita, who buried his ashes as he desired under a large tree on Mount Rainier, Koike's "holy mountain."

After the war, Yukio Morinaga was cared for by Virna Haffer but never really recovered from his experience.[80] Many of the other members of the Seattle Camera Club might have had similar feelings or experiences. During the war, photography was associated with anti-American activities, so during or after the war many of the West Coast Japanese American photographers hid their work or never showed it publicly again.[81] For many of these photographers, even their children and grandchildren were unaware of their achievements.[82] Their work and contributions to the photographic field were bypassed as Pictorial imagery faded as a popular photographic style. The Modernist sharp-focus documentary

FIGURE 20

P. KYO KOIKE
Weeping Day, ca. 1930
Gelatin silver print
8 × 9 7/8 in.
University of Washington Libraries,
Special Collections, UW29076Z

style of photography dominated the art world in the decades after the 1920s, and over time Pictorial photography came to be regarded outmoded and uninspired.[83] Hiromu Kira, one of the most successful members of the Seattle Camera Club who had moved to Los Angeles, never went back to photography after he was interned. Dennis Reed, having interviewed Kira about why, explained that "color photography had come in; it was too prominent after the war and he wasn't interested."[84] It seems possible that, in addition to lack of interest in the changing technology, Kira felt out of step with the change from the subtle tonalities expressed with the matt printing-out papers used in Pictorial photography. These had been replaced with the higher contrast tones and sharp gloss of the developing-out papers that were suited to Modernist photography, with its emphasis on documentary rather than expressive work.

By May 1946, Iwao Matsushita was fifty-four years old and out of a job as his WRA employment came to an end. In 1927, Matsushita had pioneered the first Japanese-language course at the University of Washington through the urging of his friend Eldon Griffin, a professor in the Department of Oriental Studies. Griffin, who had remained supportive throughout the war years, again came to his aid and helped him get a job teaching Japanese at the university.

Matsushita spent a number of years teaching Japanese-language courses until he was offered a job as a subject specialist for the university's Far Eastern Library. He also offered his skills to the Japanese community by teaching Japanese to young students at the reopened Seattle Japanese Language School.[85] In 1954, after thirty-five years in the United States, he was naturalized and became an American citizen.

During the internment, Hanaye Matsushita had many health and emotional problems, and she never seemed to recover from her experience. She continued to have problems with her health and finally died on February 3, 1965, leaving Iwao alone after forty-six years of marriage. Over the years, the Matsushitas had remained close friends with Frank Kunishige and his wife, Gin. Frank, who was also in poor health after the war, died in 1960. After Hanaye's death, Iwao decided to visit Japan for the first time since he left there in 1919, so in 1966 he took a tour around the world, ending up in Japan. One of the people on his tour was Gin Kunishige, and in June 1967 the two were married.

Matsushita had kept both his and Koike's photographs and negatives, the complete set of *Notan*, various publications with Koike's writings, copies of show announcements, awards, and other documentation of the Seattle Camera Club and its activities, along with the letters that Hanaye, Iwao, Koike, and others had written while in the internment camps. Now the work of three members of the club came together in one household. (Also within the collection were photographs by other club members along with work by other noted Pictorialists that Koike and Matsushita had collected during the camera club era.) Together, Iwao and Gin had a substantial collection of the Seattle Camera Club's work and a detailed record of the group's achievements.

As an intellectual, Matsushita was aware of the value of libraries and archives. He donated about 500 books in English and Japanese to the University of Washington Library in the late 1960s and followed that with a donation of 964 books in 1969.[86] Matsushita became friendly with Robert Monroe, head of University of Washington Libraries, Special Collections. In the early 1960s, photographs were still seen as peripheral to the "more important" collections of books and papers in historical archives, but Monroe had come to realize the value of photos.[87] He became a serious advocate for the photography collections and worked actively to add to the holdings in the archive by building relationships with antiquarian dealers and descendents of early Seattle photographers. "Lots of old time photographers have died and their photos are no longer thought of as valuable," he told a Seattle newspaper. "Once the person is gone, others throw the photos away, burn them or neglect them."[88] Monroe realized that the then-current practices of handling photograph collections by dismantling them were not useful for understanding the information contained in the photographs. In 1964, he wrote that the "old practice of distributing all photographs in subject folders" was not the way to keep photograph collections, and he began to "maintain significant collections separately" by keeping them together as a unit.[89] During that

time, a number of important collections were acquired by Monroe and were kept together as collections rather than split apart; he saw that they had importance beyond the individual subjects of the pictures.[90] Monroe was ahead of his time in regarding photographs as important to collect and in seeing that they had value apart from their relationship to manuscript and book materials.

Monroe was also interested in collecting both the work of minority and of artistic photographers for the archive, which was unusual for the time. He had become particularly interested in the Japanese immigrant photographers who lived in the Puget Sound area, so he asked Iwao Matsushita if he would consider donating some of the Seattle Camera Club photographs to Special Collections. Not only was it unusual for an archivist or librarian to have such a high regard for photography during this time, but it was even more unusual for one to be interested in a collection of art photography. During this era, museums were collecting and showing "straight," or Modernist, photography, which emphasized sharp focus and presenting the world "as it is," and there was little interest in collecting Pictorial photography. Monroe saw something important in preserving the Seattle Camera Club work. He was aware of its aesthetic value, something usually overlooked when photography collections are in libraries. Most archives would not have considered the club photographs as having "historical" value because the camera club work was personal rather than documentary. Many years after Robert Monroe retired, some of Ella McBride's prizewinning Seattle Camera Club prints were offered to Special Collections, but the donation was turned down because the prints were "art."

Monroe's interest convinced Iwao Matsushita that the Special Collections archive might be a good home for the Seattle Camera Club work. Iwao and Gin gave Frank Kunishige's work to the library in 1970. Monroe understood that accepting this gift was a major shift in the focus for the photography collection, and he later wrote in a report on the gift that "the Kunishige collection represents the first purely creative and decorative photographs added to the University Library collection which previously was limited to the work of documentalists."[91] Matsushita was pleased with Monroe's response to Kunishige's work and then donated some of Dr. Kyo Koike's photographs to the collection. After receiving the donation of prints, Monroe wrote to Matsushita, "The thing of the greatest interest to me now would be to learn whether any of either man's negatives are preserved—do you know? If there are any negatives to be found, I should like to have them too."[92]

Monroe continued to show interest in the Seattle Camera Club and, along with the photography, University of Washington libraries acquired the writings by Koike and others, copies of *Notan* and other photography magazines from the camera club era, and a large amount of correspondence with Koike and Kunishige and others. Matsushita even had the silver trophies won by Koike for his photography. All in all, it was a substantial record of the club and its activities. Eventually,

Matsushita donated all of his own papers, prints, and negatives, which also included the reels of 8mm home movies of his cats, outings on Mount Rainier, and scenes around Seattle that the FBI had confiscated and returned. Thus the work of Frank Kunishige, Dr. Kyo Koike, and Iwao Matsushita (along with a few photographs by other Seattle Camera Club members collected by Koike and Matsushita and photographs by other Pictorial photographers from around the world) came to the University of Washington Libraries. The papers and writings contained the only record of some of the Seattle Camera Club photographers.

Through the collaboration of Robert Monroe and Iwao Matsushita, the Seattle Camera Club history came to be preserved for future generations. As Koike had written in 1925, "Now we are all Japanese living in America. You can see it is clear what the members of the Seattle Camera Club should do for the advancement of photographic art. Yes, we must be the best interpreters for both nations, because we are not free of Japanese ideas and yet at the same time we understand Western ways. We should not make our pictures aimlessly, but must try hard to combine both ideas, in other words stick to our peculiar point of view. To add something new and valuable to the photographic circle is not a bad plan."[93]

FIGURE 21 (RIGHT)
DR. KYO KOIKE
The Serpent, ca. 1930
Gelatin silver print
9 ¾ × 6 ¾ in.
University of Washington Libraries,
Special Collections, UW29066Z

NOTES

1 Dennis Reed, *Japanese Photography in America, 1920–1940*, exhibit folder (New York: Whitney Museum of American Art at Equitable Center, 1988), n.p.

2 Letter from Mr. Edwin Franklin Dreher, *Notan*, April 12, 1929, p. 10.

3 Frank R. Fraprie, "Our Illustrations," in *The American Annual of Photography* (1928), 136.

4 As Reed made hundreds of telephone calls to try to locate relatives of the photographers, he often had to overcome suspicion about his motives or family ignorance that their relative had ever been a photographer. Abby Wasserman, "Restoring a Lost Legacy: Japanese Photography in America," *Museum of California Magazine* (January–February 1988): 8.

5 In discussing the work of the San Francisco Camera Club members, Dennis Reed says, "So few prints exist that no general assessment of their work is possible." Dennis Reed, *Japanese Photography in America, 1920–1940* (Los Angeles: Japanese American Cultural and Community Center, 1985), 31.

6 Wasserman, "Restoring a Lost Legacy," 4.

7 This fear was even more widespread than just among the West Coast Japanese photographers. Soichi Sunami, who exhibited with the Seattle Camera Club, burned a number of his works even though he was living in New York and not subject to internment. See Soichi Sunami's biography in the appendix of this book.

8 In another case, all the work of Los Angeles photographer T. Mukai, which had been left on his family's property, was lost when the home was destroyed by arson before he returned from internment. Wasserman, "Restoring a Lost Legacy," 8.

9 Ibid., 4.

10 Sandra Kroupa, "Robert Monroe, Head, Special Collections University of Washington Libraries, May 1963–October 1980," April 18, 2008 (in author's possession). Robert Monroe hired Sandra Kroupa in 1968. She worked with him in University of Washington Special Collections until his retirement in 1980, and they remained friends until his death.

11 Robert Monroe, "Light and Shade: Pictorial Photography in Seattle, 1920–1940, and the Seattle Camera Club," in *Turning Shadows into Light: Art and Culture of the Northwest's Early Asian/Pacific*

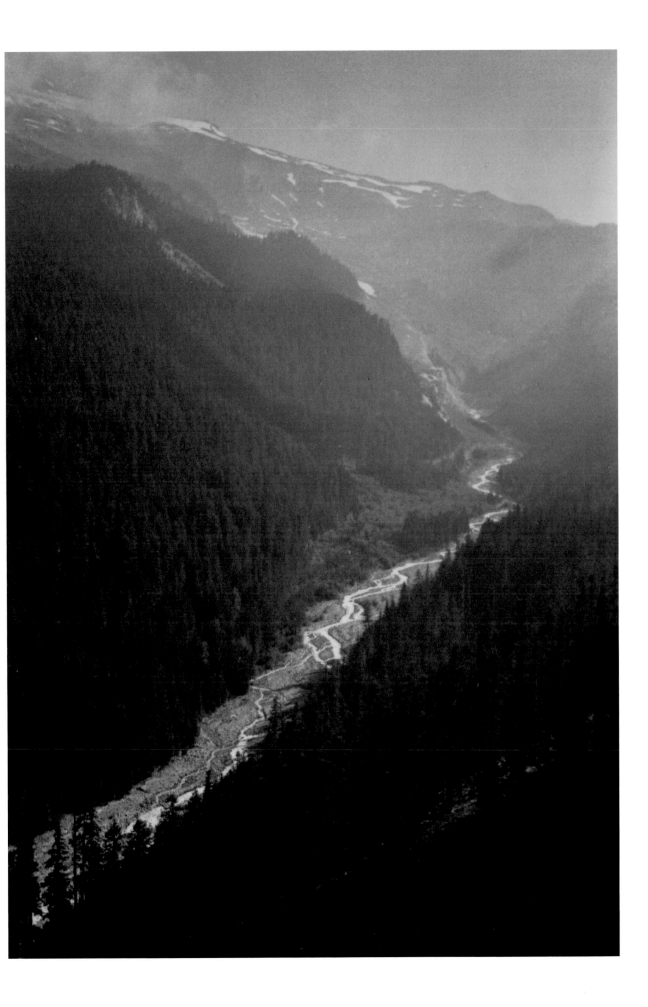

Community, ed. Mayumi Tsutakana and Alan Chong Lau (Seattle: Young Pine Press and Asian Multi-Media Center, 1982), 12.

12 Boye De Mente, *Elements of Japanese Design* (North Clarendon, VT: Tuttle Publishing, 2006), xv.

13 Shelley Sang-Hee Lee, " 'Good American Subjects Done through Japanese Eyes,' Race, Nationality, and the Seattle Camera Club, 1924–1929," *Pacific Northwest Quarterly* 96, no. 1 (Winter 2004–5): 29.

14 Kyo Koike, "The Seattle Camera Club," *Photo-Era* 55, no. 4 (October 1925): 182.

15 Manuscript by Shin-ichi Koike, Kyo Koike's grandson, written in 2007 and translated by Midori Koike Barbut (in author's possession).

16 Shuji Koike, Kyo Koike's grandson, conversation with the author, at University of Washington Libraries, Special Collections, July 2, 2007. Kyo Koike is reported to have said to his son, who visited him in Seattle in 1925, that there was no other woman like her (his wife) around him, which would explain why he never remarried. Manuscript by Shin-ichi Koike, written in 2007 and translated by Midori Koike Barbut (in author's possession).

17 Shuji Koike, conversation with the author, at University of Washington Libraries, Special Collections, June 21, 2010.

18 Iwao Matsushita, untitled biography of Kyo Koike, typescript, June 15, 1970, Box 15, Iwao Matsushita Papers, Acc. 2718, University of Washington Libraries, Special Collections (hereafter, Matsushita Papers).

19 Louis Fiset, *Imprisoned Apart: The World War II Correspondence of an Issei Couple* (Seattle: University of Washington Press, 1997), 4–5, 8–9.

20 Shuji Koike, conversation with the author, at University of Washington Libraries, Special Collections, June 22, 2010.

21 Matsushita wrote that he and Koike saw each other every day. Iwao Matsushita to Shin-ichi Koike, January 13, 1975 (copy in author's possession).

22 Kyo Koike, "Why I Am a Pictorial Photographer," *Photo-Era* 61, no. 3 (September 1928): 123.

23 Ibid.

24 This is based on the fact that there are notes on the backs of Matsushita's prints about the paper types he used and on his still-life photograph of developing chemicals.

25 Reed, *Japanese Photography in America*, 65.

26 Koike mentions his work that was included in the 1920 Frederick & Nelson Salon in his *Photo-Era* article, "Why I Am a Pictorial Photographer," 124.

27 Article VI of "Rules of the Seattle Camera Club," published in *Notan*, March 13, 1925.

28 Monroe, "Light and Shade," 12. There is some discrepancy in the number of charter members; *Notan*, the bulletin of the club, gives the number as higher. Robert Monroe's list of the charter members of the Seattle Camera Club includes: J. Amano, R. Azuma, Y. Chiba, M. Fujita, I. Higashiyama, S. Hirano, Y. Idzumi, H. Ihashi, Y. T. Iwasaki, T. Kashiwagi, H. Kira, K. Koike, K. Koitabashi, T. Koiwai, F. Kunishige, T. Matsubara, M. Matsumoto, I. Matsushita, T. Miyauchi, T. Miyazaki, Y. Morinaga, S. Nagakura, M. Nakamura, S. Nezu, S. Nimomiya, F. Ogasawara, H. Okita, S. Okugawa, H. Onishi, B. Sakaino, R. Sato, R. Sawaji, T. Shigeta, T. Shimoda, Z. Shimomura, S. Tada, R. Tamura, I. Tanaka, and S. Toda.

29 Monroe, "Light and Shade," 9–10.

30 Wasserman, "Restoring a Lost Legacy," 7.

31 Kyo Koike, "My Photographic Trip," *The Miniature Camera* (April 1934): 129.

32 Lee, " 'Good American Subjects Done through Japanese Eyes,' " 31.

33 Ibid., 30.

34 *Notan*, April 29, 1926.

35 Wasserman, "Restoring a Lost Legacy," 5.

36 Reed, *Japanese Photography in America*, exhibit folder, n.p.

37 Koike, "Why I Am a Pictorial Photographer," 123.

38 Hoshin Kuroda, "The Characteristics of Japanese Art," trans. Kyo Koike, *Notan*, March 11, 1927.

39 Kyo Koike, "Japanese Art in Photography," *Camera Craft* 32, no. 3 (March 1925): 112.

40 Kyo Koike, "Pictorial Photography from a Japanese Standpoint," *The Ground Glass* 7, no. 6 (October 1925): 5.

41 Kazuko Nakane and Alan Chong Lau, "Shade and Shadow: An Asian American Vision behind Northwest Lenses," *International Examiner*, January 23, 1991, p. 7.

42 Arthur Wesley Dow, *Composition: Understanding Line, Notan and Color* (Mineola, NY: Dover, 2007), 53, republication of *Composition: A Series of Exercises in Art Structure for the Use of Students and Teachers*, 9th ed. (New York: Doubleday, Page and Co., 1920).

43 *Photo-Era* (November 13, 1925): 186.

44 Koike, "Seattle Camera Club," 182.

45 David Martin, conversation with the author, at University of Washington Libraries, Special Collections, 2007.

46 Walter B. Pitkin, *Careers after Forty* (New York: Whittlesey House, 1937), 217.

47 David Martin, conversation with the author, at University of Washington Libraries, Special Collections, 2007.

48 David F. Martin, "McBride, Ella E. (1862–1965)," HistoryLink.org, http://historylink.org/index.cfm?DisplayPage=output.cfm&file_id=8513.

49 Lee, " 'Good American Subjects Done through Japanese Eyes,' " 25.

50 David F. Martin, *Pioneer Women Photographers* (Seattle: Frye Art Museum, 2002), 16.

51 *Notan*, November 12, 1926, and *Notan*, December 10, 1926.

52 Lee, " 'Good American Subjects Done through Japanese Eyes,' " 25. The January 11, 1929, issue of *Notan* contained this announcement: "Dr. K. Koike, the Chairman of the Seattle Camera Club, was elected an Associate of the Royal Photographic Society of Great Britain, London, England. He is the only Japanese and the only one in the Seattle pictorial circle, to have the honor at least at the present time. . . . H. H. Blacklock, Secretary."

53 Monroe, "Light and Shade," 21.

54 Kyo Koike, "Mount Rainier," *Camera Craft* 33, no. 3 (March 1926): 117.

55 Matsushita's photograph was later shown in the World's Master's Exhibition of the Cardiff Camera Club.

56 Kyo Koike, "Photographing Mountains and Peaks," in *The American Annual of Photography* (1929), 36–40. It is probable that the two figures in the *Sea of Clouds* are Iwao and Hanaye Matsushita. The peak in the distance is Mount Adams.

57 "Fame Travels across Sea to Seattle Artist's Door," *The Star*, October 27, 1925.

58 Robert Monroe and Martha Kingsbury, "The Ritual Life for Frank Kunishige, 1878–1960," undated typescript, F. A. Kunishige, University of Washington Libraries, Special Collections (hereafter, Kunishige File).

59 "Pictorial Photography," *The Town Crier*, December 13, 1924, pp. 26–34. While *The Town Crier* and Kunishige called the allegory "The Queen of the Dead," by Talhora, the magazine apparently was referring to the sixteenth-century publication by Cordova, "The Queen of Death," which the French reviewer in the *Revue du Vrai et du Beau* identified.

60 "To the Seattle Photographers, Amateur, and Professional," *Notan*, March 11, 1927.

61 Lee, " 'Good American Subjects Done through Japanese Eyes,' " 31.

62 "Photographic News," *Notan*, October 11, 1929, the farewell issue, p. 10.

63 *Notan*, March 8, 1929.

64 "Looking through the Lens," *The Town Crier*, December 17, 1930, pp. 9–15.

65 J. H. Edwards, letter "To Whom It May Concern," July 14, 1942, Box 15, Matsushita Papers.

66 Louis Fiset, "In the Matter of Iwao Matsushita: A Government Decision to Intern a Seattle Japanese Enemy Alien in World War II," in *Nikkei in the Pacific Northwest: Japanese Americans and Japanese Canadians in the Twentieth Century*, ed. Louis Fiset and Gail M. Nomura (Seattle: Center for the Study of the Pacific Northwest in association with the University of Washington Press, 2005), 215. Eventually the FBI destroyed the confiscated possessions, except for, oddly enough, the home movies, which were returned to Matsushita in 1945 while he was interned at Minidoka in Idaho.

67 Ibid., 231.

68 *Seattle Post-Intelligencer*, December 9, 1941.

69 Iwao Matsushita to Kyo Koike, Oct 17, 1942, Box 15, Matsushita Papers.

70 Matsushita to Koike, July 14, 1942, Box 15, Matsushita Papers.

71 Matsushita to Koike, January 8, 1943, Box 15, Matsushita Papers.

72 Matsushita to Koike, July 14, 1942, Box 15, Matsushita Papers.

73 Matsushita to Koike, October 17, 1942, Box 15, Matsushita Papers.

74 Quoted in Fiset, *Imprisoned Apart*, 213–14.

75 *Twin Falls (ID) Telegram*, July 16, 1945, p. 5.

76 Fiset, *Imprisoned Apart*, 86.

77 Ibid., 88.

78 Quoted in ibid., 65.

79 Iwao Matsushita to Shin-ichi Koike, January 13, 1975 (in author's possession).

80 David Martin, conversation with the author, at University of Washington Libraries, Special Collections, 2007.

81 Wasserman, in "Restoring a Lost Legacy," describes the difficulty that Dennis Reed had in 1988 persuading a family to allow him even to see beautiful work made by a man who died in 1941. The family was suspicious about why he would want to see work that had been hidden away and was reluctant at first to let him use it in the exhibition.

82 Wasserman, "Restoring a Lost Legacy," 8.

83 There are many discussions of Pictorialism as being out of date, as the form became greatly devalued in the photographic art world from the 1930s on. A statement from a book on the photographer Olive Cotton, who started out working in the Pictorial and moved on to the modern style, sums up the case against Pictorialism: "In Australian photographic history, the 1930s are characterized by the demise of Pictorialism (a movement known colloquially as the 'fuzzy wuzzy school' that had been dominant in photography circles since the early 1900s) and the rise of modernism. Pictorialist work is invariably devalued in this scenario, considered to be out-of-step with the realities of modern life. The Beauty of the new age, wrote G. H. Saxon Mills in 1931, 'is only for those who themselves are aware of the "zeitgeist"—who belong consciously and proudly to this age, and have not their eyes forever wistfully fixed on the past.' " Helen Ennis, *Olive Cotton: Photographer* (Canberra: National Library of Australia, 1995), 8.

84 Wasserman, "Restoring a Lost Legacy," 6.

85 Fiset, *Imprisoned Apart*, 90–93.

86 Matsushita to Kenneth Allen, February 20, 1970, Box 2, Matsushita Papers.

87 Before the 1980s, very few archives had dedicated positions responsible for photography collections. Most archivists or librarians who managed such collections were trained to handle textual materials such as books and papers or were historians but were not experts in photography.

88 "Koike: Immigrant's Photos Hint at What Was Lost," *Seattle Post-Intelligencer*, April, 10, 1980.

89 Kroupa, "Robert Monroe."

90 Ibid.

91 Robert D. Monroe typescript, n.d., Kunishige File.

92 Robert Monroe to Iwao Matsushita, August 25, 1970, Box 2, Matsushita Papers.

93 Koike, "Seattle Camera Club," 188.

PLATES AND ARTIST BIOGRAPHIES

WAYNE ALBEE
1882–1937

SOICHI SUNAMI
Wayne Albee, 1921
Scanned from the original glass plate negative
Collection of the Soichi Sunami estate

He is a poet of lines, a musician of tone values, a painter with the camera, and a pictorial photographer whether he is found in his professional or avocationary capacity.

—Sigismund Blumann, in *Camera Craft* (1929)

WAYNE CLINTON ALBEE was born in St. Paul, Minnesota, the son of William C. and Ida E. Albee. At the age of six, he moved with his parents to Tacoma, Washington, where he attended local schools. His interest in photography began early in his youth, primarily as a hobby until he reached the age of sixteen, when he began a more serious study in the field of portraiture. Around this time, Albee worked in the photographic supply store of Byron Harmon (1876–1942), who relocated to Banff in 1903 and became an important photographer of the Canadian Rockies.

In 1900, at the age of eighteen, Albee produced a small book titled *Characters of Evangeline* using his mother's paraphrased text derived from the Longfellow poem *Evangeline* and accompanied by his artistic photographs. By 1902, Albee had begun his professional career as a studio photographer in Tacoma while simultaneously developing his skill as a Pictorialist. As a member of the Photographers Association of the Pacific Northwest, his award-winning photograph *The Bubble* was reproduced in the January 1908 issue of *Camera Craft*. His work was consistently mentioned or reproduced in various national publications thereafter. In 1915, he was awarded the substantial amount of $450 for winning second prize in the national *Camera Craft* competition called America's Loveliest Women. He won an additional $100 for winning sixth prize as well. In 1911, he relocated and expanded his Tacoma studio, renaming it Ye Likeness Shop, which remained in operation until 1916. The following year, Albee moved to Seattle and operated a short-lived studio at 706 Pike Street until 1918, when he went into partnership with Ella McBride. McBride told the *Seattle Post-Intelligencer* in 1962 that she "got the photographic fever from him," crediting Albee for her passionate interest and success in the medium even though she had been close to photographer Edward S. Curtis since 1897.

Albee became the main photographer associated with the McBride Studio, along with assistants Frank Kunishige and Soichi Sunami. McBride herself had not actually been a photographer when she opened her studio and relied on her associates to teach her the craft. When the studio began working closely with the Cornish School of Allied Arts in Seattle, Albee and the others had access to some of the greatest modern dancers in the world. He produced several successful studies of the famed ballerina Anna Pavlova, who performed in Seattle several times, and as early as 1915. "When Mme. Pavlova comes to Seattle to fill an engagement,"

wrote C. H. Hanford in *Seattle and Environs*, "her manager hastens to the McBride Studio to make an appointment with Wayne Albee. She considers his photographs of her the best she has ever had" (pp. 644–45). One of these studies appeared in the British edition of *Vogue* magazine in August 1923. In addition to Pavlova, Albee also produced artistic photographs of other icons of modern dance. These included Adolph Bolm of the Ballet Russes, Doris Humphrey, Ted Shawn, and especially Ruth St. Denis, who commissioned him to photograph her troupe in California.

Albee's high professional standing in the community is evidenced by his serving as chairman and judge for all of the Frederick & Nelson Salons in Seattle from 1920 to 1925. To avoid any conflict of interest, he declined entering his own work, with the exception of the fifth annual in 1924, when he and McBride displayed two photographs, each as a loan exhibit not eligible for competition.

Albee was honored with a solo exhibition at the Seattle Fine Arts Society in March 1922, just two months after his *Portrait of a Player* received the fourth-place award in a national competition sponsored by *American Photography* magazine. That same year, his work was included in the annual of the Pictorial Photographers of America, the noted organization based in New York.

Albee was a regular exhibitor in numerous important photographic Salons, and his work was reproduced in several publications before the formation of the Seattle Camera Club (SCC) in 1924. On January 28, 1928, the SCC held a farewell party for Albee before his move to first LaJolla, California, and the following year to San Diego. Although he was an ardent supporter of the SCC, it is not known if he ever became a formal member, and he only exhibited with the club one time, in 1929. Following a short-lived but highly respected career in California, he died in his sleep on December 1, 1937. In the *San Diego Union*, Sigismund Blumann eulogized Albee as "extremely sensitive and so modest that it has been difficult to learn of many of his important accomplishments. His place in photography demands attention." After his untimely death, Albee's photographs were scattered among the few relatives who survived him. He was an only child and never married.

Albee's works are in the collection of Cornish College of the Arts, Seattle; University of Washington Libraries, Special Collections, Seattle; New York Public Library, Jerome Robbins Dance Division; Washington State Historical Museum, Tacoma; J. Willard Marriott Library, Manuscripts Division, University of Utah, Salt Lake City. The San Diego Museum of Art once held a large collection of Albee's photographs, but they were deaccessioned and sold at public auction in 1980.

Albee produced numerous photographs for Washington State publications, including three major series for *The Town Crier*: "The Rubaiyat," December 13, 1924, pp. 17–25; "The Kings, an Interpretative Study of the Artist," a tribute to the poet Louise Imogen Guine, December 11, 1926, pp. 17–22; and "Camera Studies by Wayne Albee," December 14, 1929.

SOURCES

CORRESPONDENCE

Judith Kipp, Tacoma Public Library, to author, concerning the list of Albee's studios in
 Tacoma, July 29, 1999.

ARTICLES AND BOOKS

American Photography 16, no. 1 (January 1922): 214–15.

Bailey, Madge. "Fine Art Notes." *Seattle Post-Intelligencer*, November 7, 1920, pt. 6, p. 3.

Blumann, Sigismund. "Camera Artist Succumbs; Rites Set Tomorrow." *San Diego Union*,
 December 3, 1937, p. B12

————. "Wayne Albee, Professional Pictorialist." *Camera Craft* 36, no 2 (February 1929): 51–61.

Camera Craft 15, no. 1 (January 1908): 379.

Hanford, C. H. *Seattle and Environs, 1852–1924.* Vol. 1. Seattle: Pioneer Historical Publishing Co.,
 1924.

Pictorial Photography in America. Vol. 3. New York: Pictorial Photographers of America, 1922.

Portrait Magazine 6, no. 11 (March 1915): 1, 4.

San Diego Union, "Friends Eulogize Wayne Albee as Rites Held Monday Morning," December 6,
 1937.

Sealth, 1921, Broadway High School, vol. 18. Seattle Collection, The Seattle Public Library.

Seattle Post-Intelligencer, "She's Halfway There: Teacher, Photographer Wants to Live to 200,"
 November 15, 1962, p. 3.

Tacoma Times, "Wayne C. Albee Dies in California," December 4, 1937, p. 12.

The Town Crier, December 15, 1923, p. 53.

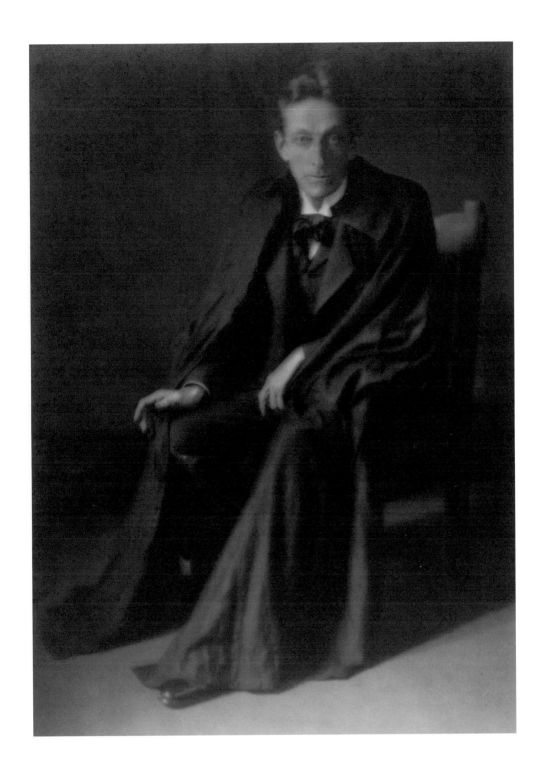

WAYNE ALBEE

Sir Johnston Forbes-Robertson, ca. 1914
Gelatin silver print
10 3/4 × 7 3/4 in.
Collection of the Washington State
Historical Society, gift of the Virna Haffer
estate

Sir Johnston Forbes-Robertson (1853–1937)
was a prominent English stage actor who
was considered the finest Hamlet of his
generation.

WAYNE ALBEE

Untitled, ca. 1918
Gelatin silver print
9 × 6 ¾ in.
Collection of the Soichi Sunami estate

90

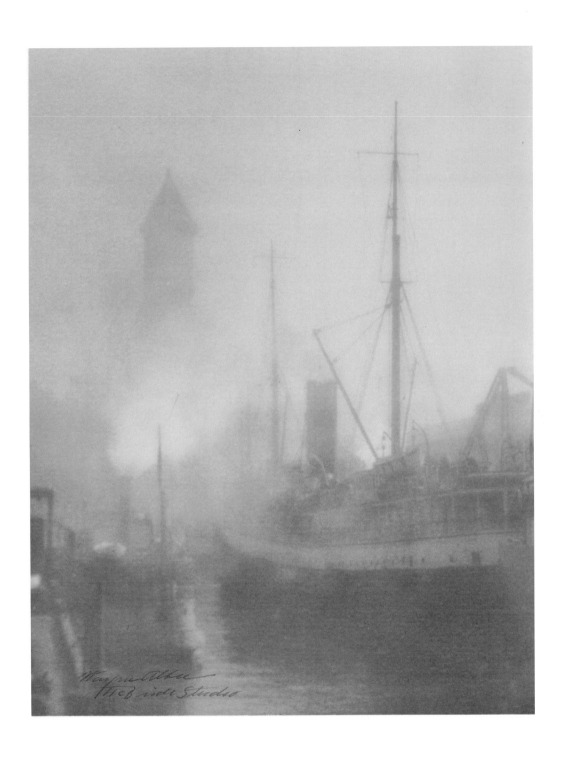

WAYNE ALBEE

Untitled, ca. 1918
Gelatin silver print
12 × 9 ½ in.
Collection of Lindsey and Carolyn
Echelbarger

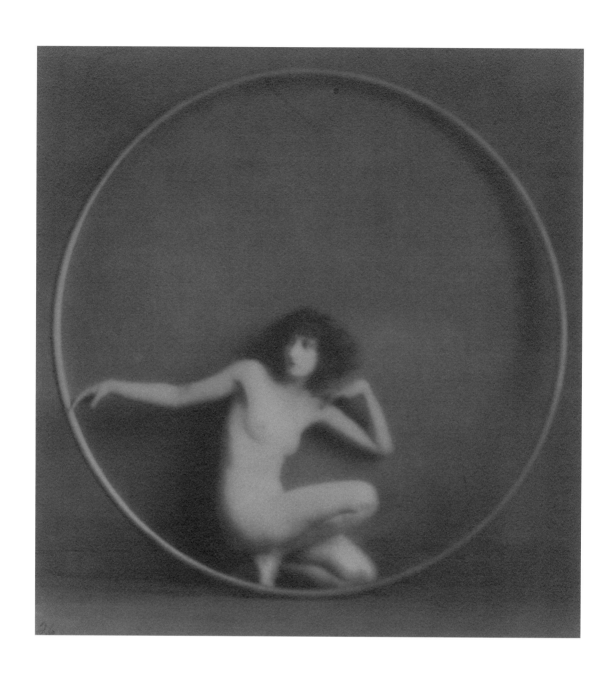

WAYNE ALBEE

Untitled (Doris Humphrey), 1924
Gelatin silver print
7 ¹/₄ × 6 ¹⁵/₁₆ in.
New York Public Library for the Performing
Arts, Jerome Robbins Dance Division

Doris Humphrey (1895–1958) was an
American modern-dance pioneer. Albee
photographed her on several occasions. In
this nude study she is posed with the golden
hoop prop from her famous and influential
dance "Scherzo Waltz."

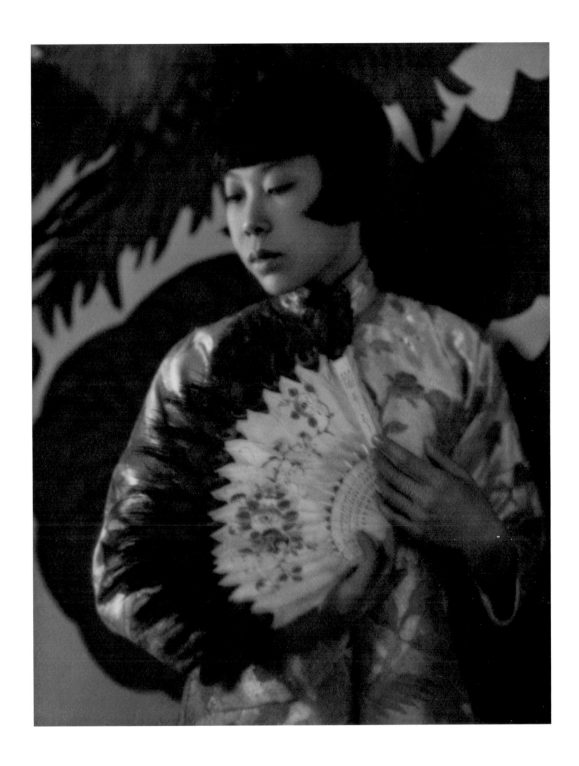

WAYNE ALBEE

The Daughter of Goon Dip, ca. 1922
Gelatin silver print
9 ½ × 7 ½ in.
Private collection

This photograph depicts dancer Lillian
Goon Dip (1905–1975), whose father was
a prominent Seattle businessman and close
friend of Ella McBride.

ALLAN CLARK

Wayne Albee, 1918
Sanguine on paper
17 × 14 in.
Private collection

WAYNE ALBEE

Allan Clark—The Sculptor, ca. 1921
Gelatin silver print
9 5/8 × 7 5/8 in.
Private collection

Allan Clark (1896–1950) was a
prominent American sculptor who,
like his friend Wayne Albee, lived in
Tacoma in his early years. Clark created
the terra cotta sculptures adorning the
University of Washington's Suzzallo
Library and produced a bust of dancer
Anna Pavlova, one of Albee's favored
models.

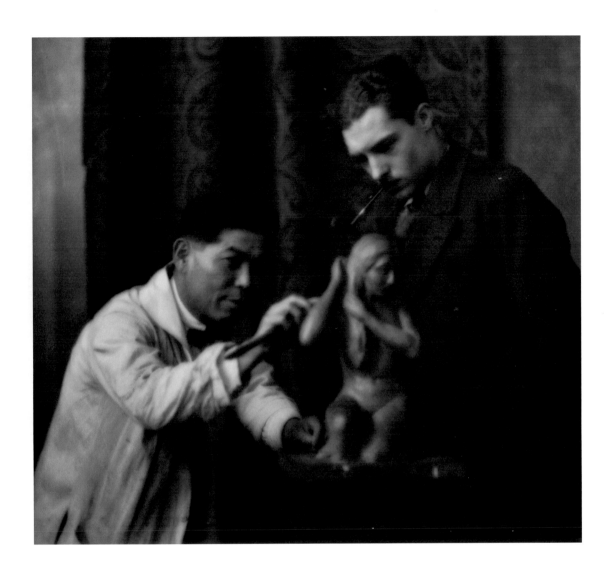

WAYNE ALBEE

Untitled, ca. 1924
Gelatin silver print
6 3/4 × 7 5/8 in.
Private collection

This photograph depicts sculptors Yasuda
Ryumon (1891–1965) and Allan Clark.
Ryumon appears in several works by Albee,
Ella McBride, and other members of the
Seattle Camera Club.

VIRNA HAFFER
1899–1974

Virna Haffer's richness of ideas, ingenuity and skill should be a constant source of encouragement to master what is one of the most inviting ways to reach a sense of artistic achievement.

—Jacob Deschin, *New York Times* photography editor, in *Making Photograms* (1969)

ONE OF THE MOST INNOVATIVE photographers ever active in Washington State, Virna Haffer exemplifies the wide and varied range of the Pictorialist movement. She was born Virna May Hanson in Aurora, Illinois, and moved with her parents to Washington's Home Colony in 1907. This utopian enclave on Puget Sound near Tacoma attracted many political and social radicals who created an environment suited to the personalities of her father, a labor-union organizer, and her mother, a teacher. While attending Stadium High School in Tacoma, Virna lived in her own apartment and began supporting herself financially from the age of fifteen. She apprenticed at a portrait studio around this time and, although it is undocumented, it was likely Wayne Albee's, as he was the most noted artistic photographer in the city. A substantial collection of his photographs in her estate indicates that the two were probably acquaintances at the very least. She established her own studio at 122 N. Cedar Street in Auburn, Washington, but it was unsuccessful and she returned to Tacoma.

In 1919, Virna had a very brief marriage to Clarence Schultz, a fellow Home Colony resident, but they divorced within the same year. Shortly afterward, she married Paul R. Haffer, the state executive secretary for the United Producers of Washington. Paul Haffer was considered an "active radical" and was convicted of libel against George Washington based on a letter he wrote, published in the *Tacoma News Tribune* on March 18, 1916. Accusing the first president of "Drunkenness," "Profanity," and "Slave-Holding," Haffer was sentenced to four months in prison in a case heard by the State Supreme Court. An outspoken voice for workers' rights, he wrote a regular feature called "The Colyum" for the *Tacoma Labor Advocate*, writing under the pseudonym "Septimus." In 1924, the couple had a son, Jean Paul, who was the subject of many of Virna's earliest experiments in photography. These innovative and sensitive works caught the attention of other parents, who sought out her services for unique portraits of their own children.

Virna Haffer was an extremely creative woman who worked in a variety of mediums, such as drawing, painting, sculpture, fabric design, and blockprinting. She was also a working musician, playing saxophone in an "all-girl's orchestra" called Fausetti's Jazettes. Her exhibition history began in 1924 in the fifth Frederick & Nelson Salon. Six of her works were accepted, including *Fraid-Cat*, for which she won a $5 prize. Another work in the same exhibition, *His First Growth*, was an unusual depiction of the back of her infant son's head. In June 1928, she

VIRNA HAFFER
Self-Portrait, ca. 1930
Gelatin silver print with textured screen
9 7/8 × 7 7/8 in.
Randall Family Collection

exhibited one work in the Seattle Camera Club's fourth annual exhibition. Her attendance at the club's October meeting was recorded in *Notan* the following month by Dr. Kyo Koike: "Our Forty-fourth meeting was held at the Gyokkoken Café on October 12. Twelve members were present and our guest was Mrs. Virna Haffer of Tacoma Camera Club, who came here to attend the meeting. She brought her eight prints of various subjects, to ask the opinion of some of our members about her pictures. We take off our hats to her earnestness and modesty."

While attending Seattle Camera Club (SCC) meetings, Haffer befriended fellow member Yukio Morinaga and began a lifelong collaboration, with him serving as her main printer. Her earliest extant works show the influence of another SCC member, Frank Kunishige. These images include nude studies of her friend, the writer Elizabeth Sale, who acted as her main model. In the late 1920s, Haffer met visiting Chinese artist Teng Baiye (Kwei Dun) and made several interesting bromoil portraits of him as their friendship developed. Kwei Dun was one of the names used by Teng Baiye (1900–1980), an influential Chinese painter and sculptor who attended the University of Washington in the 1920s and taught there after his graduation in 1927. He had a close relationship with Haffer as well as with painter Mark Tobey, who studied Chinese brush painting with him. This friendship had a significant impact on the development of modern art in the Pacific Northwest. Tobey likely owes the origins of his all-over abstract calligraphic style (dubbed "white writing") to the influence of Teng Baiye, who gave him a thorough understanding of Asian art and technique.

Haffer soon began experimenting with darkroom techniques that would enable her to produce the unique and dark imagery that would later become a hallmark of her work. Some pieces appear to have been influenced by Man Ray (1890–1976) and especially California's William Mortensen (1897–1965), an ardent proponent of creative Pictorialism. Mortensen's series of technical books and his school of photography in Laguna Beach had a wide-ranging effect on the Pictorialists of Haffer's generation. Coinciding with her photographic output, Haffer also produced an impressive body of work in the blockprint medium and sometimes included her prints and Pictorial photographs together in her solo exhibitions.

Haffer's involvement with the SCC was the basis for her local and national success. By 1928, several of her photographs had been accepted in national Salons, and her first national exposure came in 1930, when her heavily manipulated portrait of a child, *Robert*, was published in *The American Annual of Photography*. Over the next five years, her work regularly appeared in the illustrious publication. Locally, an indication of her growing regional reputation came when two of her images were reproduced in the December 1931 issue of *The Town Crier*, along with other illustrations by prominent photographers such as Edward Weston. Her photo-

graphs continued to be nationally recognized throughout the 1930s, and she won several prizes in competitions sponsored by *Camera Craft*. By 1931, she had divorced her husband and later married Norman Randall, a mining engineer whom she met in 1935. Norman, and less frequently, her adolescent son Jean, sometimes served as models, posing for some of her more daring and experimental works.

Besides utilizing her family and her own unique visage, Haffer enlisted some of her artist friends to subject their faces and bodies to sometimes grotesque distortion and manipulations that produced powerful and unsettling abstract images unlike anything else being created in the region at the time. Some of these experimental works culminated in a series produced in the mid-1930s that was intended as illustrations for a collaborative book of her photographs and the poetry of her friend Elizabeth Sale. The book, scheduled for release in 1939, was a poem sequence titled *Abundant Wild Oats* and reflected the two women's independent views regarding their erotic involvement with men, downplaying monogamy and celebrating the joys of a variety of lovers. Although Haffer's illustrations are not blatantly sexual, they utilized images that contain an erotic observation of male physical attributes. Even though the book had been heralded through several advertisements, it was never published either for lack of funding during that period's desperate economic climate or because the content might have been too controversial for a mass appeal.

During the next decades, Haffer continued working in her commercial studio and exhibited in numerous international Salons. Around 1960, she turned her attention to producing photograms, the process of making photographic prints by placing arranged objects directly onto sensitized paper without the use of a camera or negative. She developed several innovations in the medium and wrote the now standard book, *Making Photograms: The Creative Process of Painting with Light*. One of the highlights of her career came about when her photogram *California Horizon* was included in the important traveling exhibition series Photography in the Fine Arts IV at New York's Metropolitan Museum of Art in May 1963. After several national tours, the museum purchased the work for its permanent collection.

Many of Haffer's photograms display a prescient awareness of environmental and social issues, reflecting her own life as an advocate for just causes. In 1964, Haffer was granted a Masters of Photography degree by the Professional Photographers of America, one of the highest national honors awarded in her field. She was the subject of many solo exhibitions, including at the Massachusetts Institute of Technology, Cambridge, 1960; the Museum of Science and Industry, Los Angeles, 1964; the New York Camera Club, 1967; and the Museum of Contemporary Arts and Crafts, New York City, 1968. She died on April 5, 1974.

SOURCES

ARCHIVES
Virna Haffer Archive, Randall Family Collection, Seattle.

ARTICLES AND BOOKS
Cornay, Pat. "The Art of the Photogram." *Seattle Times*, Pictorial Section, August 27, 1972, pp. 2–5.

Frederick, Richard. *The Hidden World of Virna Haffer: Photographs and Photograms from the Collection of the Washington State Historical Society, Tacoma, Washington, 1985.* Tacoma: Washington State Historical Society, 1985.

Haffer, Virna, "A Novel Form of Trick Photography." *Photo Art Monthly*, June 1939, 285–89.

———. *Making Photograms: The Creative Process of Painting with Light.* New York: Hastings House, 1969.

Henderson, Christina Strang. "Virna Haffer: Regional Artist and Photographer." Degree paper, Reed College, 2007.

The Illustrated London News, June 29, 1963, pp. 1008–9.

Notan, November 9, 1928.

Rosenblum, Naomi. *A History of Women Photographers.* Paris: Abbeville Press, 1994.

Sandler, Martin W. *Against the Odds: Women Pioneers in the First Hundred Years of Photography.* New York: Rizzoli, 2002.

Schroeder, Theodore A. *Free Speech Bibliography.* New York: H. W. Wilson Co.; London: Grafton and Co., 1922.

VIRNA HAFFER

His First Growth, 1924
Gelatin silver print
9 3/8 × 7 3/8 in.
Randall Family Collection

VIRNA HAFFER

Blowing Bubbles, ca. 1928
Gelatin silver print
10 7/8 × 7 7/8 in.
Randall Family Collection

VIRNA HAFFER

Male Beauty, ca. 1928
Gelatin silver print
9 $^{13}/_{16}$ × 7 $^{11}/_{16}$ in.
Collection of The Tacoma Public Library

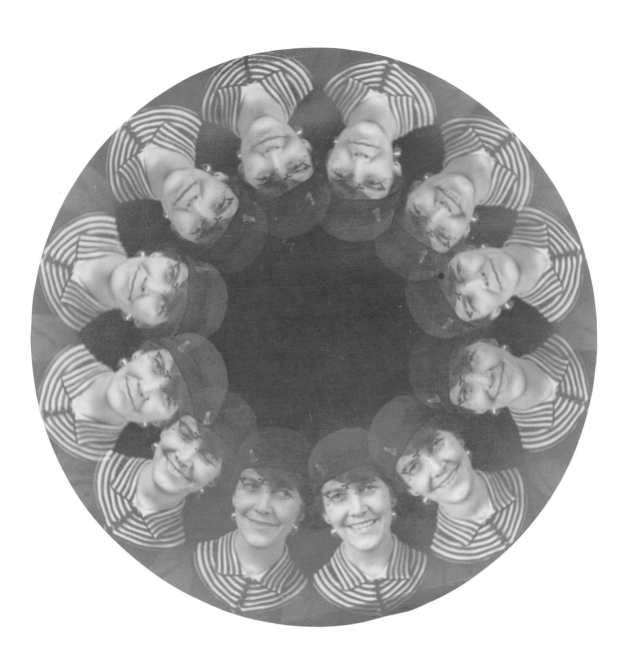

VIRNA HAFFER

Tilley-O, ca. 1928
Gelatin silver print
7 7/8 in.
Randall Family Collection

Erna S. Tilley (1887–1982) was a
writer and cultural figure in Tacoma
and a close friend of the artist.

VIRNA HAFFER

Gian Paolo, ca. 1929
Gelatin silver print
7 $\frac{11}{16}$ × 9 $\frac{3}{4}$ in.
Collection of The Tacoma Public Library

104

VIRNA HAFFER

Cherry Branch, ca. 1929
Bromoil print
9 $\frac{1}{2}$ × 6 $\frac{1}{2}$ in.
Collection of the Washington State
Historical Society, gift of the Virna Haffer
estate

VIRNA HAFFER

Kwei Dun, ca. 1928
Bromoil print
9 3/4 × 7 9/16 in.
Collection of The Tacoma Public Library

VIRNA HAFFER

Self-Portrait, ca. 1929
Gelatin silver print with added
pigmentation
11 ¹/₂ × 9 ¹/₄ in.
Private collection

VIRNA HAFFER
Untitled, ca. 1935
Gelatin silver print
9 $^{15}/_{16}$ × 7 $^{11}/_{16}$ in.
Collection of The Tacoma Public Library

DR. KYO KOIKE
1878–1947

I try to make my composition simple as possible and at the same time to contain much meaning.
—Dr. Kyo Koike

DR. KYO KOIKE was born on February 11, 1878, in the Shimane Prefecture of Japan. He attended medical school and began his practice before immigrating to the United States, where he arrived in Seattle on December 19, 1916. A few of his extant early works indicate that he had produced some skillful Pictorial work while still in Japan. By 1920 he had progressed sufficiently in his avocation to be included in the first Frederick & Nelson Salon in Seattle.

Koike was a Renaissance man who was successful in several fields. He was an empathetic, caring physician and surgeon; a published poet, writer, and editor; a naturalist and mountaineer; and most importantly, one of the most prominent Pictorial photographers ever active in America. His photography was the embodiment of the synthesis of Eastern and Western approaches. To assess these converging approaches, he stated his point of view in *American Photography* in January 1928: "The Japanese idea of composition in pictures is somewhat different from that of Americans. You will frequently find a peculiar atmosphere in their pictures that is due, no doubt, to the influence of ancient Japanese literature and art. From the literary standpoint most Japanese poems contain but a very few words and instead of stating facts and explaining the whole story, such a poem leaves much to the imagination of the reader and you will find a similar tendency in the pictorial art of Japan."

With Koike's initial entrée into the exhibition world, his work was soon accepted in national and international competitions and was often published in the leading photographic journals of the period. His first national recognition came when *Photo-Era* reproduced one of his photographs in March 1922. The work, titled *The Little Dancer*, received an honorable mention from the magazine and would initiate Koike's associations with most of the important national and international journals of his time. An eloquent spokesman for Pictorialism, especially from a Japanese point of view, Koike wrote countless articles that appeared throughout the United States, Europe, and Japan.

By the time he cofounded the Seattle Camera Club (SCC) in 1924, Koike was already a highly respected photographer in the community and served as mentor to some of the younger aspiring members. One of his most important accomplishments was serving as the editor of *Notan*, the SCC's monthly bulletin. Besides recording all of the major accomplishments of the club members, including his

own, Koike translated Japanese literature that he included in the multilingual publication. As a measure of his selfless dedication, he often used the money he was paid for writing articles to cover the expenses of producing *Notan*.

Koike's work was published many times throughout the 1920s and 1930s in major publications such as *Camera Craft*, *The Camera*, *The American Annual of Photography*, and the prestigious annual of the Pictorial Photographers of America. By 1928, his work had won numerous prizes in competitions that numbered more than 150. That same year, he was elected the director of the Association of Camera Clubs of America, a position he held for two years. This was soon followed by his acceptance as an associate member of the Royal Photographic Society of Great Britain, one of the highest honors for a photographer of that time. He was given several solo exhibitions in prominent venues, such as the Kodak Park Camera Club, Rochester, New York, 1926; Portage Camera Club, Akron, Ohio, 1927; and the Brooklyn Institute of Arts and Sciences, 1928. The following year he was honored in his hometown with an exhibition at the Art Institute of Seattle, preceded by shows in Warsaw, Poland; at the Riverside (California) Public Library; and at the California Camera Club, San Francisco. While most of his fellow SCC members either ceased or lessened their involvement in artistic photography during the Depression, Koike maintained some activity throughout those difficult years.

When the SCC ended in 1929, he became more involved in other pursuits, such as his continuing translation of Japanese literature and the cataloguing of regional flora specimens that he had collected over the years. He became a prominent member of the Rainier Ginsha, a Seattle haiku poetry society formed in 1934 by poet Kyou Kawajiri. Using the name Banjin, Koike focused his energies on writing and also edited a publication of poetry by the Rainier Ginsha in 1938.

Like his fellow Issei members, Koike was interned at Minidoka, and the incarceration exacted a severe toll on his mental and physical health. His poetry became a saving grace during the internment, and he rallied his energies to form the Minidoka Ginsha in October 1942 to teach and eventually publish haiku poetry written by himself and his fellow internees. By 1945, the group had composed more than two thousand poems by 158 poets.

Koike returned to Seattle after the internment and reopened his medical practice. However, he continued to decline and died on March 31, 1947. He was cremated and his ashes were scattered near the foothills of his beloved Mount Rainier. The Rainier Ginsha honored him in 1948 by publishing a collection of members' poetry titled *Sawarabi* and dedicating the book to his memory. *Sawarabi* is the Japanese word for fern shoots, a spring delicacy that Koike was picking when he died.

SOURCES

ARCHIVES AND INTERVIEWS

Art Institute of Seattle Annual Report (1929–30). Seattle Art Museum Library.

Mrs. Kiyomi Erickson and Mrs. Kuniko Takamura, senior Rainier Ginsha members, interview with the author, assisted in translation by scholar Michiyo Morioka, in the Seattle home of Mrs. Takamura, October 10, 2008.

SELECTED WRITINGS BY DR. KYO KOIKE

"About the Mount." *The Ground Glass* 10, no. 7 (Newark, NJ: November 1928).

"Clouds in Mountain Photography." *American Annual of Photography* 49 (1935): 209–12.

"Figures in Mountain Photography." *American Annual of Photography* 48 (1934): 67–71.

"The Influence of Old Japanese Literature and Arts on Pictorial Photography." *American Photography* 22, no. 1 (January 1928): 16–19.

"A Japan Muveszi Fenykepezes." *Magyar Fotografia* 10, no. 7 (Budapest: April 1930).

"Japanese Art in Photography." *Camera Craft* 32, no. 3 (March 1925): 110–15.

"Japanese Art in Photography." *Bulletin de la Societe Francaise de Photographie* (August 1925).

"Japanese Work in Pictorial Photography Field." *Notan*, no. 63 (Seattle: August 1929).

"Moje Zamilowanie" (My Avocation). *Fotograf Polski* 14, no. 6 (Warsaw: 1929).

"Mount Rainier," with photographs by the author. *Camera Craft* (March 1926): 117–23.

"Mountain Photography in Four Seasons." *Pacific Coast Review* (San Francisco: June 1936).

"Mountain Photography in Four Seasons." *Photo-Art Monthly* 3, no. 7 (July 1935).

"My Photographic Trip." *The Miniature Camera* 11, no. 4 (New York: April 1934).

"Photographing Mountains." *American Annual of Photography* 45 (1931): 36–40.

"Pictorial Photographic Salons." *American Annual of Photography* 46 (1932): 36–40.

"Pictorial Photography from a Japanese Standpoint." *The Ground Glass* 7, no. 6 (Newark, NJ: October 1925).

"Pictorial Photography in Japan and America." *Photofreund Jahrbuch* (Germany: 1928–29).

San Gaku Shashin no Ken Kyu [Study of Mountain Photographs]. Tokyo: ARS Publishing, 1933.

"The Seattle Camera Club." *Photo-Era* 55, no. 4 (October 1925): 182–88.

"Why I Am a Pictorial Photographer." *Photo-Era* 61, no. 3 (September 1928): 123–24.

SELECTED PUBLICATIONS EDITED BY DR. KYO KOIKE

Kusazutsumi [Grass-Covered Bank]. Minidoka, ID, July 4, 1945. Dedicated to Kyou Kawajiri, who died in the internment camp. Contains 1,139 poems by 133 poets.

Rainier Ginsha. Seattle: Rainier Ginsha, November 1938. Collected poems, edition of 100.

Rainier Ginsha. Seattle: West Coast Printing Co., May 1941. Collected poems, edition of 150.

TRANSLATED AND ILLUSTRATED BY DR. KYO KOIKE

Autumn of Snake Weed. Seattle: Self-published, 1924.

History of Ancient Japan. Seattle: Self-published, September 1922.

Hurrah, by Kokuseki Oizumi. Seattle: Self-published, 1924.

Japanese Fairy Tales. 10 vols. Seattle: Self-published, 1919–20.

The Kaishin-Maru, by Mrs. Yaeko Nogami. Seattle: Self-published, April 1923.

Modern Japanese Novels. 10 vols. Seattle: Self-published, 1919–21.

Roaming around America. 3 vols. Seattle: Self-published, 1922–23.

The Soil, by Nagatsuka Takashi. 4 vols. Seattle: Self-published, February 1922, April 1922, June 1922, July 1922.

OTHER SOURCES

Notan, November 12, 1926; December 10, 1926; November 11, 1927; February 10, 1928; March 9, 1928; March 8, 1929; June 14, 1929; September 13, 1929; October 11, 1929.

Zabilski, Carol. "Dr. Kyo Koike, 1878–1947, Physician, Poet, Photographer." *Pacific Northwest Quarterly* 68, no. 2 (April 1977): 72–79.

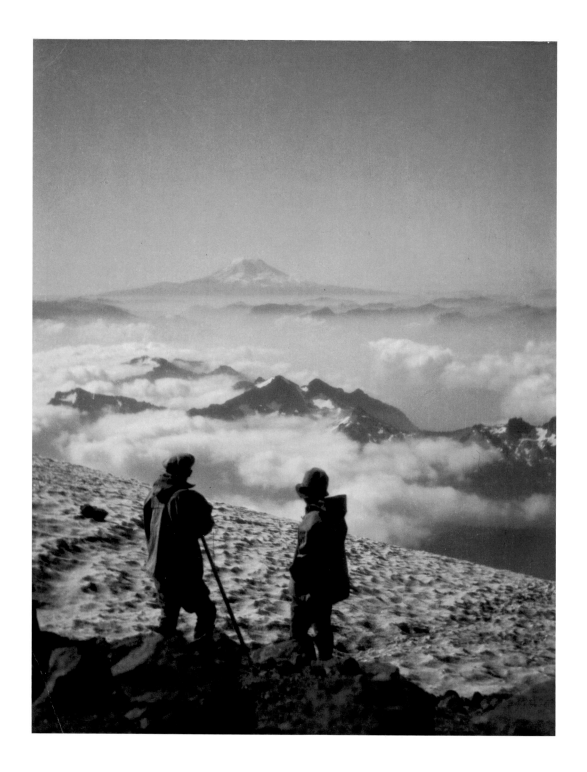

DR. KYO KOIKE

Sea of Clouds, ca. 1922
Gelatin silver print
9 7/8 × 7 11/16 in.
University of Washington Libraries,
Special Collections, UW29042Z

"Dr. K. Koike climbed up to Camp Muir,
10,000 feet high, on Mt. Rainier, slept there
overnight and the next morning he found
his subject—Mt. Adams over the sea of
clouds." *Notan,* October 12, 1928

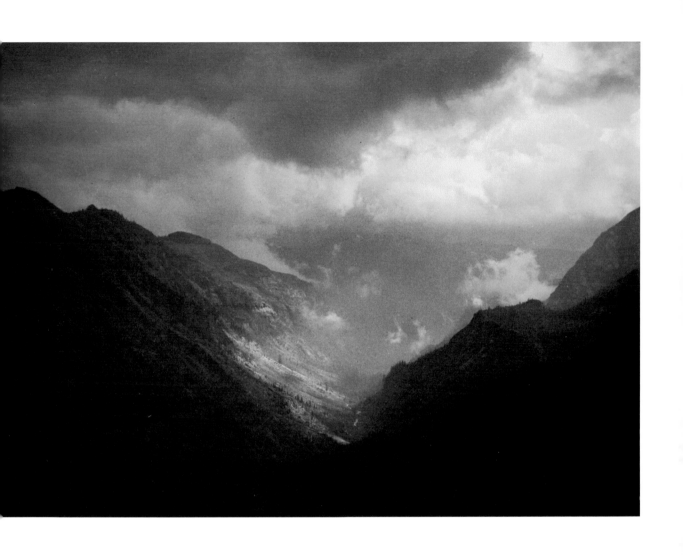

DR. KYO KOIKE

Valley Storm, ca. 1935
Gelatin silver print
7 × 9 $^{13}/_{16}$ in.
University of Washington Libraries,
Special Collections, UW29034Z

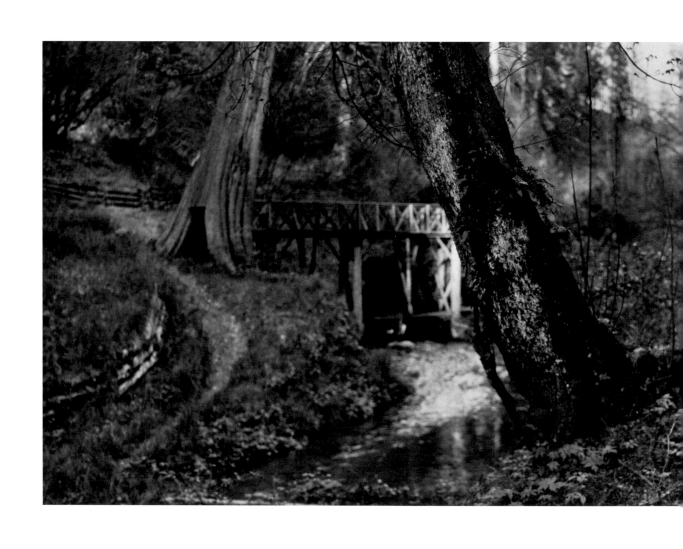

DR. KYO KOIKE

Approaching Dusk, ca. 1921
Gelatin silver print
8 1/4 × 11 7/8 in.
University of Washington Libraries,
Special Collections, UW29047Z

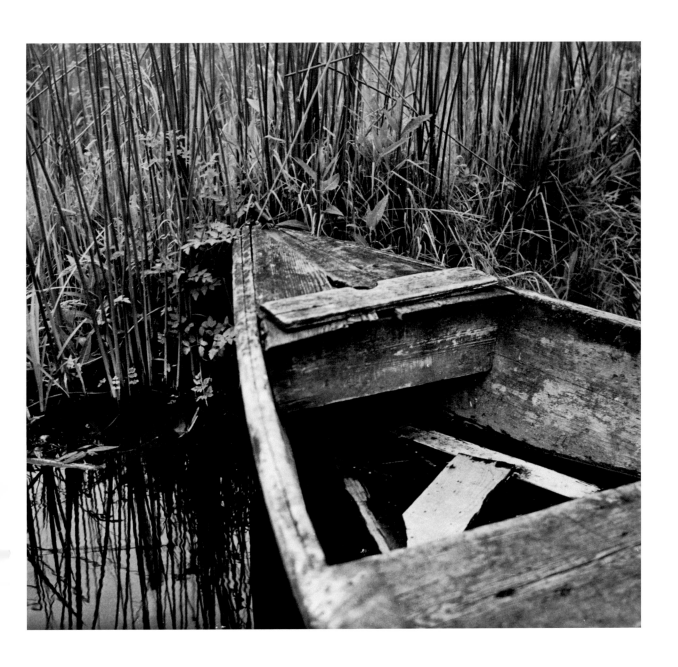

DR. KYO KOIKE

Broken, ca. 1930
Gelatin silver print
7 $^{9}/_{16}$ × 8 $^{1}/_{8}$ in.
University of Washington Libraries,
Special Collections, UW29039Z

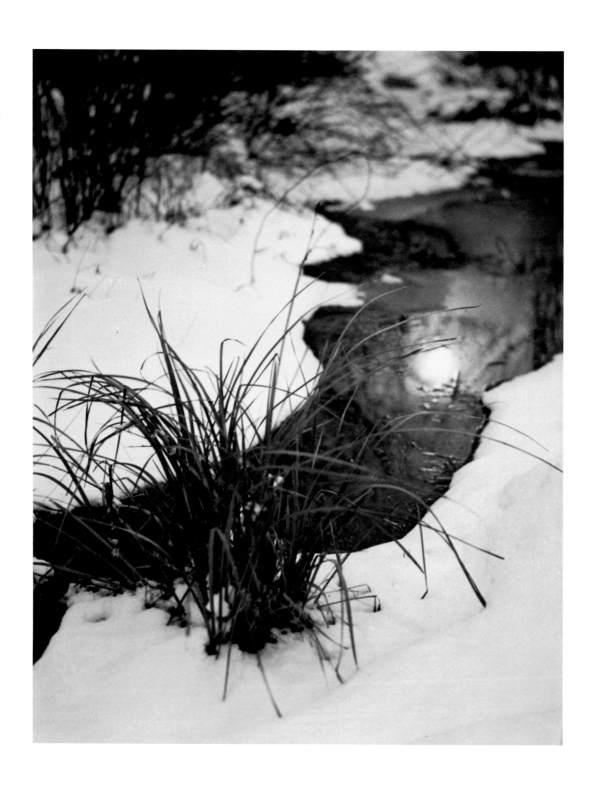

DR. KYO KOIKE

Sun Reflection, ca. 1936
Gelatin silver print
9 7/8 × 7 1/8 in.
University of Washington Libraries,
Special Collections, UW29045Z

DR. KYO KOIKE

Reclamation, ca. 1924
Gelatin silver print
7 9/16 × 9 9/16 in.
University of Washington Libraries,
Special Collections, UW29040Z

117

DR. KYO KOIKE

Landmark—Colman Dock, Seattle, ca. 1922
Gelatin silver print
6 ¹⁄₂ × 4 ⁹⁄₁₆ in.
University of Washington Libraries,
Special Collections, UW23468Z

DR. KYO KOIKE

Called a Home, ca. 1925
Gelatin silver print
7 × 9 7/8 in.
University of Washington Libraries,
Special Collections, UW29041Z

DR. KYO KOIKE

Reconstructive, ca. 1930
Gelatin silver print
9 7/8 × 7 3/4 in.
University of Washington Libraries,
Special Collections, UW29048Z

DR. KYO KOIKE

Bee Hives, ca. 1935
Gelatin silver print
6 3/4 × 9 1/2 in.
University of Washington Libraries,
Special Collections, UW29037Z

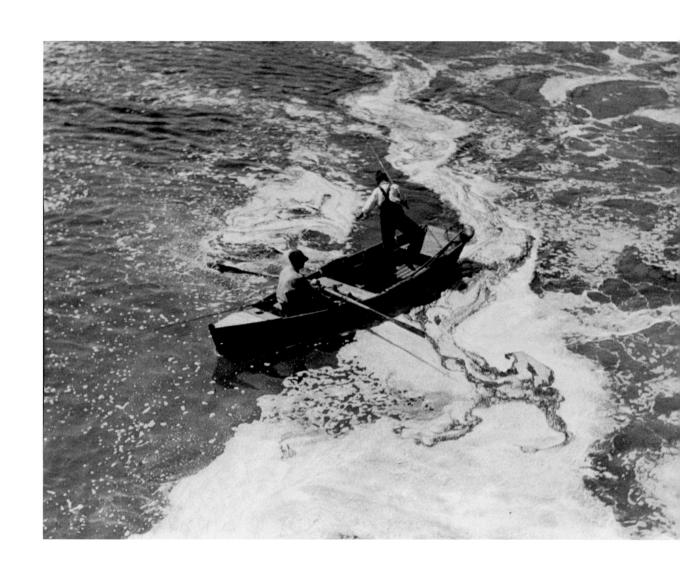

DR. KYO KOIKE

Untitled, ca. 1925
Gelatin silver print
7 1/8 × 9 1/2 in.
University of Washington Libraries, Special
Collections, UW29053Z

FRANK ASAKICHI KUNISHIGE
1878–1960

In terms of photography, I know of nothing more artistic than F. A. Kunishige's work. In front of his prints, you catch yourself forgetting that you are dealing with the mysteries of the darkroom, and totally believing that you are looking at true, authentic paintings. It takes a veritable effort to re-enter reality; for these are, truly, incomparable works of art.
—*Revue du Vrai et du Beau* (Paris, 1924)

FRANK ASAKICHI KUNISHIGE was born in Agenosho, Oshima-gun, Yamaguchi-ken, Japan, and emigrated to the United States, arriving in San Francisco on October 25, 1896. Most of the facts concerning his early life in Japan are unknown. He attended the Illinois College of Photography in Effingham from approximately 1911 to 1913. The college was one of the finest in the country and attracted a number of students from around the world as well as a significant number of immigrants. After joining the school's camera club, he received recognition in several national publications, including *Photo-Era*, which recounted in its July 1912 issue that "the College Camera Club held a reception and exhibit at their rooms last week. Mr. F. Kunishige was host for the evening and gave the guests a splendid opinion of Japanese hospitality." In December of that same year he also won a prize in the club's Salon. He returned to San Francisco after graduation, where he operated a studio on Fillmore Street for several years. After moving to Seattle in 1917, he worked in the darkroom of Edward S. Curtis and, in October of that year, married Gin Sekiguchi (1894–1981).

By 1919, Kunishige had left the Curtis Studio and began working for Ella McBride. Around this time, he submitted his artistic work to national competitions, such as the 1921 Fourth International Photographic Salon of the Camera Pictorialists of Los Angeles, where two of his prints were accepted. The prominent California photographer Louis Fleckenstein (1866–1942) recognized the superior quality of Kunishige's work and wrote to him seeking technical advice, referring to his process as "beautiful and rare."

It is not known if Kunishige was represented in the first Frederick & Nelson Salon of 1920, but the following year his work was included in Seattle's mostly Issei North American Times Exhibition of Pictorial Photographs. A few months later, four of his prints were chosen for the second Frederick & Nelson Salon, where he was one of the five Japanese American contributors among the overall 131 exhibitors. By this time, he was quickly becoming recognized as one of the leading photographers in Seattle. He was even recruited by his friend Ella McBride to model for several of her Pictorial compositions, including an evocative portrait that was exhibited in the 1922 Frederick & Nelson Salon. As a founding member of the Seattle Camera Club (SCC) in 1924, he used his expert techni-

cal skills to develop the negatives and prints for many of his colleagues. He also manufactured a printing-out paper called Textura Tissue, along with a compatible toning solution, both of which he sold nationally through his Seattle studio.

During the 1920s, Kunishige's work was included in many prominent international exhibitions, including those of the Royal Photographic Society of Great Britain; the Pittsburgh Salon; the Buffalo Salon; the Paris Salon; and numerous others. From 1925 through 1929, he was consistently listed among the most exhibited Pictorialist photographers in the world. His work was reproduced in national and international publications, including *Photofreund* (Berlin), *The American Annual of Photography*, *The Year's Photography* (London), and *Photo-Era*, where he won several competitions and awards, including five honorable mentions between 1925 and 1926.

Unlike many SCC members, he supported himself financially as a photographer. Through his employment with McBride's studio, he produced portraits and completed commercial commissions for clients such as Cornish School of Allied Arts, the Bon Marché department store, the Seattle Fine Arts Society, and the Art Institute of Seattle, where he photographed paintings and other works for regional and international artists exhibiting in the city. He also produced two photo essays for the University of Washington's yearbook, *The Tyee*, in 1929 and 1931.

Although Kunishige produced several accomplished landscapes, his urban and figural compositions illustrate his talent at its finest. His depictions of Seattle's architectural landmarks and interiors are infused with a moody and poetic atmosphere, with extraordinary tonal variations. One of the aspects of his work that distinguishes him from his fellow SCC members is his frequent use of the nude or partially clad figure. His male and female subjects, in solitary poses or sometimes in pairs, are arranged either in a studio composition or set against the lush landscape of Seattle's numerous parks. They are often tinged with erotic and suggestive voyeuristic elements. It is interesting to note that he rarely used Asian models in his figure studies, especially the nudes.

A few of his works also contain ambiguous gender references, such as *Masculine Dancer*, which depicts a female figure, and *Traumerie*, whose subject is a mysterious combination of both sexes of an indiscernible race. One of his most unusual works, *Poppy Dreams*, depicts an androgynous Caucasian figure dressed in traditional Chinese clothing and confronting the viewer through the suggestion of an opium-induced stupor.

Often overlooked are his still lifes, which owe less to a standard Pictorial vision and instead display more modern and sometimes disturbing qualities. His closely observed and highly scrutinized studies of flowers or other inanimate objects usually refer more to the abstract design elements of the subjects rather than trying to convey their inherent natural beauty.

Kunishige's first known solo exhibition was at the Commercial Club in Seattle, June 28–30, 1924, where seventy of his prints were displayed. His next

large exhibition in Seattle was held at the Japanese Chamber of Commerce, November 16–18, 1940. In this retrospective assembly, he displayed eighty prints (which included five two-color straight prints) on twenty separate panels. Many of the prints in this exhibition were made from earlier negatives and contained variations in cropping and tonal values. Most of these works are now housed in the collection of the Seattle Public Library.

Like Kunishige's fellow Nikkei SCC members, with the U.S. entry into World War II he and his wife were detained at Camp Harmony, the Puyallup Assembly Center, before being transferred to Minidoka in Idaho. After their release, the Kunishiges remained in Idaho, where Frank was employed in a Twin Falls photography studio doing commercial work. He held a few exhibitions of his artistic photography in Idaho: one on Sunday, July 15, 1945, at the home of Mrs. Emma Clouchek and another on February 19, 1946, at the 20th Century Club. The local press reviewing the show reported that the photographs were created in Seattle, San Francisco, Los Angeles, and other coastal towns, and the titles given were those of Kunishige's earlier works, indicating that he did not produce many new works past the 1930s.

He returned to Seattle by 1950, where he and his wife shared a duplex with painter Kenjiro Nomura (1896–1956) and his family. Nomura's son George recalled that Mr. Kunishige was very unhealthy and spent most of his hours bedridden. Apparently a young man who was learning the photography trade also lived with the Kunishiges during this time. Frank Kunishige remained in Seattle until his death in 1960. He had no children.

What remained of his work and archive was donated to the Seattle Public Library and the University of Washington Libraries, which contain the bulk of his estate. This donation came through the estate of fellow SCC member Iwao Matsushita, who married Gin Kunishige after the deaths of their respective spouses. Gin died in 1981 following complications from a stroke. In 1971, the University of Washington's Henry Art Gallery mounted a solo exhibition of fifty of Frank Kunishige's finest prints.

SOURCES

ARCHIVES AND INTERVIEWS

Louis Fleckenstein, Camera Pictorialists of Los Angeles, to Frank Kunishige, November 28, 1921. Kunishige Collection, University of Washington Libraries, Special Collections.

George and Betty Nomura, telephone interview with the author, March 22, 2008.

ARTICLES AND BOOKS

The American Annual of Photography, 1927. Boston: American Photographic Publishing Co., 1927.

American Photography, November 1926; December 1927.

Asahi Camera (Japan), October 1927.

The Camera, September 1926.

Camera Craft 20, no. 1 (January 1913): 48.

Camera Switzerland, July 1926.

Fusco, Coco, and Brian Wallis. *Only Skin Deep: Changing Visions of the American Self*. New York: Harry N. Abrams, 2003.

North, Marilyn. *Twin Falls (ID) Telegram*, July 16, 1945.

Notan, 1924–29.

Photo-Era 29, no. 1 (July 1912): 95.

Photofreund (Berlin) 5, no. 19 (1927).

Reed, Dennis. *Japanese Photography in America, 1920–1940*. Los Angeles: Japanese American Cultural and Community Center, 1985.

Revue du Vrai et du Beau, December 1924.

Twin Falls (ID) Times-News, "20th Century Club," February 15, 1946.

———, Society Section, February 19, 1946.

———, "20th Century Club Elects Department Officers at Meeting," February 20, 1946.

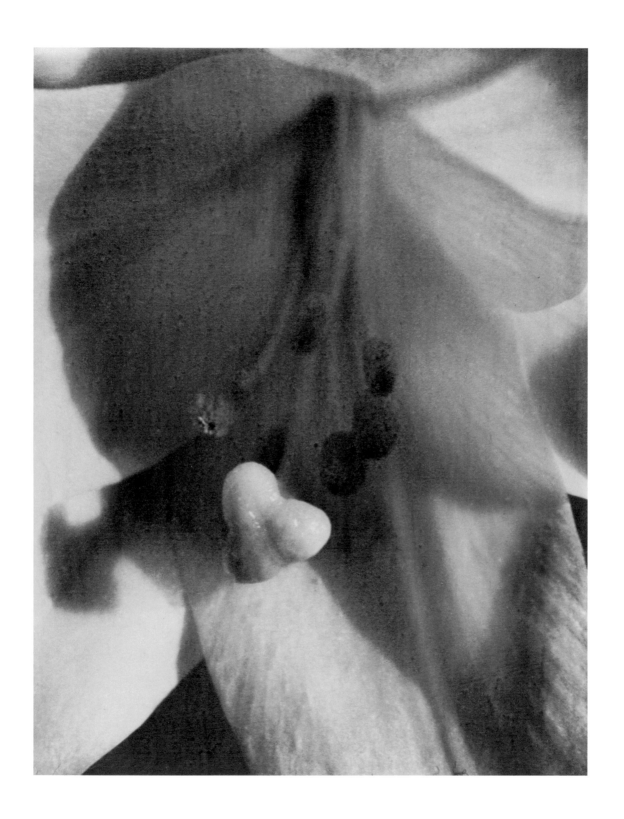

FRANK ASAKICHI KUNISHIGE

In the Heart, ca. 1921
Gelatin silver print on Textura Tissue
12 7/8 × 10 1/8 in.
University of Washington Libraries,
Special Collections, UW13198

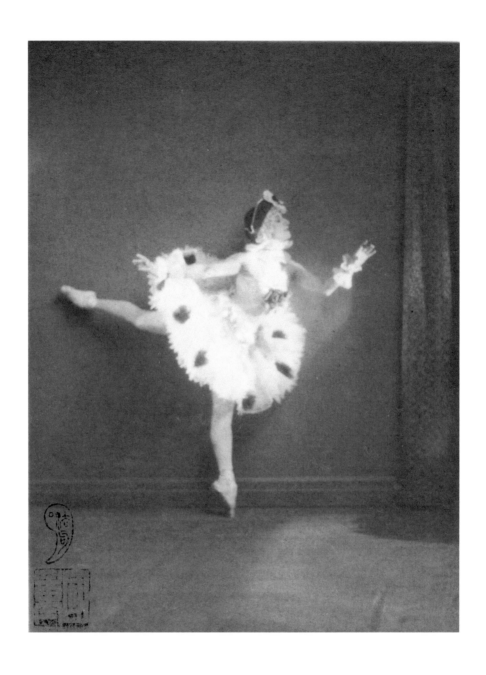

FRANK ASAKICHI KUNISHIGE

Untitled (Anna Pavlova in costume for
"The Coquetteries of Columbine"), ca. 1921
Gelatin silver print
5 ⁹/₁₆ × 4 ¹/₈ in.
University of Washington Libraries,
Special Collections, UW29025Z

Kunishige asserted his Japanese heritage
with the use of a magatama-shaped seal
with two highly stylized characters that read
"furan ku," the Japanese pronunciation of
his adopted American name, Frank. The
lower seal reads Kuni and Shige.

FRANK ASAKICHI KUNISHIGE

Untitled, ca. 1921
Gelatin silver print on crepe tissue
13 $^{1}/_{2}$ × 10 $^{9}/_{16}$ in.
University of Washington Libraries,
Special Collections, UW29023Z

FRANK ASAKICHI KUNISHIGE
Untitled, ca. 1921
Gelatin silver print on crepe tissue
10 3/8 × 11 1/8 in.
University of Washington Libraries,
Special Collections, UW29024Z

FRANK ASAKICHI KUNISHIGE

Untitled, ca. 1920
Gelatin silver print
8 3/4 × 7 1/8 in.
University of Washington Libraries,
Special Collections, UW29027Z

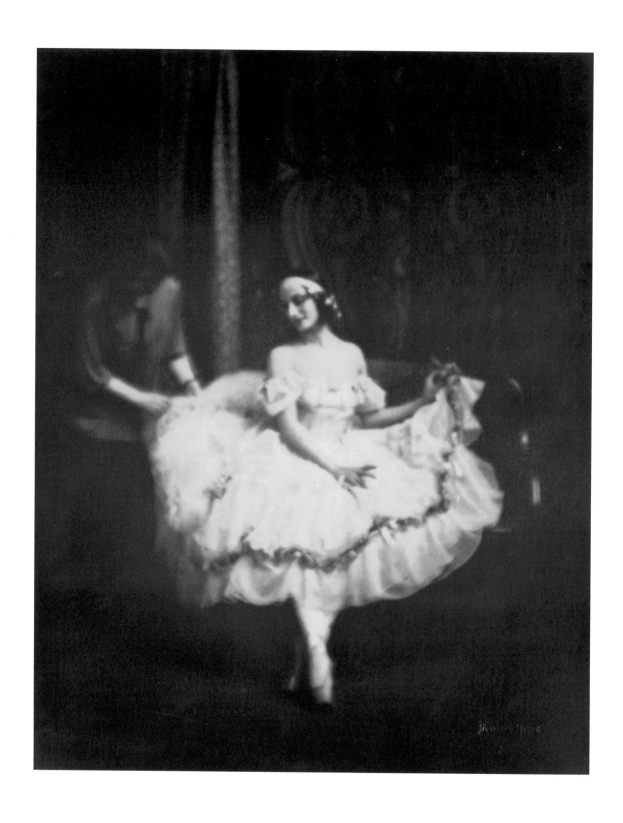

FRANK ASAKICHI KUNISHIGE

Finishing Touches, ca. 1921
Gelatin silver print
12 5/16 × 9 7/8 in.
University of Washington Libraries,
Special Collections, UW29031Z

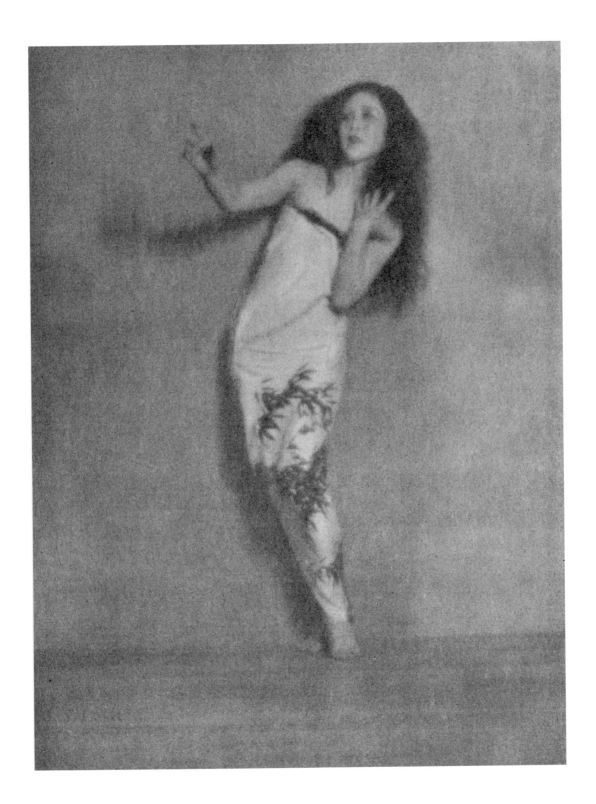

FRANK ASAKICHI KUNISHIGE

The East Awakes, ca. 1927
Gelatin silver print on Textura Tissue
12 5/8 × 9 7/16 in.
University of Washington Libraries,
Special Collections, UW29030Z

The model for this photograph was dancer
Hisayo "Aida" Kawakami (1902–1980),
who appears in several of Kunishige's works.

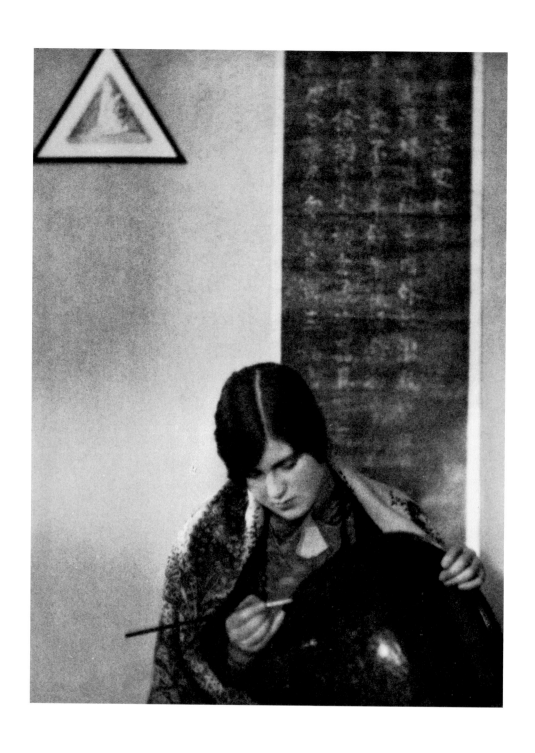

FRANK ASAKICHI KUNISHIGE

Designer, ca. 1928
Gelatin silver print
9 5/8 × 7 1/8 in.
University of Washington Libraries,
Special Collections, UW10098

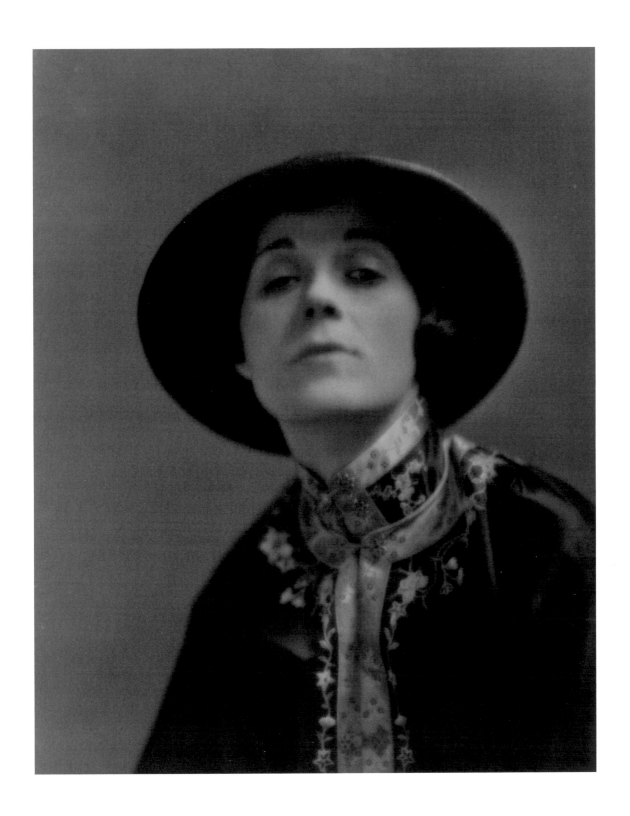

FRANK ASAKICHI KUNISHIGE

Poppy Dreams, ca. 1924
Gelatin silver print
12 $\frac{1}{2}$ × 9 $\frac{15}{16}$ in.
University of Washington Libraries,
Special Collections, UW29028Z

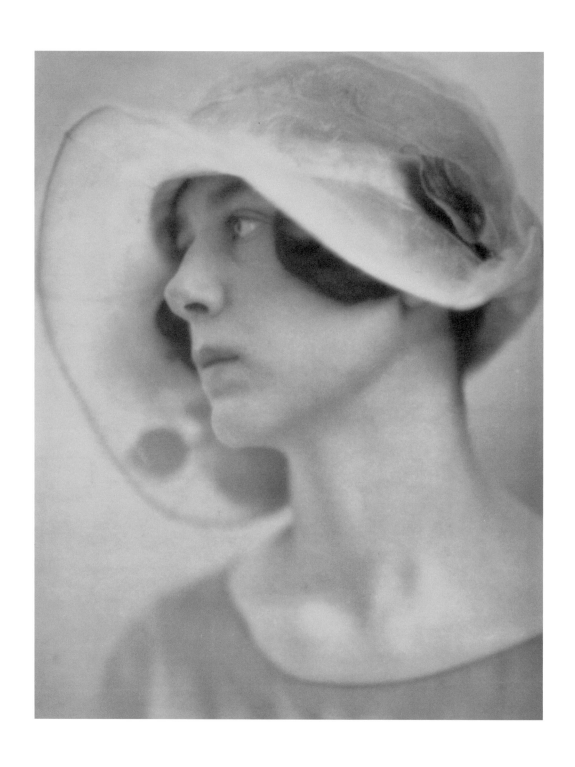

FRANK ASAKICHI KUNISHIGE

Betti, ca. 1924
Gelatin silver print on Textura Tissue
9 1/2 × 7 3/8 in.
Private collection

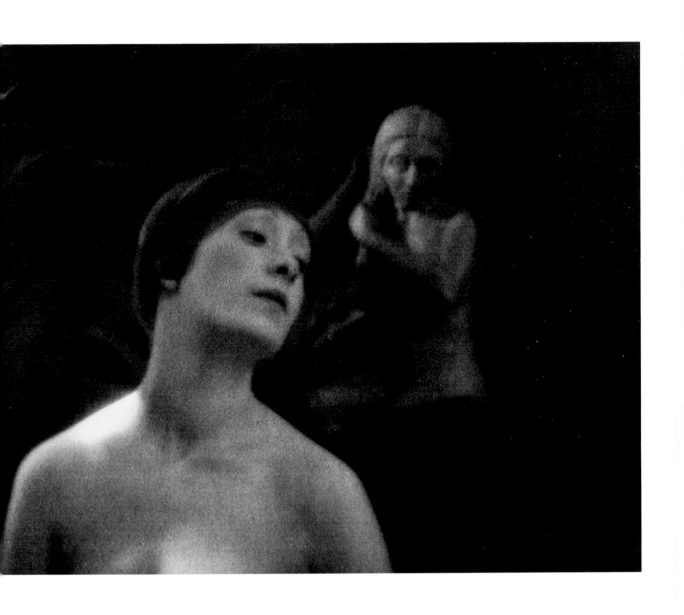

FRANK ASAKICHI KUNISHIGE

Traumerie, ca. 1926
Gelatin silver print on Textura Tissue
7 ¹/₂ × 9 ¹/₂ in.
Private collection

137

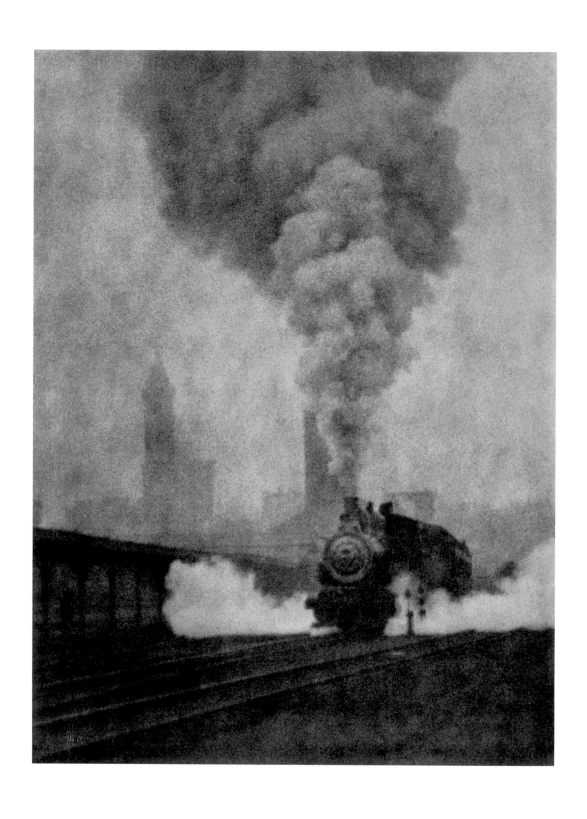

FRANK ASAKICHI KUNISHIGE

7:15 a.m., ca. 1921
Gelatin silver print on Textura Tissue
13 1/2 × 10 1/16 in.
Private collection

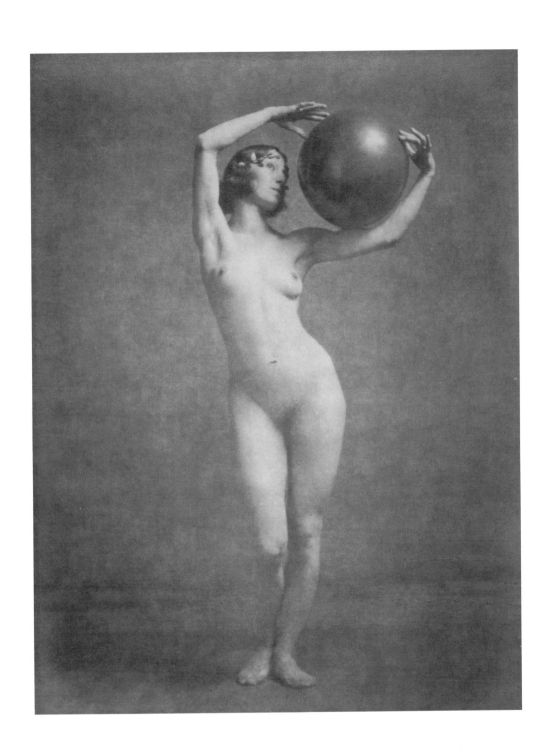

FRANK ASAKICHI KUNISHIGE

Masculine Dancer, ca. 1921 (printed ca. 1940)
Gelatin silver print on Textura Tissue
13 3/8 × 10 1/4 in.
Collection of The Seattle Public Library

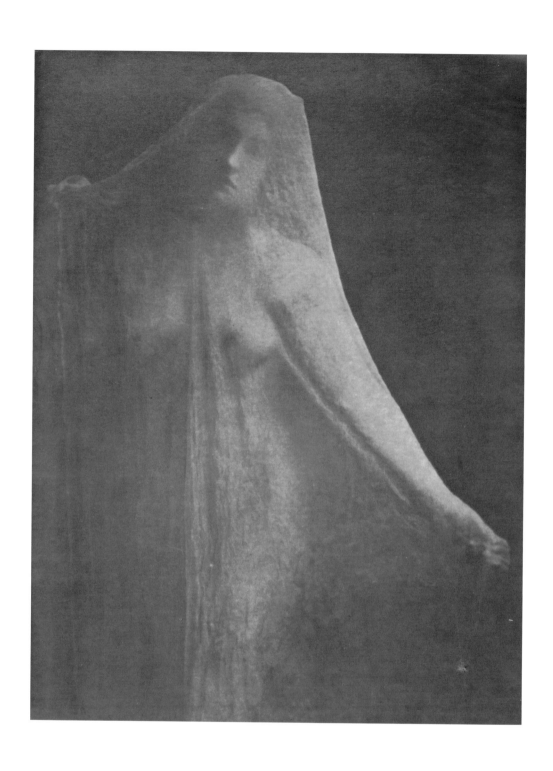

FRANK ASAKICHI KUNISHIGE

Untitled ca. 1921
Gelatin silver print on Textura Tissue
13 ¾ × 10 ½ in.
University of Washington Libraries,
Special Collections, UW29052Z

AYNE ALBEE
McBride, ca. 1920
elatin silver print
/8 × 7 1/2 in.
vate collection

ELLA E. MCBRIDE
1862–1965

An artist photographer is not a new title, but it is one backed by international honors that give it weight when applied to Ella E. McBride of Seattle, Wash., whose camera studies in still life have been exhibited over half the world and have been awarded many a coveted honor. International honors have been awarded her, and her exhibitions are now placed among the fine arts hung in the well-known salons of Great Britain, France, Warsaw, Brussels, Antwerp, Stockholm, New Zealand, Scotland and Japan.

—Cyrilla P. Lindner, *New York Sun* (October 20, 1927)

ELLA E. MCBRIDE was born in Albia, Iowa, on November 17, 1862. She was one of three children born to Samuel B. McBride and America McIntire McBride, who came to Oregon via the Isthmus of Panama in 1865. Ella completed high school in 1882 and received a teaching certificate, becoming an instructor in several Portland, Oregon, area schools beginning in 1889 and eventually principal of the Ainsworth School by 1894.

Before beginning her photographic career, McBride developed a passionate interest in mountain climbing. Mount Hood became the first of more than thirty-seven major climbs that she would make on the West Coast. In 1896, she joined the Portland mountaineering organization, the Mazamas, and served as their historian and secretary for the next two years. By 1897, she met photographer Edward S. Curtis, who was leading a Mazamas-sponsored climb to Mount Rainier along with his wife and several distinguished mountaineers and scientists. On that historic climb, Edgar McClure, known for developing the data to record the height of Rainier, lost his footing and died on the descent. McBride was with him when the accident occurred. Curtis was very impressed with her physical and mental agility and he recruited her to assist him on other mountaineering treks. He later recalled in correspondence with Harriet Leitch of the Seattle Public Library, "Yes, she was quite a mountain climber in the days of long ago. She failed to mention that she was a member of the large party of Mazamas who climbed Mt. Rainier and that she was the only woman who reached the summit unaided. As to Miss McBride and the Curtis Studio, she was a star helper for quite some years. During that time she lived with our family as one of us. She was a second mother to Beth and Florence [his daughters]."

McBride's ascent of Sahale Mountain in the North Cascades was documented in the August 26, 1899, issue of *Harpers Weekly*: "Clinging to the life-line, the Mazamas held their characteristic exercises at the summit. Dr. Young delivered a speech, though in the howling wind his words were hardly audible fifteen feet away. The American and English colors were raised, and then Miss Ella

McBride, secretary of the club, breaking a bottle of wine over the rock, said 'I christen thee Sahale!' "

By 1907, Curtis convinced McBride to leave her teaching position in Portland, and she relocated to Seattle to assist in managing his studio. This included operating his booth at the Alaska-Yukon-Pacific Exposition in 1909. She continued to work for Curtis in the darkroom, showroom, and office until 1916, when she ended her association with him and opened her own studio. Edmund Schwinke, one of the photographers closely associated with Curtis, joined McBride as partner in her studio from 1917 through 1922, even though he had relocated to Oak Hill, Ohio, at the time of their association. Wayne Albee had also joined the McBride Studio by 1918 as partner and chief photographer, assisted by Frank Kunishige and Soichi Sunami. Around this time, the studio developed a close association with the Cornish School of Allied Arts in Seattle, where photographers from the studio made portrait studies of many important dancers and musicians who were performing or teaching in Seattle.

The McBride Studio also provided numerous illustrations for Seattle's *Town Crier* magazine as well as for other local cultural and commercial publications. Although McBride had a close relationship with Curtis for many years, she told the *Seattle Post-Intelligencer* in 1962 that she credited Albee for giving her "the photography fever." By 1920, with the help of her assistants, McBride began her own foray into fine-art photography. She concentrated primarily on floral subjects, a theme that brought her immediate success and recognition. The first recorded exhibition that she participated in was the 1921 North American Times Exhibition of Pictorial Photographs sponsored by the Seattle Japanese newspaper of the same name. She was the only woman and the single Caucasian represented in the exhibition. This was followed a few months later by her inclusion in the more prominent Frederick & Nelson Salon, where three of her eight floral photographs won honorable mentions in the competition.

The following year, McBride entered a more intimidating competition sponsored by the Royal Photographic Society of Great Britain. Her work was accepted into this prestigious Salon for the sixty-seventh annual. This signaled an impressive beginning to her career as a Pictorialist, since there were thousands of international entries submitted and only 154 selected. Twelve of these were by American photographers, including her three floral studies. From this auspicious beginning and at nearly sixty years of age, she entered additional regional, national, and international competitions with increasing success. Also in 1922, eight of her photographs were selected for the third Frederick & Nelson Salon, where she submitted mostly landscape and figure studies, including a portrait of Frank Kunishige. Her only floral entry was a still-life of two water lilies titled *Life & Death*, a work that would bring her additional success over the next few years. She would exhibit in two additional Frederick & Nelson Salons in 1923 and 1925.

Although she was not a founding member, McBride joined the Seattle Camera Club (SCC) shortly after its formation and became one of their most accomplished members, ranking among the most exhibited photographers in the world. Like her colleagues, she would sometimes include figure studies along with the florals, often using dancers and artists as models for her compositions. Her achievements were noted in numerous photographic publications of the day, and her work was mentioned as among the best in many of the reviews of the international Salons that displayed her work. Her Pictorialist works were illustrated in several important publications, including *The American Annual of Photography*, *Camera* (Switzerland), *American Photography*, *The Amateur Photographer*, *Fotokunst* (Antwerp), *Focus* (Holland), and *The Photographic Journal*, which was the official publication of the Royal Photographic Society of Great Britain. McBride's award-winning print *A Shirley Poppy* (p. 146) was the most internationally exhibited photograph by any Seattle Camera Club member. It was so well known that McBride received a complimentary letter from the Rookwood Pottery Company in Cincinnati, which manufactured the vase that appears in the photograph: "We were all very much delighted with the charming example of photographic art. The whole composition is beautifully conceived and the relationship of background to the vase pattern seems a really remarkable piece of execution."

The year 1927 was especially successful for McBride. In May, her work was accepted into the First International Photographic Salon of Japan. This was followed by two known solo exhibitions consisting of thirty of her best prints, shown at the California Camera Club, San Francisco, in August and again at the Portage Camera Club, Akron, Ohio, in November. Locally, *The Town Crier* produced several of McBride's Pictorialist photo-essays, as did the University of Washington's *Tyee* yearbooks in 1926 and 1928. She was honored with a solo exhibition at the Art Institute of Seattle (predecessor to the Seattle Art Museum), January 7–January 18, 1931.

When the Depression caused her and most of the other SCC members to cease their involvement in international exhibitions, McBride put most of her efforts into her commercial studio to maintain an income. By 1932, she added a new partner to replace Albee, who had moved to California a few years earlier. Richard H. Anderson (1908–70) was born in Ohio and moved to Seattle in 1925. He attended a school of photography in Philadelphia and apprenticed at the renowned Bachrach Studio. A commercial photographer, he was especially accomplished at children's portraiture, which provided a great benefit by bringing a steady stream of proud parents into their business. Over the next thirty years, McBride and Anderson maintained their reputation as one of the leading studios in Seattle. Their first location was in the Loveless Studio Building, where Myra Albert Wiggins also lived and worked. A few surviving photographs indicate that McBride printed some of Wiggins's later photographs during this time.

Besides her studio activities, McBride was involved with the Seattle Metropolitan Soroptimist Club, which she cofounded in 1925. She remained an active officer and member of this professional women's organization for nearly forty years.

As she advanced in age, McBride finally decided to retire at the age of ninety-one, but only because of failing eyesight. In the local press surrounding her hundredth birthday, McBride commented to the *Seattle Times* about being paid a dollar a year as a consultant to Anderson: "You know what that means; I'm to keep my nose out unless I am consulted." McBride remained quick-witted and alert until her death on September 14, 1965, two months short of her 103rd birthday. Following her death, the archive of negatives from her studios, dating from approximately 1917 through the 1950s, was stored at two local photography establishments that offered to donate the collection to any interested institution. All declined except for Seattle's Museum of History and Industry, which retained a random selection. The remaining thousands of negatives that essentially documented the important social and cultural events during that period of Seattle's history were deliberately destroyed.

McBride's works are included in the collections of the Seattle Art Museum; the Museum of History and Industry, Seattle; the Tacoma Art Museum; the Los Angeles County Museum of Art; the Minneapolis Art Institute; and the Nora Eccles Harrison Museum, Logan, Utah.

SOURCES

Several articles published about McBride during her lifetime contain numerous errors and conflicting dates. I have rechecked the important dates and facts about her life and career with extant public records to correct and verify as many of these inconsistencies as possible. Both the Gidley and Holm/Quimby texts relied heavily on the correspondence between Edward S. Curtis and his associate Edmund Schwinke. The correspondence was stored at the Thomas Burke Memorial Museum, but as of this writing it has been lost.

Archives, Correspondence, and Interviews
Mazamas, Portland, Oregon.
Photographers Clippings. Art Department, The Seattle Public Library.
Soroptimist International, Northwestern Region, Seattle.

Paul Hoerlein, McBride's cousin, correspondence with the author, April 11, 2000, and
 February 7, 2008.
Harriet Leitch and Edward S. Curtis, correspondence 1949–51. Seattle Collection, The
 Seattle Public Library.
Dee Molenaar to the author, June 23, 1999.

Richard Anderson, son of Mr. and Mrs. Richard H. Anderson, interview with the author,
 Seattle, December 11, 1997.
Mrs. Richard H. Anderson, interview with the author, Mercer Island, October 1997, and
 February 14, 1998.

Ella McBride at age 100, audio interview conducted by Dee Molenaar at McBride's Seattle
apartment, April 19, 1963 (in author's possession). Does not include information about
her photographic career and is based primarily on her activities as a mountain climber.

ARTICLES AND BOOKS

Almquist, June Anderson. "Ella McBride, 100, Saturday, Wants Big Party at Age 200." *Seattle
Times*, November 15, 1962, p. 19.

American Photography (July 1926): 343.

Davis, Barbara A. *Edward S. Curtis: The Life and Times of a Shadow Catcher*. San Francisco: Chronicle,
1985.

Gidley, Mick. *Edward S. Curtis and the North American Indian, Incorporated*. Cambridge: Cambridge
University Press, 1998.

Guie, Heister Dean. "A Famous Camera Artist." *Sunset Magazine*, March 1927.

Holm, Bill, and George Irving Quimby. *Edward S. Curtis in the Land of the War Canoes: A Pioneer
Cinematographer in the Pacific Northwest*. Thomas Burke Memorial Washington State
Museum Monographs no. 2. Seattle: University of Washington Press, 1980.

Jue, Willard G., and Silas G. Jue. "Goon Dip: Entrepreneur, Diplomat, and Community
Leader." In *Annals of the Chinese Historical Society of the Pacific Northwest*. Bellingham, WA:
1984.

Martin, David F. "Ella E. McBride 1862–1965," HistoryLink.org, http://historylink.org/index
.cfm?DisplayPage=output.cfm&file_id=8513.

McBride, Ella. "Lochkelden." *The Town Crier*, Christmas 1927, pp. 18–23. Photo essay.
Lochkelden was the residence of Seattle pioneer Rolland H. Denny.

Notan, 1925–29.

The Photographic Journal 62 (1922): 351.

Seattle Post-Intelligencer, "Ella McBride Looks Back on Two Top Careers," November 5, 1950.

———, "She's Halfway There: Teacher, Photographer Wants to Live to 200," November 15,
1962, p. 3.

The Town Crier, "Art and Artists," December 15, 1923, pp. 33–39.

———, "Garden Photographs by Ella McBride," Christmas 1927.

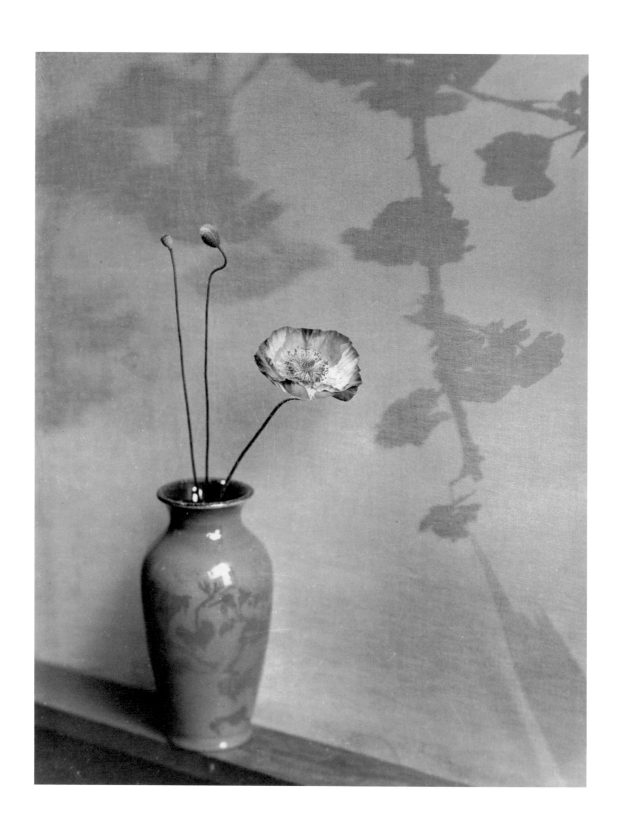

ELLA MCBRIDE

A Shirley Poppy, 1925
Gelatin silver print
9 ¹/₂ × 7 ³/₈ in.
Private collection

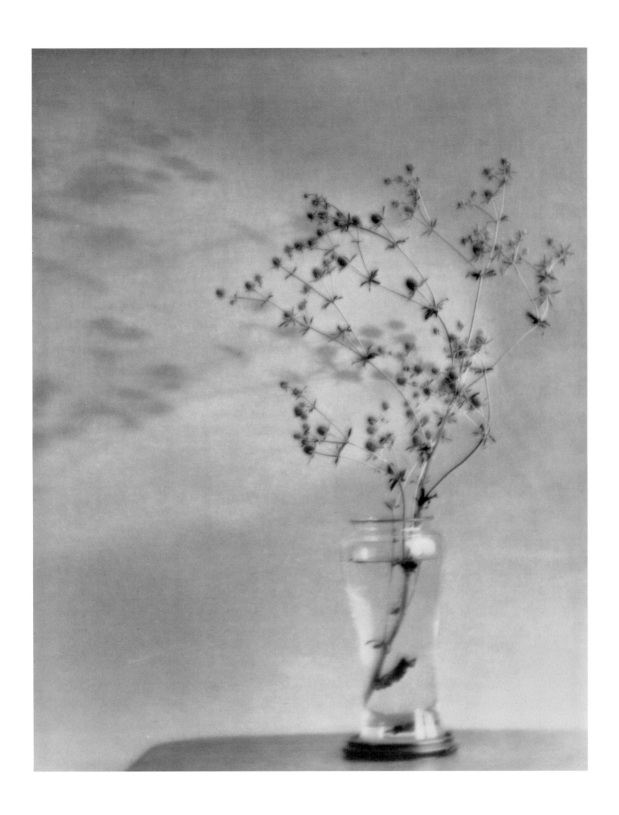

ELLA MCBRIDE

Eryngium, an Arrangement, ca. 1924
Gelatin silver print
9 $\frac{1}{2}$ × 7 $\frac{1}{2}$ in.
Private collection

147

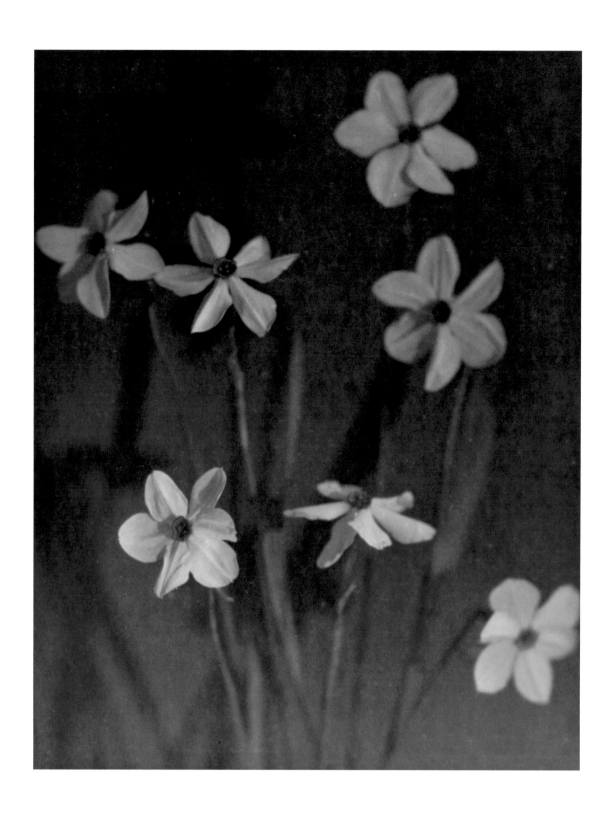

ELLA MCBRIDE

A Pattern, ca. 1922
Gelatin silver print
9 5/8 × 7 1/2 in.
Private collection

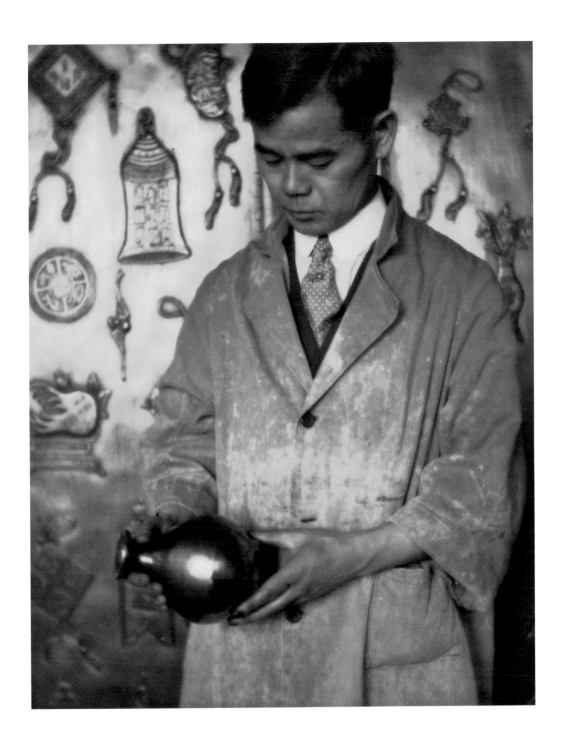

ELLA MCBRIDE

The Connoisseur, ca. 1925
Gelatin silver print
9 1/2 × 7 3/8 in.
Private collection

McBride's studio assistant and friend Frank
Asakichi Kunishige is the model for this
widely exhibited work. Kunishige's fingers
appear stained from the photographic fixer.

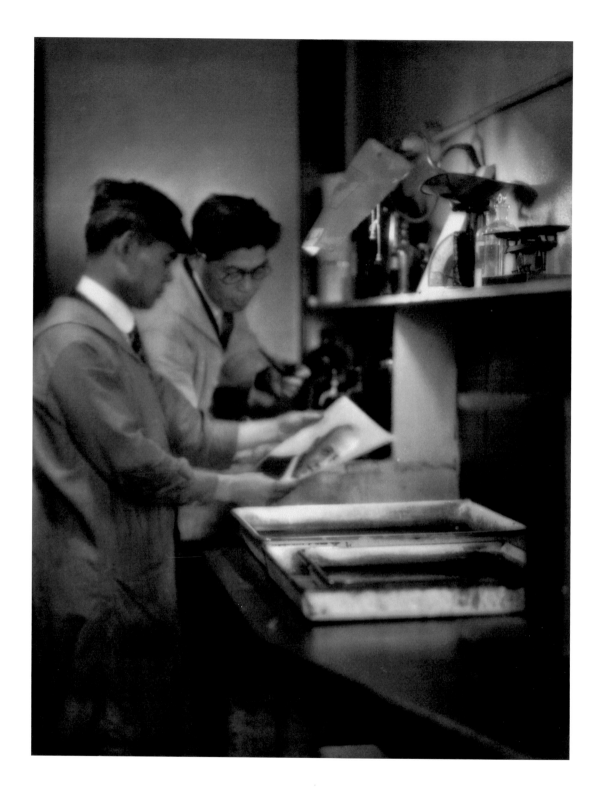

ELLA MCBRIDE

Judging a Print, ca. 1926
Gelatin silver print
9 3/4 × 7 1/2 in.
Private collection

The models for this photograph are, from left, Frank Asakichi Kunishige and Japanese painter/sculptor Yasuda Ryumon (1891–1965).

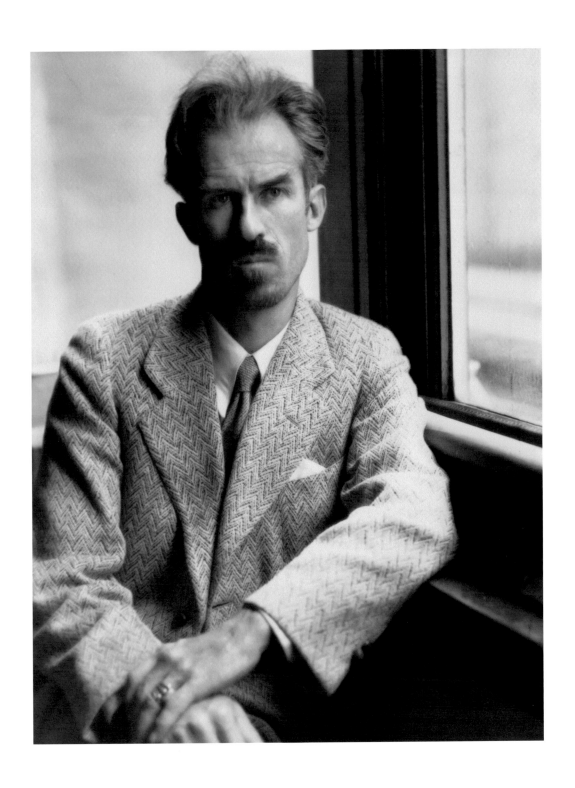

ELLA MCBRIDE

Untitled (Roi Partridge), ca. 1927
Gelatin silver print
9 9/16 × 7 3/16 in.
Private collection

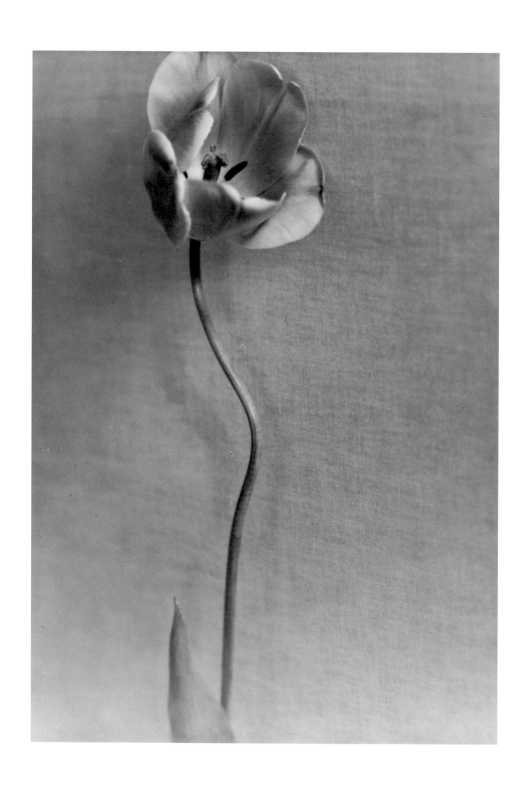

ELLA MCBRIDE

Portrait of a Tulip, ca. 1924
Gelatin silver print
9 $^{11}/_{16}$ × 6 $^{3}/_{4}$ in.
Private collection

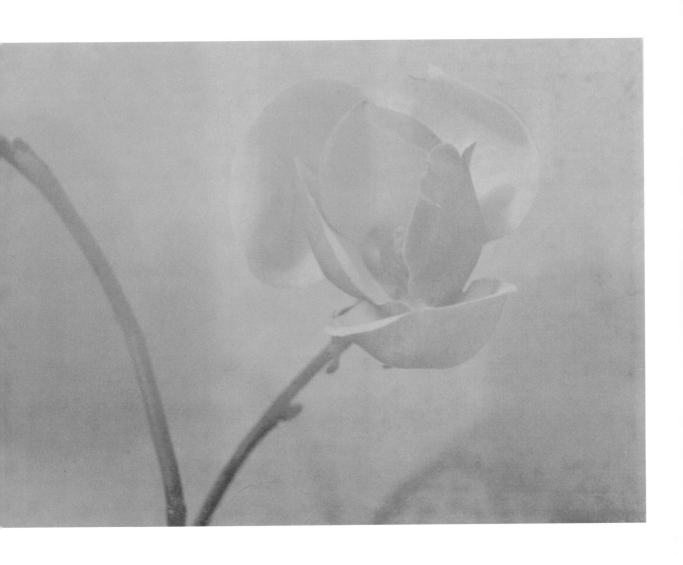

ELLA MCBRIDE

Magnolia, ca. 1922
Gelatin silver print
7 $\frac{1}{16}$ × 9 $\frac{5}{8}$ in.
Private collection

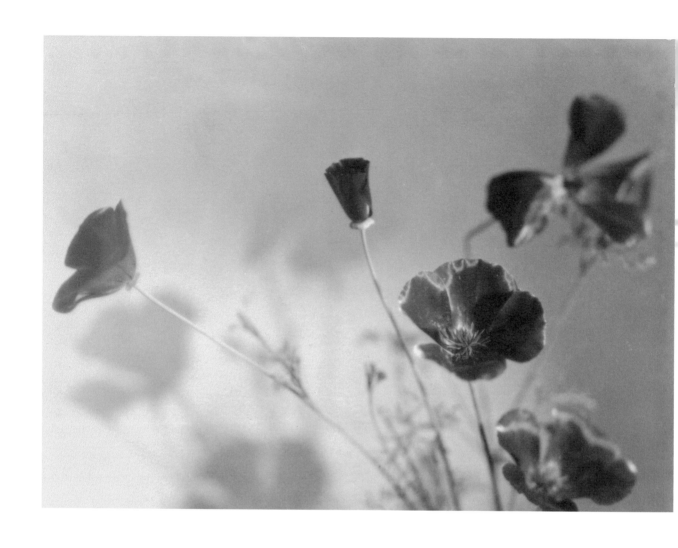

ELLA MCBRIDE

Poppies, 1921
Gelatin silver print
6 7/8 × 9 1/2 in.
Private collection

ELLA MCBRIDE

Leaves, ca. 1924
Gelatin silver print
9 9/16 × 6 5/8 in.
Private collection

YUKIO MORINAGA
1888–1968

I should not overlook Y. Morinaga of Seattle, who finds his subjects on the streets and handles them cleverly. Everybody does not pay attention to such trifling things, but this worker has such keen observation that one cannot surpass him easily in this, his chosen field.

—Dr. Kyo Koike, *Notan* (November 9, 1928)

YUKIO MORINAGA was born on January 11, 1888, in Yamaguchi Prefecture, Japan. After emigrating to the United States he moved to Seattle in 1907. He purportedly studied at the Eastman School of Photography in Rochester, New York, but due to a lack of extant records this has not been verified. After holding various jobs, including seafood packager and store clerk, he accepted a position at the Main Drug Store by 1923. He and fellow photographer Hiromu Kira worked for the store's owner, Mr. Yasukichi Chiba, who was also an amateur photographer and, like the two men, a founding member of the Seattle Camera Club (SCC). Morinaga and Kira worked in the camera department of the store, and they often socialized with Dr. Kyo Koike, whose medical practice was a few blocks away. Koike and other SCC members relied on Morinaga's darkroom expertise to print many of their exhibition photographs.

Morinaga began exhibiting his work at the Frederick & Nelson Salons in 1924 and again in 1925, where he won honorable mention for a work titled *Tower of Blessing.* He was very active with the SCC and exhibited in all of their Salons, with the exception of 1929. During that time he served on several committees, including as secretary of the organization. Offering a different perspective than other regional Pictorialists, his rich bromide prints display a preference for urban subjects and the activities of city life. They are less idealized and express a more modern outlook. Like the other key members of the SCC, his work was also exhibited in many of the leading international photographic Salons of the day.

In 1927, two of Morinaga's prints were included in the First International Photographic Salon of Japan; *In the Harbor* was reproduced in the catalogue. A few months later, this same work was included in the seventy-first annual of the Royal Photographic Society of Great Britain that was held at the Smithsonian Institution, the American venue. In the 1927–28 seasons of Pictorial exhibitions, *The American Annual of Photography* listed Morinaga as the second most exhibited photographer in the world, trailing slightly behind Dr. Koike.

Through his activities with the SCC, Morinaga met and befriended Virna Haffer, who maintained a successful commercial studio in Tacoma. He became her indispensable assistant, developing and printing the majority of her works in his small third-floor studio apartment in Seattle's Nihonmachi (Japantown). Besides working with Haffer, he supported himself by advertising as a photo

finisher beginning in 1929. Living frugally, he slept on a small bed in the corner of his apartment, where all of his photographic work was produced with a handmade enlarger.

Following his internment at Minidoka during World War II, Morinaga relocated to Tacoma, Washington, where his friend Virna Haffer had purchased a small house for him in which he could live and work. As part of Haffer's extended family, he resumed his employment with her and accepted work from other commercial studios in Tacoma as well. In an act of defiance toward the government that had betrayed him, Morinaga refused to pay any more taxes after his forced incarceration at Minidoka. Haffer remained a source of strength and support, caring for him in his later years until, in desperation, he starved himself to death in 1968. Yukio Morinaga never married and was survived by a brother living in Japan at the time of his death.

Although Morinaga produced hundreds of exhibition prints during his lifetime, only about thirty of his photographs have survived through the efforts of Haffer and her descendents. Several of these works are in the collection of the Washington State Historical Society.

SOURCES

ARCHIVES AND INTERVIEWS
George Eastman House, Rochester, New York.
Gene and Lillian Randall, Haffer's son and daughter-in-law, interviews with the author, Gig Harbor, Washington, conducted over several dates beginning in 1998.

JOURNALS AND NEWSPAPERS
American Photography 19, no. 7 (July 1925): 391; 19, no. 10 (October 1925): 549; 20, no. 8 (August 1926): 425; 20, no. 11 (November 1926): 595.
Asahi Camera (Japan), October 1927.
The Camera, February 1927, 85, 100.
Camera (Switzerland), August and September 1926.
Das Magazin (Germany) 4, no. 37 (1927).
Fotokunst (Antwerp), April 1928.
L'Illustration (Paris), October 1926.
The New Photographer 7, no. 180 (1926).
Photofreund (Berlin) 7, no. 13 (1927); 9, no. 4 (February 20, 1929).
Photographische Korresponenz (Vienna) 14, no. 2 (1928).
Tacoma News Tribune, Obituary, June 13, 1968, p. D17.

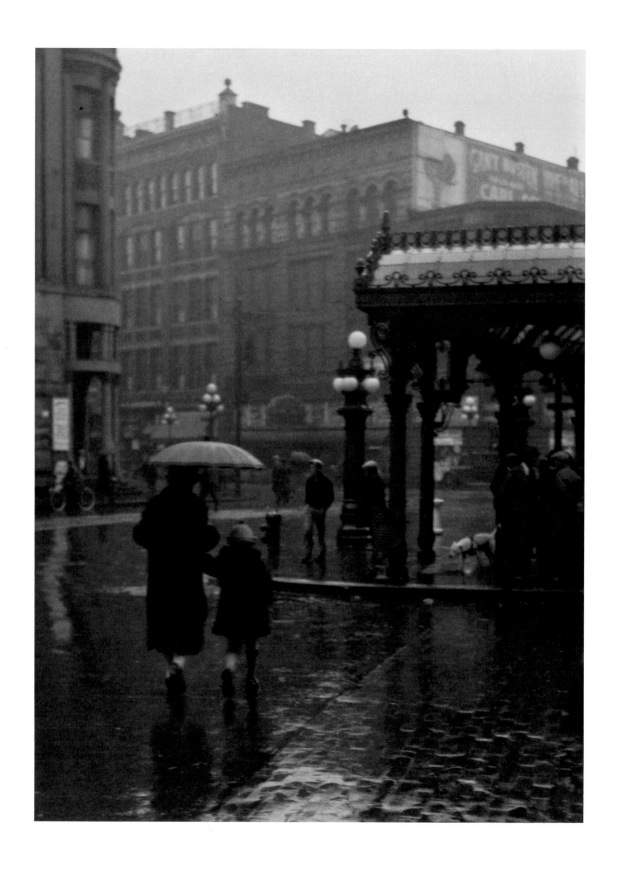

YUKIO MORINAGA
Untitled, ca. 1925
Gelatin silver print
13 1/2 × 9 7/8 in.
Randall Family Collection

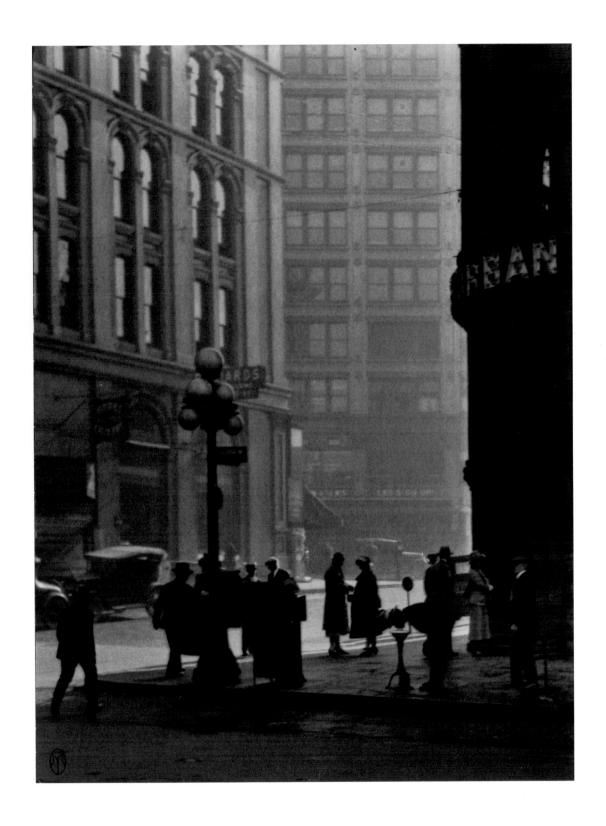

YUKIO MORINAGA

Canyon of Streets, ca. 1925
Gelatin silver print
13 3/8 × 10 1/8 in.
Randall Family Collection

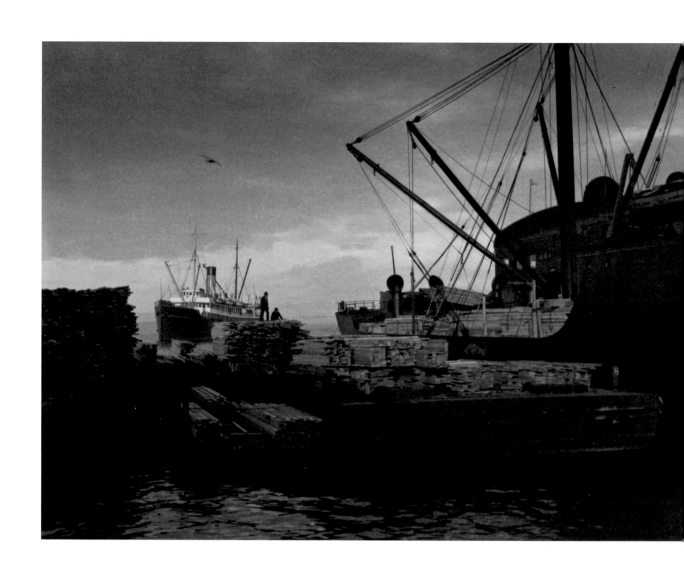

YUKIO MORINAGA

In the Harbor, ca. 1926
Gelatin silver print
8 3/4 × 11 1/2 in.
Randall Family Collection

160

YUKIO MORINAGA

Magellans of Today, ca. 1925
Gelatin silver print
9 × 11 7/8 in.
University of Washington Libraries,
Special Collections, UW29044Z

YUKIO MORINAGA

Untitled, ca. 1924
Gelatin silver print
12 $^1/_2$ × 10 $^3/_4$ in.
Randall Family Collection

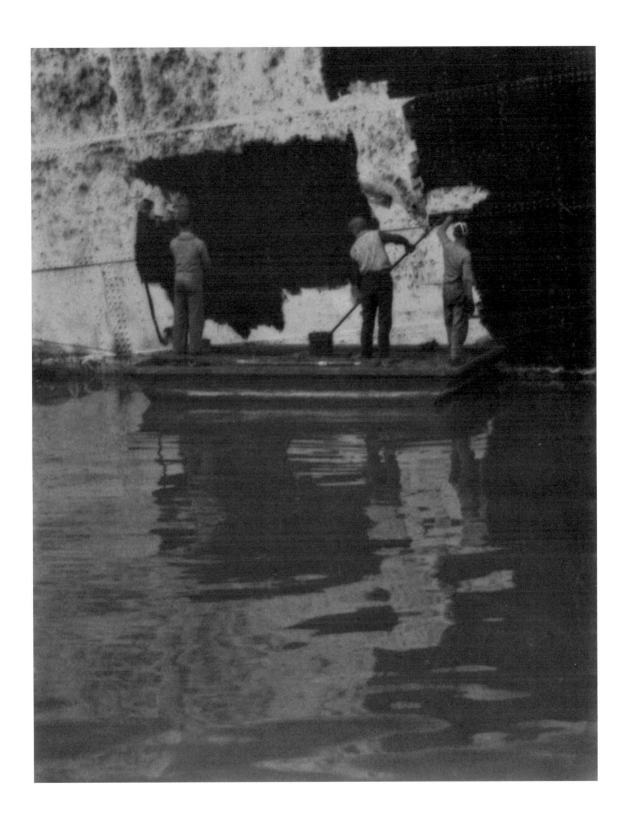

YUKIO MORINAGA

Untitled, ca. 1924
Gelatin silver print
13 ³/₄ × 10 ³/₄ in.
Randall Family Collection

163

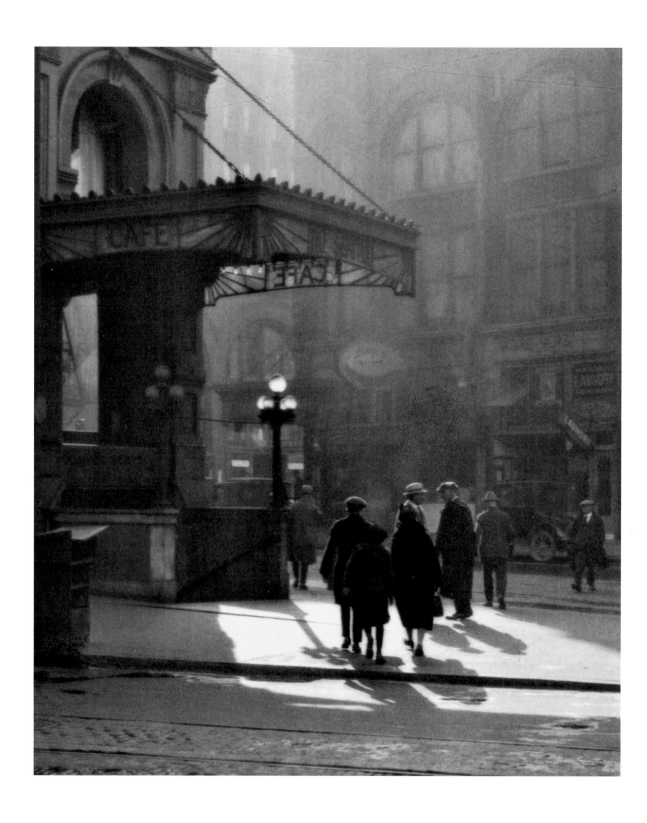

YUKIO MORINAGA

Morning, ca. 1924
Gelatin silver print
11 $\frac{1}{2}$ × 9 $\frac{1}{2}$ in.
Randall Family Collection

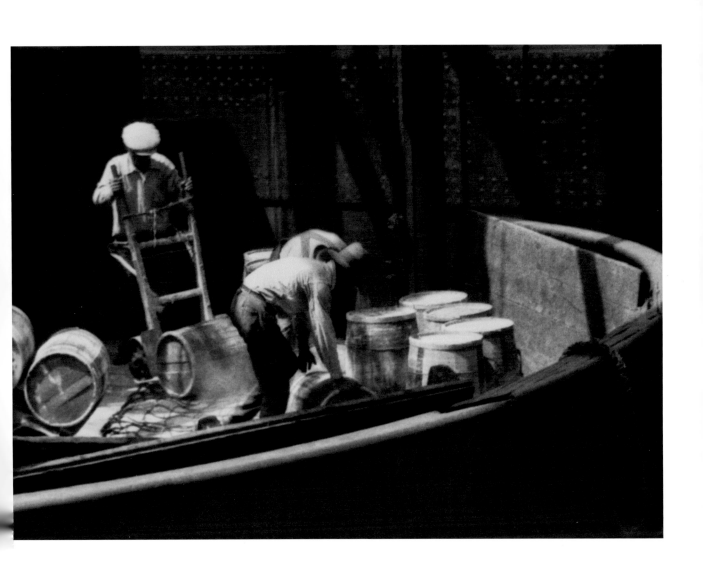

YUKIO MORINAGA

Stevedores, ca. 1925
Gelatin silver print
8 5/8 × 11 5/8 in.
Randall Family Collection

SOICHI SUNAMI
1885–1971

SOICHI SUNAMI
Self-Portrait, 1912, Seattle
Gelatin silver print
6 1/2 × 4 1/2 in.
Collection of the Soichi Sunami estate

Animating all of Sunami's work is the soul of a poet.
—Wayne Albee, *The Town Crier* (1921)

SOICHI SUNAMI was born in Okayama, Japan, on February 18, 1885. He emigrated to the United States in 1905 and arrived in Seattle on February 24, 1907. He became interested in photography as a young art student when he was part of a group of young Issei modern artists in Seattle who studied under Fokko Tadama. These included Yasushi Tanaka, Toshi Shimizu, Kenjiro Nomura, and Kamekichi Tokita, all of whom had successful careers as painters. Tadama was a Dutch immigrant who was born in Bandar, in the region of Palembang, Sumatra (Indonesia), and was active with the art colony at Egmond-Binnen before his arrival in Seattle in 1910.

Initially, Sunami's primary aspiration was to become a painter, and he became an active member of the Seattle Art Club. It is not known how he became interested in photography, but he was working in the medium at the same time that he was producing paintings and sculpture. By 1918 he was living in Tacoma, where he worked as a cook, but shortly thereafter he returned to Seattle and found employment in Ella McBride's studio. In the December 17, 1921, issue of *The Town Crier*, he expressed his frustration over the inadequacies of his technical abilities as a painter: "I often have the wish to put down on canvas my idea of life. My mind is willing but often my hand is weak. I then turn to the camera, the lens my brush, the plate my canvas, and God's sun draws my mind's picture much better than my hand can do."

Sunami exhibited in the first Frederick & Nelson Salon in 1920, where he was one of only a few regional artists to be presented with an award. The following year, he participated in the North American Times Exhibition of Pictorial Photographs represented by six works. A few months later, he was awarded two additional prizes in the second Frederick & Nelson Salon. In 1922, he moved to New York City to pursue his art studies. Upon his arrival, Sunami attempted to earn a living by going door to door in search of portrait commissions. But soon afterward, he began working in the studio of famed photographer Nickolas Muray to maintain an income. Still determined to be a painter, he enrolled at the Art Students League, where he studied under John Sloan and others. In New York, he exhibited eight paintings with the Society of Independent Artists between 1925 and 1931. His painting depicting Union Square was accepted in the 1925 Salons of America exhibition. In 1927, Sunami participated in the First Annual Exhibition of Paintings and Sculpture by Japanese Artists in New York. His Seattle friend Toshi Shimizu, who had also relocated to New York, was included in the exhibition as well.

Because of his endearing personality and the high quality of his photography, Sunami was always considered a peer among his fellow artists, even though his success as a painter was limited. Although he moved to the East Coast, he maintained his contacts in the Pacific Northwest and exhibited with the Seattle Camera Club (SCC) in 1926, where his single entry was a portrait of artist Walter Kethmiller. The following year, he exhibited a chloride photograph titled *Clair de Lune* in the third SCC annual. According to his widow, Soichi Sunami, like Fred Yutaka Ogasawara, was an out-of-state member of the SCC. After opening his first commercial studio on Fifteenth Street, off of Fifth Avenue in New York, he began a five-year collaboration with renowned dancer Martha Graham, producing some of the most striking early images of the iconic dancer.

Along with several of his Seattle friends, Sunami was included in the First International Photographic Salon of Japan, where he exhibited two chloride prints: the aforementioned portrait of Kethmiller and another titled *Danse Languide*, which was reproduced on the cover of *Notan* on October 14, 1927. That same year, his Kethmiller portrait was published in *The American Annual of Photography*, where he shared the pages with Frank Kunishige, Hiromu Kira, Hideo Onishi, and Yukio Morinaga. The annual also included two studies of the ballet dancer Anna Pavlova by Sunami's mentors, Wayne Albee and Ella McBride, along with work by his New York employer, Nickolas Muray.

Interacting with some of the finest painters and printmakers in New York, Sunami used his talents to photograph his friends and their works of art for various professional purposes. He worked with several of the leading art galleries of the period as a commercial photographer, including Edith Halpert's highly influential Downtown Gallery, the Pierre Matisse Gallery, and the Whitney Museum of American Art, among others. His occupation was secured by 1930, when Mrs. John D. Rockefeller Jr. asked him to work with the recently opened Museum of Modern Art (MOMA). For the next thirty-eight years, he produced more than twenty thousand large-format negatives for the archive of this important museum.

In 1945, he married Suyeko Matsushima (1914–2007) of Bainbridge Island, Washington, who was then living in New York and working as a pharmacist. Before her marriage, Suyeko was interned at Tule Lake in northern California. She later recalled that, although Sunami was living on the East Coast during World War II and therefore not subjected to internment, he deliberately burned a number of his earlier works, including all of his nude studies, for fear of repercussion from the government. He became an American citizen on August 5, 1957, and died on November 12, 1971, in New York City. His wife and two children survived him.

Besides his collection at MOMA, the New York Public Library, Jerome Robbins Dance Division, contains many excellent examples of Sunami's numerous dance studies.

SOURCES

CORRESPONDENCE AND INTERVIEWS

Dr. Peter J. H. van den Berg, e-mail to the author, concerning information about Fokko
 Tadama, December 18, 2007.

Anne Kutka McCosh (1902–94), painter and close friend of Sunami, conversations with the
 author, Eugene, Oregon, July 21, 1991, and October 1993.

Mrs. Suyeko Sunami and daughter Reiko Kopelson, interviews with the author, New York
 City, August 1997, August 2000, and August 20, 2007.

ARTICLES AND BOOKS

Ackerman, Gerald. "Photography and the Dance: Soichi Sunami and Martha Graham." *Ballet
 Review* (Summer 1984): 32–35.

Albee, Wayne. "Soichi Sunami." *The Town Crier*, December 17, 1921.

Marlor, Clark S. *The Salons of America*. Madison, CT: Sound View Press, 1991.

———. *The Society of Independent Artists: The Exhibition Record, 1917–1944*. Park Ridge, NJ: Noyes
 Press, 1984.

Wolf, Tom. "The Tip of the Iceberg, Early Asian American Artists in New York." In *Asian
 American Art A History, 1850–1970*, 83–109. Stanford, CA: Stanford University Press, 2008.

SOICHI SUNAMI

Untitled, ca. 1920
Gelatin silver print
6 $\frac{1}{2}$ × 4 $\frac{1}{2}$ in.
Collection of the Soichi Sunami estate

SOICHI SUNAMI

Sumner, 1917
7 1/4 × 9 1/2 in.
Gelatin silver print
Collection of the Soichi Sunami estate

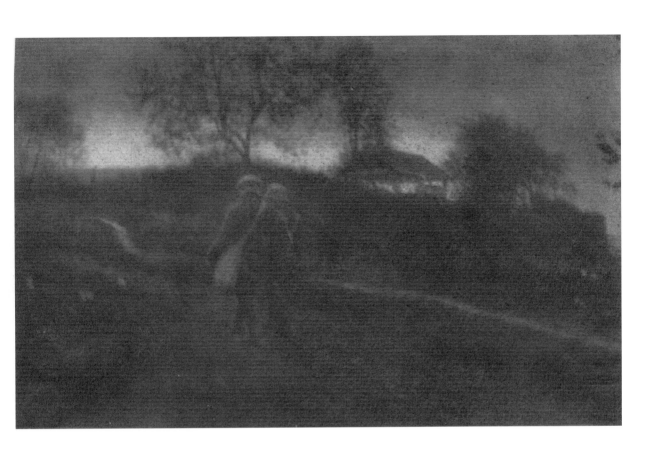

SOICHI SUNAMI

Untitled, ca. 1920
Gelatin silver print
5 × 7 3/4 in.
Collection of the Soichi Sunami estate

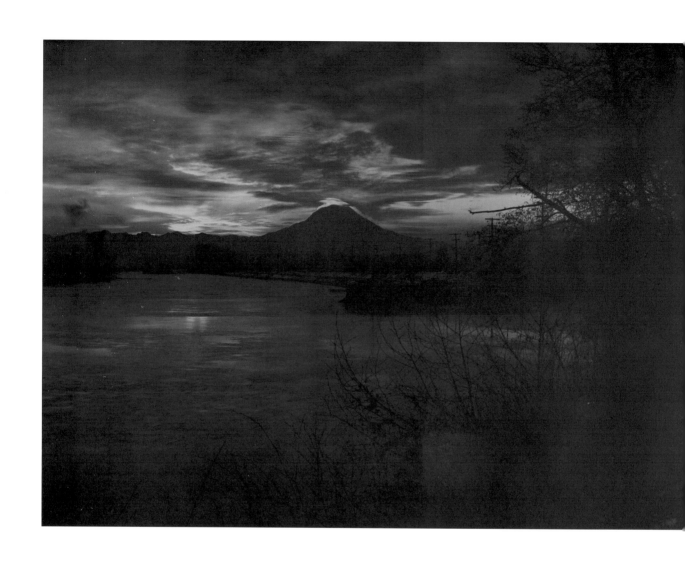

SOICHI SUNAMI

Untitled, ca. 1920
Gelatin silver print
8 ¹/₂ × 11 in.
Collection of the Soichi Sunami estate

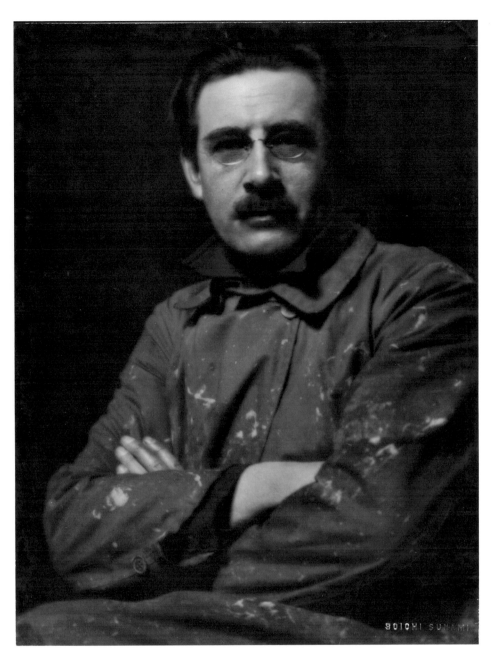

SOICHI SUNAMI

Untitled (Fokko Tadama), ca. 1918
Gelatin silver print
9 × 7 in.
Collection of the Soichi Sunami estate

Fokko Tadama (1871–1937) was born of
Dutch parents in Bandar, in the region of
Palembang, Sumatra (Indonesia). He was
a successful painter who was active with
the art colony at Egmond-Binnen in the
Netherlands before arriving in Seattle in
1910. Tadama helped to establish Seattle's
nascent art scene and became the instructor
of many of the region's finest artists. He
was particularly associated with Seattle's
Issei artists, including Soichi Sunami, and
served on the jury of several local Pictorialist
salons.

SOICHI SUNAMI

Untitled, ca. 1919
Gelatin silver print
5 ³/₄ × 7 ¹/₂ in.
Collection of the Soichi Sunami estate

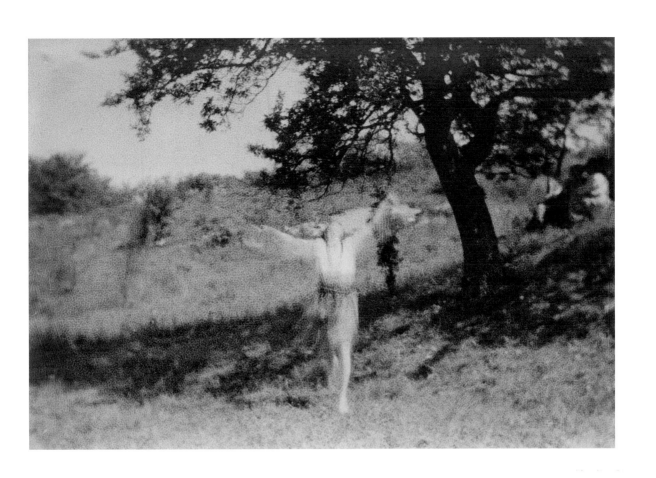

SOICHI SUNAMI

Untitled, ca. 1920
Gelatin silver print
4 ¹/₂ × 6 ¹/₂ in.
Collection of the Soichi Sunami estate

SOICHI SUNAMI

Self-Portrait, ca. 1920
Gelatin silver print
8 1/4 × 6 3/4 in.
Collection of the Soichi Sunami estate

BIBLIOGRAPHY

Albee, Wayne. "The Seattle Camera Club." *The Town Crier*, Christmas 1927, pp. 6–27.

Almquist, June Anderson. "Ella McBride, 100, Saturday, Wants Big Party at Age 200." *Seattle Times*, November 15, 1962, p. 19.

Bannon, Anthony. *The Photo-Pictorialists of Buffalo*. Buffalo, NY: Media Study, 1981.

Blumann, Sigismund, and Dr. Kyo Koike. "Our Japanese Brother Artists, Japanese Art in Photography." *Camera Craft* 23, no. 3 (1925): 109.

The Camera, "The First Exhibition of Pictorial Photography," June 1926, p. 357.

Camera (Switzerland), September 1926. Issue dedicated to the Seattle Camera Club with numerous illustrations.

Clarke, David. "Cross-Cultural Dialogue and Artistic Innovation: Teng Baiye and Mark Tobey." In *Shanghai Modern 1919–1945*, ed. Jo-Anne Birnie Danzker, Ken Lum, and Zheng Shengtian, 84–103, 417–18. Ostfildern, Germany: Hatje Cantz, 2005.

———. "Teng Baiye and Mark Tobey: Interactions between Chinese and American Art in Shanghai and Seattle." *Pacific Northwest Quarterly* 93, no. 4 (Fall 2002): 171–79.

Davis, Barbara A. *Edward S. Curtis: The Life and Times of a Shadow Catcher*. San Francisco: Chronicle, 1985.

Dow, Arthur Wesley. *Composition*. Garden City, NY: Doubleday, Page and Co., 1913.

Ehrenkranz, Anne. *A Singular Elegance: The Photographs of Baron Adolph De Meyer*. San Francisco: Chronicle, 1994.

Enyeart, James L. *The Photographs of Arthur Wesley Dow: Harmony of Reflected Light*. Santa Fe: Museum of New Mexico Press, 2001.

Fairbrother, Trevor. *Ipswich Days: Arthur Wesley Dow and His Hometown*. New Haven, CT: Yale University Press, 2007.

Fiset, Louis. *Camp Harmony: Seattle's Japanese Americans and the Puyallup Assembly Center*. Urbana: University of Illinois Press, 2009.

———. *Imprisoned Apart: The World War II Correspondence of an Issei Couple*. Seattle: University of Washington Press, 1997.

———. "Nikkei Life in the Northwest: Photographic Impressions, 1912–1954." *Pacific Northwest Quarterly* 91, no. 1 (Winter 1999–2000): 25–41.

Fulton, Marianne, and Bonnie Yochelson. *Pictorialism into Modernism: The Clarence H. White School of Photography*. New York: Rizzoli, 1996.

Glauber, Carole. "Myra Albert Wiggins Arts and Crafts Photographer." *Style 1900*, Spring–Summer 1999, pp. 34–40.

———. *Witch of Kodakery: The Photography of Myra Albert Wiggins, 1869–1956*. Pullman: Washington State University Press, 1997.

Griffith, Bronwyn A. E. *Ambassadors of Progress: American Women Photographers in Paris, 1900–1901*. Hanover, NH: University Press of New England, 2001.

Hanford, Cornelius H. *Seattle and Environs, 1852–1924*. Vol. 1. Seattle: Pioneer Historical Publishing Co., 1924.

Indvik, Gail Marie. *Adelaide Hanscom Leeson Pictorialist Photographer, 1876–1932*. Carbondale: University Museum, Southern Illinois University, 1981.

Koike, Kyo. "Mt. Rainier." *Camera Craft* 33, no. 4 (March 1926): 117–23.

———. "The Seattle Camera Club." *Photo-Era* 55, no. 4 (October 1925): 182–88.

Kreisman, Lawrence, and Glenn Mason. *The Arts and Crafts Movement in the Pacific Northwest.* Portland, OR: Timber Press, 2007.

Lee, Shelley Sang-Hee. "Cosmopolitan Identities: Japanese Americans in Seattle and the Pacific Rim, 1900–1942." PhD diss., Stanford University, 2005.

———. " 'Good American Subjects Done through Japanese Eyes': Race, Nationality, and the Seattle Camera Club, 1924–1929." *Pacific Northwest Quarterly* 96, no. 1 (Winter 2004–5): 24–33.

Lorenz, Richard. *Imogen Cunningham: Ideas without End.* San Francisco: Chronicle, 1993.

———. *Imogen Cunningham on the Body.* Boston: Bulfinch, 1998.

Mann, Margery. *Imogen Cunningham: Photographs.* Seattle: University of Washington Press, 1970.

———. *Imogen! Imogen Cunningham Photographs, 1910–1973.* Seattle: Henry Art Gallery, University of Washington Press, 1974.

Margolis, Fulton Marianne, ed. *Alfred Stieglitz: Camera Work; A Pictorial Guide.* New York: Dover, 1978.

Martin, David F. "Photographs by the Seattle Camera Club." *American Art Review* 12, no. 1 (January–February 2000): 164–69.

———. *Pioneer Women Photographers.* Seattle: Frye Art Museum, 2002.

McCarroll, Stacey. *California Dreamin': Camera Clubs and the Pictorial Photography Tradition.* Boston: Boston University Art Gallery, 2004.

Monroe, Robert D. "Light and Shade: Pictorial Photography in Seattle, 1920–1940, and the Seattle Camera Club." In *Turning Shadows into Light: Art and Culture of the Northwest's Early Asian/Pacific Community*, ed. Mayumi Tsutakawa and Alan Chong Lau, 8–32. Seattle: Young Pine Press and Asian Multi-Media Center, 1982.

Naef, Weston J. *The Collection of Alfred Stieglitz.* New York: Metropolitan Museum of Art, 1978.

Nakane, Kazuko, and Alan Chong Lau. "Shade and Shadow: An Asian American Vision behind Northwest Lenses." *International Examiner*, January 23, 1991.

Peterson, Christian A. *After the Photo-Secession: American Pictorial Photography, 1910–1955.* New York: Minneapolis Institute of Art, W. W. Norton, 1997.

———. *Alfred Stieglitz's Camera Notes.* Minneapolis: Minneapolis Institute of Arts, 1993.

———. *Index to the American Annual of Photography.* Minneapolis: Privately printed, 1996.

———. *Index to the Annuals of the Pictorial Photographers of America.* Minneapolis: Privately printed, 1993.

Pictorial Photography in America. 5 vols. New York: Pictorial Photographers of America, 1920, 1921, 1922, 1926, 1929.

Prodger, Phillip, Patrick Daum, and Francis Ribemont. *Impressionist Camera: Pictorial Photography in Europe, 1888–1918.* London: Merrell, 2006.

Reed, Dennis. *Japanese Photography in America, 1920–1940.* Los Angeles: Japanese American Cultural and Community Center, 1985.

Roberts, Pam. *Photo Historica: Landmarks in Photography.* New York: Artisan Publishers, 2000.

Salloum, Sheryl. *Underlying Vibrations: The Photography and Life of John Vanderpant.* Victoria, BC: Horsdal & Schubart, 1995.

Sandler, Martin W. *Against the Odds: Women Pioneers in the First Hundred Years of Photography.* New York: Rizzoli, 2002.

Seattle Daily Times, Rotogravure Section, November 13, 1927; November 20, 1927.

The Seattle Press Club Annual. Seattle: Seattle Press Club, 1926–27.

The Town Crier, "Art and Artists," December 15, 1923.

———, "Pictorial Photography," December 13, 1924, pp. 26–34.

———, "Pictures," pp. December 12, 1925.

———, "The Kings," December 11, 1926, pp. 17–22.

————, Christmas 1926.

————, "The Seattle Camera Club," Christmas 1927, pp. 6–27.

————, "Art Institute of Seattle," June 22, 1929, p. 6. Review of the Seattle Camera Club.

————, "Looking through the Lens," December 17, 1930, pp. 9–15.

Warren, Beth Gates. *Margrethe Mather and Edward Weston: A Passionate Collaboration*. Santa Barbara: Santa Barbara Museum of Art in association with W. W. Norton, 2001.

Wilson, Michael G., and Dennis Reed. *Pictorialism in California: Photographs, 1900–1940*. Malibu, CA: J. Paul Getty Museum; San Marino, CA: Henry E. Huntington Library and Art Gallery, 1994.

Yeo, Sarah C. *A Different Slant of Light: The Art and Life of Adelaide Hanscom Leeson*. Anacortes, WA: Orange Trumpet Honeysuckle Publishing, 2002.

Dr. Koike's hand-lettered case for transporting exhibition photographs. 18 × 21¹/₂ × 2 ¹/₂ in. Collection of Patrick Suyama

ACKNOWLEDGMENTS

This project is made possible with the generous support of the University of Washington Libraries Kenneth S. Allen Library Endowment and by the assistance of a grant from the Scott and Laurie Oki Endowed Fund for publications in Asian American Studies. The project is also supported by the Friends of the University of Washington Libraries, the Blakemore Foundation, the Hugh and Jane Ferguson Foundation, and by the following donors:

Joyce Agee
Sharon Archer
Carole Barrer
The Boeing Company
The Estate of Dick Cleveland
Neil Collins
Lindsey and Carolyn Echelbarger
Eklund Electric
Kerry Fowler and Jon Gray
Rochelle Goffe, JD
Beverly C. Graham
John Impert
M2 Innovative Concepts
Pruzan Foundation
Alan Rudolph
Rob and Jolie Scheibe
Milt and Sherry Smrstik
Roger Van-Oosten and Jeanna Hoyt-Van Oosten, MD
Kathie Werner
Women Painters of Washington
Wyman Youth Trust

I WAS FIRST INTRODUCED to the work of the Seattle Camera Club more than twenty years ago by Dennis Andersen and the late Robert D. Monroe. Bob was the head of the University of Washington Libraries Special Collections division, and Dennis was in charge of photographs and architectural drawings. Both deserve special thanks and recognition for the early care and enthusiasm they gave to this important collection. Bob had strongly encouraged me to build upon his own research and writing on SCC members, and I hope that I have lived up to his high standards. Dennis has an encyclopedic knowledge of Seattle's cultural history and has always been extremely generous in sharing that knowledge with me and with everyone else in the community.

Joyce Agee, associate director of advancement for the University of Washington Libraries, is the true hero of this project. Her support, patience, and tenacity took this book from a dream to reality.

For their professional and personal dedication to this book, I thank Jacqueline Ettinger, Mary Ribesky, Nina McGuinness, and Director Pat Soden of the University of Washington Press. I must also credit Naomi Pascal, former editor-in-chief of the Press, who encouraged this project early on.

Special thanks goes to Elizabeth Brown, Paul Cabarga, and the staff at the Henry Art Gallery.

Phil Kovacevich is a brilliant designer and is always a joy to work with.

Selecting the images for my essay, the biographies, and especially for the plates was an extremely challenging and time-consuming process. I give my heartfelt thanks to everyone who gave me the opportunity to access their collections over the past fifteen years of researching this project.

From the University of Washington Libraries Special Collections, I am indebted to my co-author Nicolette Bromberg for her contributions and enthusiastic advocacy on behalf of these photographers. I would also like to thank Carla Rickerson, Blynne Olivieri, Sandra Kroupa, Gary Lundell, and the libraries staff.

I am grateful to Jodee Fenton, manager of special collections, and Stanley Shiebert, librarian, The Seattle Public Library, for many years of special attention and assistance.

Dennis Reed, a pioneer in the study of Japanese American photography, has for many years been a source of inspiration and support. Thank you for always being so generous with your knowledge.

Michiyo Morioka has patiently assisted me in several capacities for this publication. She provided written and verbal translations to explain aspects of Japanese language and culture with a sensitive clarity that contributed immensely to this project.

Mary Randlett is a dear friend and brilliant photographer whose work continues the poetic legacy of the SCC.

Mick Gidley, emeritus professor of American Literature, University of Leeds, provided scholarship on Edward S. Curtis and gave assistance and advice with aspects of my essay.

Dr. David Clarke, Department of Fine Arts, University of Hong Kong, provided information about Kwei Dun (Teng Baiye).

For assistance in identifying the processes of the photographs, I gratefully thank Nicolette Bromberg, photographer Tod Gangler, and especially photography conservator Lisa Duncan.

Ruth Kitchin, collections assistant, National Media Museum, provided information regarding the Royal Photographic Society.

Beth Gates Warren, photography historian, provided copies of scarce Frederick & Nelson salon catalogues, as did Jonathan Frembling, archivist and reference services manager, Amon Carter Museum, Fort Worth.

One of my friends who unfortunately did not live to see this project completed was Sarah "Sally" C. Yeo. Sally was the grand-niece of photographer Adelaide Hanscom and spent decades researching and maintaining the reputation and extant works of her aunt. Shortly before her death she generously donated her Adelaide Hanscom collection to the University of Washington Libraries. Her surviving life partner, Virginia Foley, facilitated the donation through a very difficult time, and I thank her. The collection was further strengthened by generous donations from Sally's cousin, Catherine Leeson Pelizzari.

For their support, assistance, and insight, I wish to thank the following individuals: Richard Anderson, Susan Harris, Liz Little, Amy Johnson, and the late Mrs. Elizabeth H. Anderson for providing a surrogate family for Ella McBride and for sharing their loving memories of her with me; Paul A. Berry, professor of Japanese Art History, Kansai Gaidai University, Japan; Olaf Bolm and Marilyn McLeod, Adolph Bolm Archive; Audrey Borges, Records & Archives for the Canadian National Exhibition, Exhibition Place, Toronto; Margaret Bullock and Rock Hushka, Tacoma Art Museum; Helen Burnham, Jody Bush, and Paul Hoerlein, relatives of Ella McBride; Les Cook of Grass Skirt Records for providing information about Aida Kawakami; Susan Ehrens, photography historian, who assisted me with information on Imogen Cunningham and Claire Shepard Shisler; David Evans, archivist, Portland Public Schools; Trevor Fairbrother, who gave early support and sensitive encouragement for the exhibition and study of this work; Louis Fiset for his continued assistance with research on members of the SCC and on several aspects of the Japanese internment; Kathleen Fraas, registrar, Castellani Art Museum of Niagara University; Audrey Garbe, Effingham Genealogical and Historical Society; Gail Gibson, G. Gibson Gallery, Seattle; Curator of Photography Howard Giske, Kristin Halunen, and Carolyn Marr, Museum of History and Industry, Seattle; Carole Glauber, photography historian and biographer of Myra Wiggins; Nancy E. Green, senior curator, Herbert F. Johnson Museum of Art, Cornell University; Christina Henderson for her expert

studies on Virna Haffer; Sharon Howe, archivist for Mazamas; Bill Jeffries, Simon Fraser University Gallery; Reiko Kopelson, daughter of Soichi Sunami, who has assisted me on numerous occasions over the past ten years, and the late Mrs. Suyeko Sunami; Lawrence Kreisman and Wayne Dodge; Greg Lange, Puget Sound Regional Archives; Charles P. LeWarne, Priscilla Long, senior editor, Historylink.org; Glenn Mason; Curator Barbara Matilsky and Curator of Collections Jan Olson, Whatcom Museum of Art; Kathleen McCluskey, The Mountaineers Library; Lynette Miller, Maria Pascualy, Elaine Miller, and Fred Poyner, Washington State Historical Society; Yuri Mitsuda, curator, Shoto Museum of Art, Tokyo; Dee Molenaar; Mimi Muray, Nickolas Muray Photo Archives, LLC; Hollis Near, librarian, Cornish College of the Arts; Gael Newton, senior curator of photography, National Gallery of Australia; Curator of Photographs Alison Nordström and Collection Manager Wataru Okada, George Eastman House, International Museum of Photography and Film; Director Masaaki Ozaki and Assistant Curator Chinatsu Makiguchi, National Museum of Modern Art, Kyoto; Catherine Leeson Pelizzari; Christian A. Petersen, associate curator of photography, Minneapolis Institute of Arts, for his groundbreaking research and scholarship on Pictorialism; Phillip Prodger, curator of photography, Peabody Essex Museum, for reading my essay and offering valuable advice; Meg Partridge, The Imogen Cunningham Trust; Gene, Lillian, and Jacky Randall, family of Virna Haffer; Patrick Ravines, director and associate professor, Art Conservation Department, Buffalo State University; Naomi Rosenblum, photography historian, for her encouragement and advice over the years; Robert Schuler and Judith Kipp, Tacoma Public Library; Alice Standin, New York Public Library for the Performing Arts, Jerome Robbins Dance Division; Patrick and Anne Suyama; Mrs. Kuniko Takamura and Mrs. Kiyomi Erickson, Rainier Ginsha, Seattle; Traci Timmons, Seattle Art Museum Library; and Marlene Wallin, research associate, Oregon Historical Society Research Library.

Finally, I would like to offer my personal thanks to Christopher Martin Hoff, Christopher Hydinger, Rose Marie Seawall, and my partner, Dominic Zambito.

DAVID F. MARTIN

I WOULD LIKE TO ACKNOWLEDGE the photographers of the Seattle Camera Club, who were people in love with the pure joy of photography and with sharing their work with others. We are fortunate today in that we are able to share some of their passion for photography through the efforts of Robert Monroe and Rich Berner, who brought the club's photographs and papers into the University of Washington Libraries to preserve them for posterity. I would like to thank the people whose work set the stage for my research for this book: Robert Monroe, for his early writing on the club; Louis Fiset, who wrote *Imprisoned Apart,* the story of the internment experience of Iwao and Hanaye Matsushita; and Shelley Sang-Hee Lee for her insightful article on the group, "'Good American Subjects Done through Japanese Eyes': Race, Nationality, and the Seattle Camera Club, 1924–1929." I am also pleased to thank Alice Barbut for introducing me to Dr. Kyo Koike's grandson Shuji Koike, who shared family stories and Iwao Matsushita's correspondence containing memories of Dr. Koike.

Special thanks goes to my colleagues: Special Collections Book Arts and Rare Book Curator Sandra Kroupa for the recollections of her friend and mentor, Robert Monroe, and his role in preserving the club's materials; and Chief Curator Elizabeth Brown of the Henry Art Gallery for her recognition of the artistry of the photographs and the importance of an exhibition. My deep appreciation goes to co-author David Martin for his tireless advocacy of regional art and of the Seattle Camera Club and for his support of Special Collections over the years.

This project has been developed with the help of many other people. I would like to acknowledge Dean Lizabeth (Betsy) Wilson and Associate Dean Paul Constantine of the University of Washington Libraries for their strong support of the project. I would also like to thank Friends of the Libraries, who gave critical early funding for conservation work to preserve the materials. My lasting gratitude goes to this group for its advocacy on behalf of the Libraries and whose members generously give of their time and support year after year. Finally, my thanks go to my colleague and friend, Associate Director of Advancement Joyce Agee, who provided leadership and vision to move the project from an idea to reality and whose tenacity ensured that the project went forward even when it hit roadblocks and seemed like it would never happen.

NICOLETTE BROMBERG

INDEX

沙港寫眞俱樂部

"Seattle Photograph [Camera] Club" in Japanese script as published in several issues of *Notan*